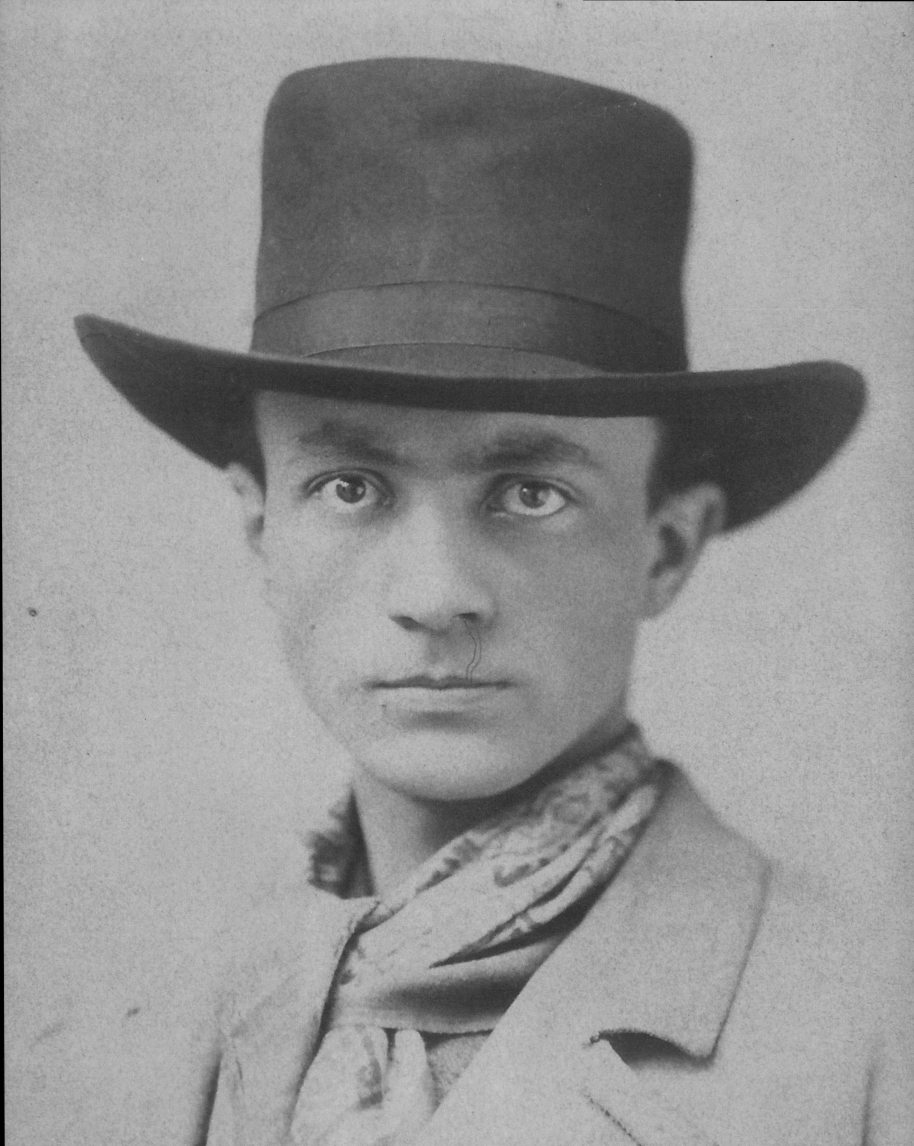

THE ARTISTIC FURNITURE OF CHARLES ROHLFS

THE ARTISTIC FURNITURE OF
Charles Rohlfs

Joseph Cunningham

American Decorative Art 1900 Foundation
New York

Yale University Press
New Haven and London

Published in conjunction with the exhibition *The Artistic Furniture of Charles Rohlfs*, organized by the Milwaukee Art Museum, Chipstone Foundation, and American Decorative Art 1900 Foundation.

Principal photography by Gavin Ashworth
Art design and rights clearance by Joseph Cunningham
Edited by Bruce Barnes
Designed by MGMT. design
Set in Fedra Sans by Peter Bilak
Printed in Italy by Mondadori

Library of Congress Cataloging-in-Publication Data
Cunningham, Joseph.
 The artistic furniture of Charles Rohlfs / Joseph Cunningham.
 p. cm.
 "Published in conjunction with the exhibition 'The Artistic Furniture of Charles Rohlfs', organized by the Milwaukee Art Museum, Chipstone Foundation, and American Decorative Art 1900 Foundation"—T.p. verso.
 Catalog of an exhibition held at the Milwaukee Art Museum and four other institutions between June 2009 and Jan. 2011.
 Includes bibliographical references and index.
 ISBN 978-0-300-13909-9 (cloth : alk. paper) —ISBN 978-0-300-14546-5 (pbk. : alk. paper)
1. Rohlfs, Charles, 1853–1936—Exhibitions. 2. Furniture design—United States—History—20th century—Exhibitions. I. Rohlfs, Charles, 1853–1936. II. Milwaukee Art Museum. III. Title.
 NK2439.R64A4 2008
 749.092—dc22 2008017676

A catalogue record for this book is available from the British Library.

The paper in this book meets the guidelines for permanence and durability of the Committee on Production Guidelines for Book Longevity of the Council on Library Resources.

10 9 8 7 6 5 4 3 2 1

Front cover: Charles Rohlfs and Anna Katharine Green, *Desk Chair*, ca. 1898–1899, from the Rohlfs home. Oak, 53¹⁵⁄₁₆ × 15¹³⁄₁₆ × 16⅞ in. (137 × 40.5 × 42.9 cm). The Metropolitan Museum of Art, New York. Promised gift of American Decorative Art 1900 Foundation in honor of Joseph Cunningham.

Back cover: *Corner Chair*, ca. 1898–1899. Oak, 28⅞ × 19 × 19 in. (73.3 × 48.3 × 48.3 cm). Dallas Museum of Art. Promised gift of American Decorative Art 1900 Foundation in honor of Joseph Cunningham.

Frontispiece: Charles Rohlfs in the role of Dixon in *One Hundred Wives*, 1 November 1880, Philadelphia. Reverse of original photograph reads "Gave me my opening with Lawrence Barrett." American Decorative Art 1900 Foundation.

Pages VI–VII: *Tall Back Chair*, furniture tag on underside of seat (see fig. 5.18)

Overleaves:

Foreword: *Corner Chair*, detail, maker's mark on underside of seat (see fig. 7.6)

Acknowledgments: *Fretted Octagonal Cabinet*, detail, maker's mark and date (see fig. 7.33)

Introduction: *Hall Chair*, detail, backrest (see fig. 4.11)

Chapter 1: *Carved Box*, detail, top (see fig. 8.18)

Chapter 2: Charles Rohlfs and Anna Katharine Green, *Settee*, detail, seat (see fig. 2.2)

Chapter 3: *Lamp*, detail (see fig. 9.26)

Chapter 4: *Rotating Desk*, detail, fall front (see fig. 4.12)

Chapter 5: *Tall Back Chair*, detail, backrest (see fig. 5.18)

Chapter 6: *Chiffonier*, detail, side panel (see fig. 8.11)

Chapter 7: *Library Table*, detail, front (see fig. 7.21)

Chapter 8: *Partners' Desk*, detail, side (see fig. 8.13)

Chapter 9: *Standing Desk*, detail, side panel (see fig. 9.1)

Chapter 10: *Desk with Suspended Gallery*, detail, gallery (see fig. 10.5)

Chapter 11: Lamp made for Sterling Rohlfs, detail, base (see fig. 11.24)

Appendix: *Candelabrum*, detail (see fig. 9.20)

Notes: *Bench*, detail, front panel (see fig. 5.13)

Endpaper: *Carved Desktop Shoe*, 1904. Ebonized oak, 3⅛ × 8⅛ × 3⅛ in. (7.9 × 21 × 7.9 cm). Private collection.

For Bruce, whose commitment to Rohlfs brings these works to life

Charles

Buffalo, N. Y., U

TO

Origi

Rohlfs,
S. A.

MUSEUM EXHIBITION SCHEDULE

Milwaukee Art Museum, Milwaukee, Wisconsin
(June 2009–August 2009)

Dallas Museum of Art, Dallas, Texas
(September 2009–December 2009)

Carnegie Museum of Art, Pittsburgh, Pennsylvania
(January 2010–April 2010)

The Huntington Library, Art Collections, and Botanical Gardens, San Marino, California
(May 2010–September 2010)

The Metropolitan Museum of Art, New York, New York
(October 2010–January 2011)

CONTENTS

FOREWORD

Since the seminal exhibition *The Arts and Crafts Movement in America* was organized by the Princeton University Art Museum and Art Institute of Chicago in 1972, the furniture-maker Charles Rohlfs has been considered an important figure in this movement. His work has been prominently featured in every significant survey of American Arts and Crafts. Yet many of his designs are radically different from those of any other Arts and Crafts maker. Rohlfs himself rejected being categorized as part of any movement. He considered himself a maker of "Artistic Furniture" with a highly individualistic style.

Rohlfs began making furniture for his home in the 1880s because he and his wife were dissatisfied with the furniture they could afford. Surprisingly, his earliest surviving works, made around 1888, long before the Arts and Crafts Movement became a force in the United States, exhibit many characteristics of his mature style. These early works, in fact, were very influential on some of Gustav Stickley's first pieces of furniture in the Arts and Crafts style. Nevertheless, Rohlfs went to considerable pains to distinguish his works from furniture made by such contemporaries as Stickley and the Roycroft Shops.

On one hand, the commonalities in their styles are undeniable. Rohlfs worked predominantly with oak, which was considered de rigueur for many in the Arts and Crafts Movement. For most of his career, he favored matte dark stains, also characteristic of many Arts and Crafts makers. Their similar use of dark-stained oak was likely the result of a shared admiration of medieval precedents. This reverence was a key part of the Arts and Crafts philosophy. On the other hand, Rohlfs did not seek to place himself within the Arts and Crafts Movement. Although he spoke of the merits of handmade objects, he did not quote John Ruskin, William Morris, or other Arts and Crafts prophets. As Sarah Fayen discusses in the Introduction, Rohlfs did not abide by the Arts and Crafts precepts of honest construction, and he even went so far as to deceive the viewer that such techniques had been used.

Many furniture-makers in the American Arts and Crafts Movement distrusted ornamentation, which was an essential feature of Rohlfs's oeuvre. In some of Rohlfs's best work, the form is the ornamentation, and the ornamentation is the form. In contrast, in many of Gustav Stickley's best pieces, all that there is or is needed is the form. Both Rohlfs and Stickley found great beauty and solidity in oak, but they expressed their reverence in different ways. Rohlfs evinced his love for wood through carving, Stickley by leaving it unadorned. Rohlfs was critical of makers like Stickley for their "indiscriminate use of wood."

For decades Rohlfs was unwilling to admit a relation between his work and Mission furniture (then synonymous with American Arts and Crafts). Still, late in his life, Rohlfs readily accepted credit for creating the Mission style while insisting that he went on to create the "Rohlfs style," which remained distinctly his own. On his death, his Associated Press obituary, carried in the *New York Times* but written in Buffalo, New York, credited Rohlfs as the creator of the Mission style. Though surely influential on Gustav Stickley, Rohlfs's designs stand apart from the Arts and Crafts style (and none had the sensibility of furniture from a Spanish mission). Bernard Maybeck and A. Page Brown and their enormously influential chair, later called the "Mission Chair," from the Swedenborgian Church in San Francisco (1893) are more deserving of credit for originating the American Arts and Crafts style of furniture (see fig. 3.13).

Although Rohlfs may have been a progenitor of the American Arts and Crafts style, he does not seem to have benefited much from its popularity. The Rohlfs style was at odds with the simplicity and honest construction advocated by Stickley's *Craftsman* magazine and other influential design publications. In fact, once it took hold, the fashion for simplicity likely hampered Rohlfs's efforts to promote his own vision. Yet he did seem to adapt somewhat to the popular fashion, and some of his later furniture designs (1903–1907) are closer to the mainstream Arts and Crafts style.

Some have argued that Charles Rohlfs is a representative of the Art Nouveau Movement in America. For example, his iconic carved *Tall Back Chair* (see fig. 5.18) was appropriated (along with several works from the Prairie School Movement) in the Victoria and Albert Museum's overinclusive recent *Art Nouveau* exhibition. Although Rohlfs is one of the only American furniture-makers whose works exhibit some affinity with the Art Nouveau style (see, for example, *Calendar Rack*; fig. 5.4), he is misplaced in this stylistic movement. This book makes the case that Louis Sullivan's stylization of naturalistic imagery, which was in full bloom by 1885, before the origin of the Art Nouveau Movement, had more influence on Rohlfs than Art Nouveau.

As critics and art historians have noted, Rohlfs's structures are generally quite plain, with simple geometric shapes creating the overall framework, even where elaborate flourishes of carving are present. As early as January 1901, a review in *Art Education* noted, "The wild whirls of *l'art nouveau* have not entrapped Mr. Rohlfs. . . . The structural lines, indeed, are not played with overmuch as is so often the case in *l'art nouveau*. The ornamental design, therefore, gives him all the more scope, in the form of panels, medallions, clear cuttings, and carvings upon boxes, cases and chests principally." This distinction evokes an essential difference between the architecture of Louis Sullivan and such Art Nouveau architects as Victor Horta and Hector Guimard. Sullivan applied decorative panels with elaborate motifs to structures that were essentially rectilinear; Horta and Guimard, in contrast, each designed structures that broke through rectilinear constraints.

In general, one must look further afield for the direct influences on Rohlfs's designs. In particular, it is likely that Rohlfs drew on pattern books published in Europe and America during the late nineteenth century. This book traces influences on Rohlfs's designs to Germanic, Scandinavian, English, Chinese, Japanese, Moorish, and Byzantine sources, among others. Although his oeuvre incorporates many design influences, it is perhaps most strongly rooted in his own interpretation of Germanic design traditions.

In the Introduction, Sarah Fayen asserts that Charles Rohlfs was profoundly influenced by the Aesthetic Movement. The stylistic connections are tenuous, but, as Martin Levy has suggested, the Aesthetic Movement may be best understood as a cultural phenomenon rather than as a style. In this light, Rohlfs's view of himself as an artist in furniture connects him to British and American Aesthetic designers and makers of "art furniture." At their best,

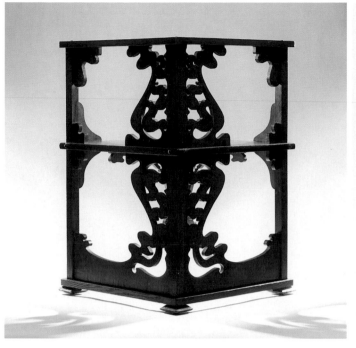

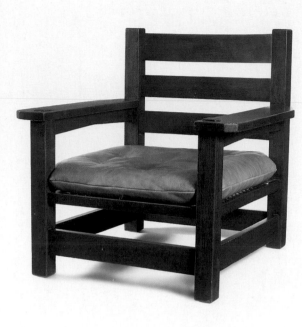

these makers sought to create unique works of beauty rather than merely to produce furniture typical of the time. This was Rohlfs's avowed goal.

As much as I may wish to argue that Charles Rohlfs was an idiosyncratic protomodernist—analogous to James Ensor or Vincent van Gogh—only a minority of his works would support such a claim. His work is perhaps best understood as the culmination of nineteenth-century forces, including the Aesthetic Movement and prevailing taste for eclecticism and exoticism. On the other hand, one might build a case that Rohlfs, a man with a singular vision and a small workshop, was a precursor of the American studio furniture movement.

Rohlfs's work was influenced by his training as an engineer and flair for invention, his close relationship with his gifted wife, and his desire to turn his artistic endeavors into a profitable business. He was an artist with a practical and inventive temperament. In early adulthood, he moved between touring as an actor with theatrical companies and working as a pattern maker and designer for stove foundries. Although his flair for the dramatic certainly shows in his designs, his skills come from his training at the Cooper Union in New York and from his industrial work, as Sarah Fayen cogently argues in her Introduction. Whenever Rohlfs spoke about his approach as a designer of furniture and decorative objects, he emphasized the combination of artistry with useful design. Rohlfs was also an inventor, with a half dozen patents to his name, generally for improbable objects. His flair for idiosyncratic innovation left its mark on some of his quirkier furniture designs, such as his famous *Rotating Desk* form and his rotating *Calendar Rack*, which is not known to be extant.

F.1 *Corner Chair* (back view), ca. 1898–1899. Oak, 28 ⅞ × 19 × 19 in. (73.3 × 48.3 × 48.3 cm). Dallas Museum of Art. Promised gift of American Decorative Art 1900 Foundation in honor of Joseph Cunningham.
F.2 Gustav Stickley, Eastwood chair, 1902. Oak, 36 ¾ × 36 × 34 ½ in. (91.9 × 90 × 86.3 cm). Private collection.

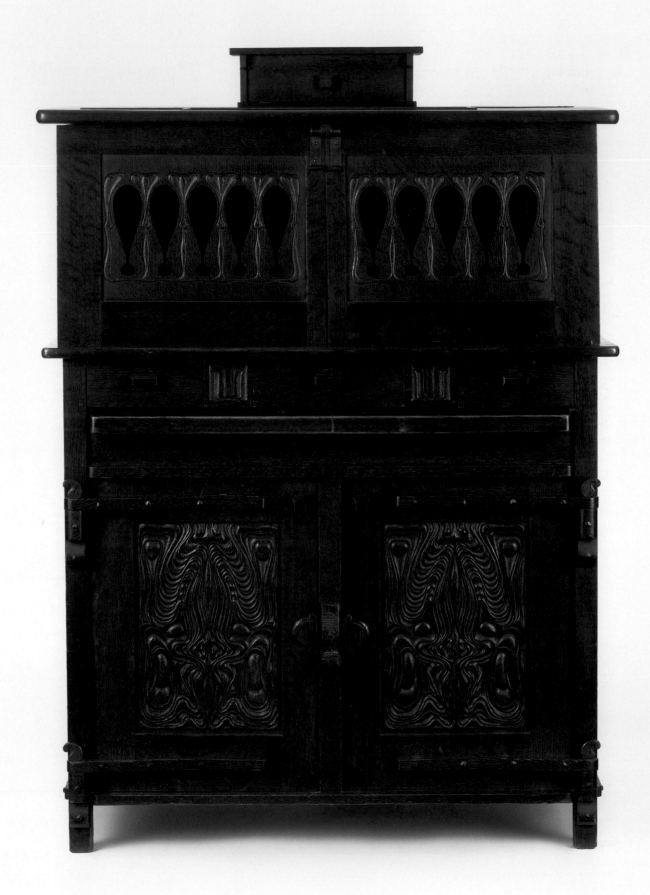

F.3

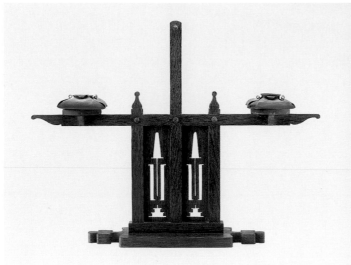

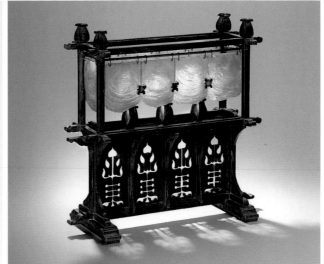

F.4 F.5

It is not possible to understand Charles Rohlfs outside the context of his marriage with Anna Katharine Green, an enormously successful mystery writer, whose income from royalties supported the Rohlfs family. Anna Katharine's most famous book, *The Leavenworth Case*, gave Charles another chance to pursue his dream of a career on the stage; her reputation and literary connections gave him access to press coverage; and her assured income gave him the flexibility to pursue both acting and artistic furniture-making without the economic pressures for immediate success. This book presents, for the first time, evidence that Anna Katharine also made an important artistic contribution to some of the furniture Charles made and designed.

An anomaly in his day, Rohlfs was never the primary breadwinner in his home, but he was determined to turn his furniture-making into a profitable business. He offered his works through Marshall Field and Company, the influential Chicago retailer, where they met with limited success at best. A master of false modesty, Rohlfs was a gifted self-promoter, who received important coverage in the American and German design press. He eagerly sought commissions and willingly adapted his style to his clients' tastes. Although he never maintained much inventory, Rohlfs ultimately sought to reach a broader audience by publishing a portfolio of illustrations of his works in late 1907, when his business was well past its peak. Despite his efforts, Rohlfs never built a sustainable business. Many of his best works went unsold and ended up in the family home.

Regardless of how his work should be categorized, Rohlfs was the first of the American furniture designers and makers from the period around 1900 to have been embraced by museums (other than architects, such as Frank Lloyd Wright). The first museum known to have accessioned a work by Charles Rohlfs is the Brooklyn Museum of Art, which in 1960 accepted as a gift a double candlestick by a then-unknown maker, thought possibly to have been French. The candlestick was later discovered by Robert Judson Clark to be the work of Charles Rohlfs and was included in the landmark 1972 Arts and Crafts exhibition. The Princeton University Art Museum accessioned six works generously donated by Charles's son Roland,

F.3 *Standing Desk*, 1902/1904. Oak and mahogany with copper, 55 × 38 ¼ × 26 ⅞ in. (139.7 × 97.2 × 68.3 cm). Private collection.
F.4 *Double Candle Stand*, 1904. Oak and copper, 16 ¾ × 21 ½ × 4 ⁹⁄₁₆ in. (42.5 × 54.6 × 11.6 cm). Private collection.
F.5 *Candelabrum*, 1903. Ebonized and gold-rubbed oak, kappa shell, and copper, 17 × 16 ¾ × 7 in. (43.2 × 42.5 × 17.8 cm). Private collection.

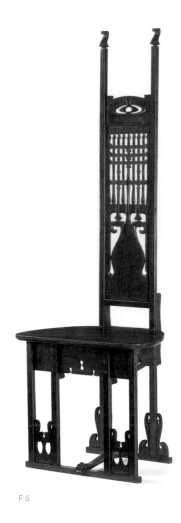

F.6

shortly after the show. The Metropolitan Museum of Art accessioned a tall case clock from Rohlfs's home, also a gift from Roland Rohlfs, in 1985.

Almost every major American museum that collects American decorative art from the period around 1900 has a work by Rohlfs in its collection today. The widespread acceptance of his works by museums may in part be the result of their "artistic" look. On the other hand, many museums have been slow to accept the works of Gustav Stickley as worthy of inclusion in their collections because of the very characteristic that makes them important: their radical simplicity.

As a collector of decorative art, my history with the work of Charles Rohlfs progressed along a different path. I became interested in furniture from the American Arts and Crafts Movement because it combined modernist simplicity with traditional material and good craftsmanship. The focus of my collecting for the first few years, therefore, was furniture by Gustav Stickley from 1901 to 1903. The first Rohlfs object I acquired was a bride's chest, dated 1907, with a simple design and little ornamentation. It was not far from the Stickley furniture in my collection. After collecting American Arts and Crafts furniture for about four years, I was offered the opportunity to acquire some of Rohlfs's most important objects and made a serious commitment to his work. Since then I have been a passionate collector of his works.

In retrospect, I believe that I may have embraced Rohlfs's works to offset the austerity of Stickley's furniture. Made of quarter-sawn oak with dark finishes, most of Rohlfs's decorative art is harmonious with other Arts and Crafts furniture and can add visual interest to an otherwise predominantly rectilinear environment. Whereas an environment filled with works by Stickley may be austere, a home filled with works by Rohlfs would be overwhelming, like many interiors from the Aesthetic Movement. This book reproduces many photographs of the interiors of the Rohlfs family homes. The rooms were filled with stunning works by the artist, but the overall effect is cacophonous. One may have a great taste for Rohlfs's work without sharing his taste for interior decoration.

Although Charles Rohlfs's works are now well represented in museum collections, there has never been a public exhibition of a large body of his best objects. Because his designs are so imaginative and so varied, we believe that understanding and appreciating Rohlfs's accomplishments requires the opportunity to see and analyze them as a group. We are grateful to the institutions and private individuals who have made their objects available for this book and exhibition.

The objects have been selected to show the best of Rohlfs's works, rather than a representative sampling. Rohlfs made a surprisingly broad range of notable decorative art objects, several of which are sublime and transcend attempts at categorization. He also made a large number of objects that are aesthetic failures, including some veritable eyesores. Some of these missteps can be blamed on clients, whose specifications Rohlfs was pleased to meet, but others are simply examples of bad design. We make no apology for excluding his failures, some of which can be seen in the portfolio of illustrations of his work that are printed in the Appendix, courtesy of The Metropolitan Museum of Art.

This book covers the life of Rohlfs in roughly chronological order, but the focus is on the objects he designed and made, rather than on his life and times. Many of these objects are analyzed in depth. This approach reflects the philosophy of the American Decorative Art 1900 Foundation, which gives primacy to the objects and their aesthetics.

The mission of American Decorative Art 1900 Foundation is to stimulate, enhance, and promote the understanding and appreciation of American decorative art from the period

F.6 *Hall Chair*, 1904. Oak, 54 ½ × 19 × 19 in. (138.4 × 48.3 × 48.3 cm). Milwaukee Art Museum. Gift of American Decorative Art 1900 Foundation in honor of Glenn Adamson.

around 1900, in particular from the American Arts and Crafts Movement and the Prairie School Movement. To further this objective the foundation has developed relationships with more than twenty museums and four graduate school programs in decorative arts. The foundation has placed important decorative art objects at many of these museums, either through gifts or through extended loans. Over the long-term, the foundation will facilitate the donation of most of my collection of American decorative arts to museums across the United States.

The Artistic Furniture of Charles Rohlfs is the first book published by our foundation. It accompanies an exhibition of his works organized by Milwaukee Art Museum, Chipstone Foundation and American Decorative Art 1900 Foundation. The exhibition was suggested by Glenn Adamson, then curator at Chipstone Foundation and Milwaukee Art Museum. Over the last several years, Milwaukee Art Museum and Chipstone Foundation have been great partners in this project. I am grateful for the invaluable contributions of Daniel T. Keegan, David Gordon, Jonathan Prown, Joseph D. Ketner II, Sarah Fayen, Dawnmarie Frank, and many others acknowledged elsewhere.

I am also grateful for the support of the other institutions participating in this exhibition tour: the Carnegie Museum of Art; Dallas Museum of Art; The Huntington Library, Art Collections, and Botanical Gardens; and The Metropolitan Museum of Art. Each of these institutions has made a great commitment to American decorative arts from the period around 1900, and each is the proud owner of one or more important works by Charles Rohlfs. In organizing the exhibition tour, I am particularly grateful for the support of Richard Armstrong, Jason Busch, Philippe de Montebello, Alice Cooney Frelinghuysen, Morrison H. Heckscher, Jack R. Lane, John Murdoch, Sarah Nichols, Bonnie Pitman, Jessica Todd Smith, and Kevin Tucker.

The contributions of many are essential for any project of this size, but this book and exhibition are the result of Joseph Cunningham's vision and tireless effort. In addition to writing the text, he was responsible for conducting primary research, organizing the object checklist, clearing photo rights, acting as art director for the extensive new photography, and overseeing the book design. That he did this without the benefit of any support staff is remarkable. I am grateful to Joseph Cunningham and Martin Eidelberg for their helpful comments on this foreword.

Joseph Cunningham and I are enormously indebted to the kindness and generosity of Liza Ortman, the great-granddaughter of Charles Rohlfs and Anna Katharine Green. She and other members of her family had the foresight to preserve extensive archives related to the works of Charles Rohlfs. These materials provided invaluable primary source material for this project. Much of this archival material has since been generously donated by Liza Ortman to form the core of the Charles Rohlfs Archive at The Winterthur Library: Joseph Downs Collection of Manuscripts and Printed Ephemera in Winterthur, Delaware. American Decorative Art 1900 Foundation has donated, in honor of Liza Ortman, additional archival material to augment this archive. Our hope is that this will prove a valuable resource for future researchers.

Although my acquaintance with Charles Rohlfs began with the purchase of a fairly humble chest, his genius soon captivated my attention. We hope that the information, analysis, and photography in this book will inspire scholars, curators, collectors, and the public to embrace the complex and exciting world of Charles Rohlfs.

Bruce Barnes, Ph.D.
Founder and President
American Decorative Art 1900 Foundation

ACKNOWLEDGMENTS

This book on the life and work of Charles Rohlfs could never have been completed without the help of many friends and colleagues. I have been able to rely on the knowledge and insights of many people in shaping the content and form of the present work.

My first debt of gratitude is to Bruce Barnes, without whose support the research, documentation, and writing for this book would not have been possible. He is the first collector ever to embrace and deeply understand the work of Charles Rohlfs. His insights about and enthusiasm for Rohlfs's fantastic creations have resulted in the definitive collection of the designer's work, to which I have been honored to have unfettered access for more than ten years. Not only has Bruce been involved in every aspect of the research and documentation for this book, but he has also closely read and edited this work, improving it in every way imaginable. Above all, I am indebted to him for his collaboration on this project.

Second, I cannot begin to acknowledge the contribution of Liza Ortman, the great-granddaughter of Charles Rohlfs, her husband, John, and her daughter, Rebecca Crozier. The Rohlfs-Walther-Zetterholm-Ortman family dutifully kept the Rohlfs family archive safe and intact through three generations. Liza extended every courtesy to Bruce Barnes, Sarah Fayen, and me, making these resources available without exception throughout our work on this project. Without their unfailing support, this work would not have been possible.

The Milwaukee Art Museum and the Chipstone Foundation have enthusiastically embraced this project since its inception with Glenn Adamson. Sarah Fayen, Assistant Curator for the exhibition, has diligently assisted in research and organization, offered helpful insights on the show and tour, and contributed a wonderful Introduction to this volume. Organizing exhibitions and book projects of this magnitude is not easy, and I am grateful to Glenn, Sarah, Jonathan Prown, Daniel T. Keegan, David Gordon, Joseph D. Ketner II, Dawnmarie Frank, Jim DeYoung, Therese White, and Larry Stadler for all their efforts in making this adventure a success.

Many colleagues at the exhibition venues have provided critical support in numerous ways. Thanks to Philippe de Montebello, Morrison H. Heckscher, and Alice Cooney Frelinghuysen at The Metropolitan Museum of Art; Richard Armstrong, Sarah Nichols, Jason Busch, and Rachel Delphia at the Carnegie Museum of Art; John R. Lane, Bonnie Pitman, Kevin Tucker, and Tamara Wooton-Bonner at the Dallas Museum of Art; and John Murdoch, Jessica Todd Smith, and Alan Jutzi at The Huntington Library, Art Collections, and Botanical Gardens.

Research and documentation for this project have taken many forms, and I thank the following contributors for their help: Gavin Ashworth (principal photography), Frya Barnes (German translations), David and Susan Cathers, Ken Dukoff, Martin Eidelberg and Seth Gopin, Nina and Jack Gray, Don Magner, Polly Rubin, and Jim Wolford, as well as Paul Urban and Dennis Gonzalez of Baron Upholstery, and Lenny Lapadula, James Murphy, and Thomas Venturella of Venturella Studio.

For their assistance in the design and publication of this book I thank Patricia Fidler, Mary Mayer, and Laura Jones Dooley of Yale University Press and Sarah Gephart and Alicia Cheng of MGMT. design.

The lenders to the exhibition and others have also made research files, photography, and objects available throughout our work and deserve great thanks: Susan Taylor, Alexia Hughes, Maureen McCormick, Karen Richter, Betsy Jean Rosasco, and Karl Kusserow at the Princeton University Art Museum; Wendy Kaplan, Thomas Michie, Bobbye Tigerman, and Andrea McKenna at the Los Angeles County Museum of Art; Malcolm Rodgers, Elliot Bostwick Davis, Gerald Ward, and Nonie Gadsden at The Museum of Fine Arts, Boston; Ulysses Grant Dietz at The Newark Museum; Mitchell Wolfson, Jr., and Marianne Lamonica at the Wolfsonian–Florida International University; Scott Propeack at The Burchfield-Penney Art Center; Ronald T. Labaco at the High Museum of Art; Howell Perkins, Frederick Brandt, and Barry Shifman at the Virginia Museum of Fine Arts; Judy Hart and John Angelo, Bruce Austin, Kathleen and Andrew Hasselberg, Henry Hawley, Joyce and Irving Wolf, and Daniel Wolf and Maya Lin.

I can never adequately recognize the contributions made by those who have assisted in research for this book, but each person listed here has significantly enhanced the book: Howard Agriesti, Kim Ahara, Frances Ambler, Kenneth Ames, Bart Auerbach, Don Bachigalupi, Nicholas Bacuez, Wendy Hurlock Baker, David Barquist, Clare Batley, Jim Bloomer, Leslie Greene Bowman, Edward R. Bosley, Scott Braznell, Melissa Brown, John H. Bryan, Rudy Ciccarello, Carol Ciulla, Robert Judson Clark, Sarah Coffin, Jerry Cohen, Maria Ann Conelli, David Conradsen, Matt Cottone, Sam Cottone, Niall Cremin, David Park Curry, Anna D'Ambrosio, Peggy and Richard Danziger, Donald Davidoff, Owen Davies, Bert Denker, Ellen Denker, Susan Doherty, Max Donnelly, Nurit Einik, Anita Ellis, Robert Ellison, Ulrich Fiedler, Marilyn Fish, Jacqueline Fowler, Deana Fox and Robert Shaver, Adriana Friedman, Barbara and Henry Fuldner, Catherine Futter, Andrew Garn, Tom Gleason, Ann Godoff, Bernard Goldberg, John Stewart Gordon, Nancy E. Green, Mary Greensted, Eleanor Gustafson, Stephen Harrison, Barry Harwood, Biff Henrich, Katherine Howe, Anne Hoy, Betty and Bob Hutt, Jeanie James, Michael James, Catherine Jenkins, Marilyn Jensen, Kurt Johnson, Marilyn Johnson, Patricia E. Kane, Diane Keaton, Sally King, Ellen and Harvey Knell, Arlene and Robert Kogod, Annik LaFarge, Gregory Landrey, Sarah Lawrence, Allison Ledes, Martin Levy, Wallace Lewis, Karen Livingstone, Nilda Lomascolo, Boyce Lydell, Ann Smart Martin, Don Mason, Cara McCarty, Nancy McClelland, Eileen Manning Michaels, Nadine Müseler, Graham Nisbet, Anne O'Donnell, Jennifer Komar Oliverez, Jutta Page, Max Palevsky and Jodi Evans, David Parker, Linda Parry, David Parson, Amelia Peck, Jodi Pollack, William Porter, Jessie and H. Charles Price, Naomi Pritchard, Paul Provost, Lars Rachen, David Rago, Cleota Reed, Curtis Reed, Cheryl Robertson, Debbie Goldwein and David Rudd, Kerry Rucidlo and Tiziano Cucciella, Patricia Rucidlo, David Ryan, Jeni Sandberg, Cynthia Schaffner, Deirdre Smerillo, Edgar Smith, John Sollo, Ann and Christopher Stack, Jewel Stern, Cindi Strauss, Susan Tarlow, Jan Toftey, Thayer Tolles, Terri Toretto, James Tottis, Michelle Tucker, Kitty Turgeon, Charles Venable, Patricia Virgil, Jean-Georges Vongerichten and his team, Beth Carver Wees, Joy Weiner, Eric Wheeler, David Whitney, Clare Yellin, Sylvia Yount, Joseph Yurcik, and Janet Zapata.

I am grateful to the following institutions that were invaluable in the course of the research for this book: Adirondack Collection, Saranac Lake Library; Archives of American Art, Smithsonian Institution; Brooklyn (New York) Historical Society; The Buffalo and Erie County Historical Society; Cooper-Hewitt, National Design Museum and Library, Smithsonian Institution; Cornell University, Carl A. Kroch Library; Crab Tree Farm Foundation, Lake Bluff, Ill.; Hunterian Museum, University of Glasgow; The Huntington Library, Art Collections, and Botanical Gardens; The Metropolitan Museum of Art, The American Wing; The Metropolitan Museum of Art, Archives; The Metropolitan Museum of Art, Department of Drawings and Prints; Minnesota Historical Society; The William Morris Gallery, London; National Arts Club, New York; New-York Historical Society; New York Public Library, Research Division; Philadelphia Public Library Research Division; Poultney (Vermont) Historical Society; Harry Ransom Humanities Research Center, The University of Texas at Austin; The Royal Collection, St. James's Place, London; The Royal Academy of Arts, London; University of St. Andrews Special Collections Department, St. Andrews, Scotland; Smithsonian Archives; United States Patent and Trademark Office; Victoria and Albert Museum, Archives of Art and Design, Blythe House; Victoria and Albert Museum, Department of Furniture and Woodwork; and The Winterthur Library.

There is always peril in characterizing the number of extant examples of any work of decorative art because it is often the case that examples of forms exist but have not emerged into the market or are unknown to the author. I have taken considerable pains to make myself aware of the known examples of works by Charles Rohlfs. This effort entailed advertising in relevant publications and reaching out to more than a hundred dealers, collectors, curators, and scholars who are active or knowledgeable in this field. This research revealed a number of objects previously unknown to me and even two objects that had been "lost" in museum collections until this search uncovered them. As used in this book, the term *extant* means known by me to exist at the time of publication of this book. We can expect that unknown examples of objects will emerge, and we hope that objects that are characterized herein as no longer extant will be discovered.

Decorative art objects by Charles Rohlfs that are referred to frequently in the text are assigned italicized names (such as *Settee*) for purposes of clarity and brevity. Only objects designed by Charles Rohlfs are italicized. In the illustrations, all works of decorative art for which the maker is not credited are by Charles Rohlfs.

Unless otherwise noted, all references to sources in The Winterthur Library are to archival materials generously donated by Charles Rohlfs's great-granddaughter, Liza Ortman, in honor of her grandmother Elizabeth Walther Rohlfs (Mrs. Sterling Rohlfs), to form the Charles Rohlfs Archive in The Winterthur Library: Joseph Downs Collection of Manuscripts and Printed Ephemera, Winterthur, Delaware.

Joseph Cunningham, Ph.D.
Curator
American Decorative Art 1900 Foundation

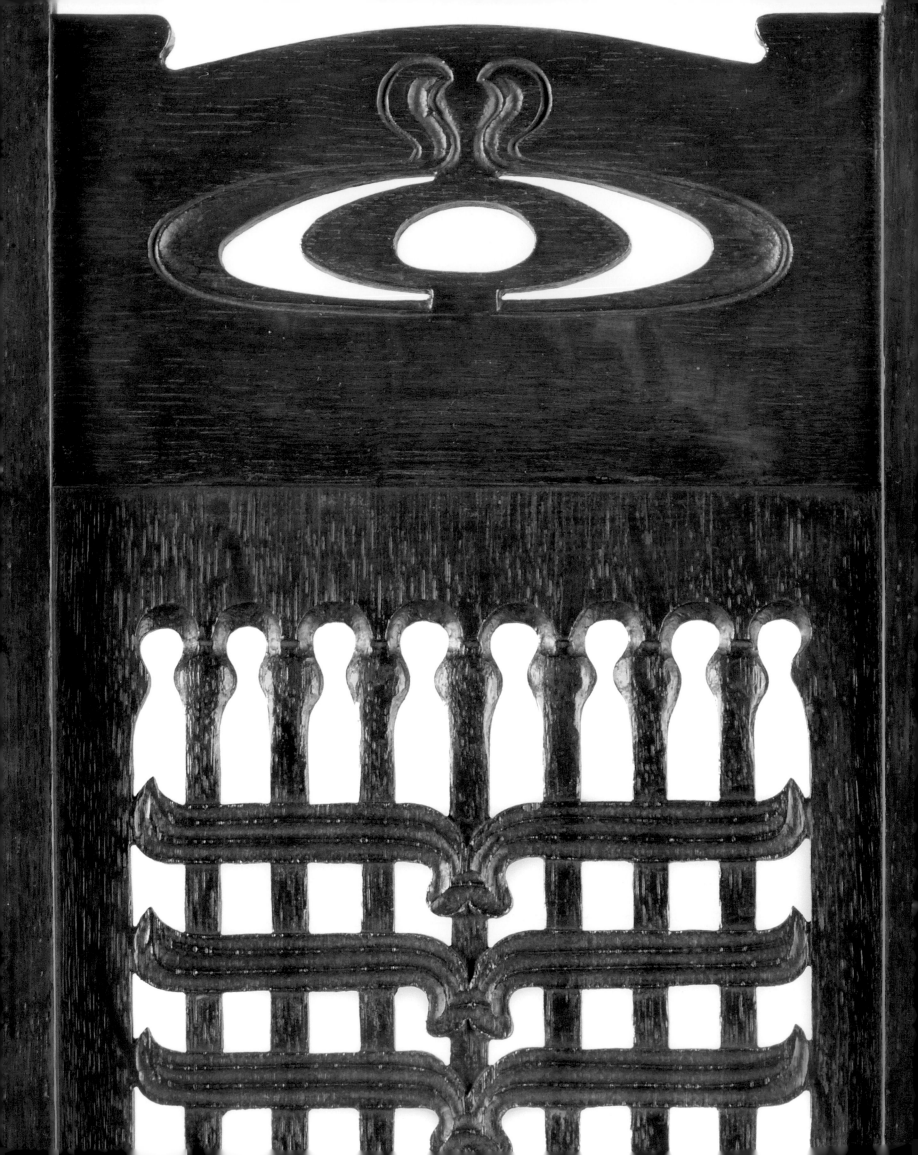

EVERYTHING IN MY LIFE
SEEMED TO POINT TOWARD THIS WORK

Sarah Fayen

In a 1900 magazine article, author Will M. Clemens praised the individuality of Charles Rohlfs's furniture designs. "The Rohlfs style is something entirely new and belongs in a class quite by itself. Try your best and you cannot place it in association with anything else."[1] Rohlfs was the charismatic designer and craftsman who led a small workshop in Buffalo, New York, that produced dark oak furniture with a matte finish. Although his choice of materials and generally ahistorical ornament linked his work to other progressive furniture of the time, Rohlfs's designs stood out for their animated silhouettes, bold forms, and expressive carving. Clemens's inability to categorize Rohlfs's furniture surely pleased the designer himself. "Please do not ask me to define my work," he wrote in a 1902 interview, "just put me down as a man who loves [making furniture]."[2] Rohlfs further cultivated his distinctiveness by resisting the labels "Mission," "Arts and Crafts," and "Art Nouveau," all of which were used to describe his work. He preferred "Artistic Furniture" or simply "The Rohlfs Style," terms that identified his designs not as part of a specific style or movement but rather as expressive art made by a single individual.

Although Charles Rohlfs has been consistently associated with the Arts and Crafts Movement by today's art historians, curators, and collectors, he remains an idiosyncratic figure whose designs, writings, and personal history make his work as hard to categorize now as when Clemens wrote his article. Rohlfs resists conventional art historical classification in part because he brought to his workshop an unusual variety of formative experiences. Rohlfs was already in his mid-forties when he started to make furniture professionally around 1897. By that time he had attended school for both science and art and pursued a career as a pattern maker and designer of cast-iron stoves. Though often overlooked in scholarly considerations of his work, Rohlfs's early schooling and experiences in industrial production strongly influenced the construction and appearance of his later furniture. Of additional influence were the ideals of the Aesthetic Movement, whose "art for art's sake" philosophies dominated the last quarter of the nineteenth-century American artistic scene. In his stove designs, his acting career, and the life he created with his novelist wife, Rohlfs immersed himself in the pursuit of the artistic. Into his deeply rooted Aesthetic Movement framework Rohlfs incorporated the woodworking and design skills gained in his early careers with new twentieth-century tastes. The result was furniture that was truly, as Clemens wrote, "in a class by itself."

Contributing to historians' difficulty in grasping Rohlfs's early life is the artist's own tendency to obfuscate the details. The explanations he gave later in life about how he turned to

I.1 I.2

furniture-making intentionally obscured many early experiences that influenced his career. In a 1923 Buffalo newspaper article, he explained, "It was purely accidental, my making furniture. I had been an actor. . . . And then I met Mrs. Rohlfs. Of course her family would not tolerate an actor so I turned to furniture-making."[3] In reality, the chronology was not so simple. Charles Rohlfs and Anna Katharine Green were married in 1884, but he is not known to have made furniture of any kind until later that decade and did not work in furniture professionally until around 1897. During the intervening years, when not pursuing his career on the stage, Rohlfs worked as a pattern maker in iron foundries, an industry in which he had been employed since he was a teenager. In fact, the family's move from New York City to Buffalo in 1887 was precipitated by a job offer from a major stove manufacturer. These facts make Rohlfs's romantic story about choosing to make furniture to please his in-laws impossible. Although he chose later in life to emphasize his past as an actor rather than his industrial work, Rohlfs's experiences in foundries gave him the solid grounding in engineering, woodworking, design, and business that encouraged him to make furniture professionally and influenced how he made it.

Rohlfs entered the foundry business after being trained in drafting and design at the Cooper Union. Charles's father, Peter Rohlfs, a cabinetmaker who worked for piano companies in Brooklyn, died early, leaving young Charles to help provide for his mother and siblings.[4] In 1867, at age fourteen, he enrolled in night classes at the Cooper Union, where his instructors called him "the best draughtsman in the school."[5] In addition to classes in math and natural philosophy, Rohlfs also received instruction in mechanical drawing and perspective drawing. Most important, he would have been inculcated in the reformist belief that art and design could improve society. Peter Cooper founded the school in 1859 based on the model of Britain's

I.1 **Charles Rohlfs,** ca. 1905. The Winterthur Library.
I.2 **Frederick A. Peterson**, Foundation Building at the Cooper Union, 1853–1859. The Cooper Union Library Archives.

South Kensington School and Museum, which had been founded after the 1851 Great Exhibition in London's "Crystal Palace." The furnishings on display at the exhibition led many commentators to criticize what they considered indiscriminate decoration and poor use of materials in everything from stained glass to wallpaper, furniture, ceramics, and textiles. Items produced according to artistic principles, they believed, would improve domestic interiors and society as a whole. Proponents of these aesthetic and cultural reforms founded art schools on both sides of the Atlantic to educate craftspeople as well as the general public in organized theories of art, design, and decoration, which would help bring art to all areas of daily life. At the Cooper Union, Rohlfs internalized these beliefs, maintaining throughout his life a keen desire to learn the history of world design.

Beginning in 1871, eighteen-year-old Charles Rohlfs was listed in the Brooklyn City Directory as a "patternmaker" living with his mother, Fredericka, at 80 President Street.[6] A pattern maker in a nineteenth-century iron foundry determined the shapes of the pieces to be cast and carved the wooden patterns used to make the molds.[7] Each pattern was packed in casting sand to make a mold in which foundry men cast pieces of iron and steel. The quality of the patterns determined not only the appearance but also the functionality of the final products, which ranged from small decorative housewares to great industrial steam engines for boats and railroads. Since companies succeeded or failed in large part by the skills of their pattern makers, these men held important positions within foundries.[8]

Rohlfs's primary activity as a pattern maker was woodworking and carving. The handbooks published for pattern makers in Rohlfs's day explained basic woodworking techniques and tools that were used to build up the shapes needed to be cast.[9] Rohlfs would have learned basic joints: laps, mortise and tenons, miters, and dovetails. Images of pattern makers' shops from this period include woodworking benches with saws, chisels, lathes, and other conventional woodworking apparatus. Patterns generally were built and carved from white pine because it resisted shrinking over time, was soft enough to work easily in all directions, and was comparatively inexpensive. For castings requiring high precision, however, pattern makers used higher-quality tight-grained woods like mahogany, maple, or cherry.[10] Notably, pattern makers generally did not use oak because its deep grain would have transferred to the iron castings. Stoves were generally made from several thin panels connected with solder and some sort of clamp or other physical mechanism to create tightly sealed cooking and heating compartments. In addition to building the patterns for these structural panels, Rohlfs would have carved words or decorative flourishes to add to the panels, as well as patterns for functional latches, flues, and hooks or decorative elements like embellished legs, handles, or doors.

In addition to improving his craft and design skills, Rohlfs gained significant engineering knowledge as a pattern maker while he read and drew measured plans, drew the shapes for individual iron parts, figured out how to cast them, and assembled them into finished products. One of the most difficult tasks in pattern making was predicting and controlling the inevitable shrinkage that occurred as molten metal cooled. Much of a pattern maker's skills lay in his ability to scale up the wooden patterns to be slightly larger than needed and still produce parts precise enough to be assembled into the finished product.[11] The city directories never listed Rohlfs's employers, but he probably started as an apprentice to a master pattern maker in any number of foundries in Brooklyn or New York City. He also may have traveled to follow available jobs as he did in 1884, when he worked for a foundry in Taunton, Massachusetts.[12]

Looking back at his career, Rohlfs claimed that when he started making furniture he "had no knowledge of cabinetmaking."[13] Similarly, in 1925, he wrote that he started making furniture with "only limited acquaintance with the art [of carving and designing]." Given his

SCIENTIFIC AMERICAN

[Entered at the Post Office of New York, N. Y., as Second Class Matter.]

A WEEKLY JOURNAL OF PRACTICAL INFORMATION, ART, SCIENCE, MECHANICS, CHEMISTRY AND MANUFACTURES.

Vol. XLII.—No, 22.]
[NEW SERIES.]

NEW YORK, MAY 29, 1880.

[$3.20 per Annum.
[POSTAGE PREPAID.]

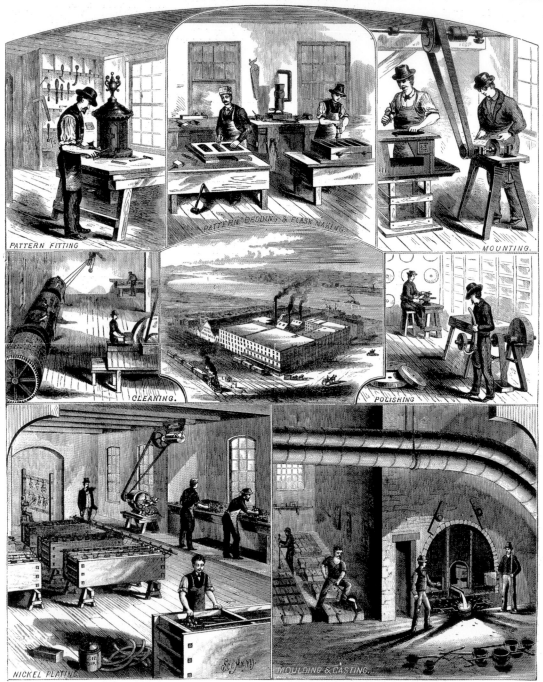

PATTERN FITTING.

PATTERN BEDDING & FLASK MAKING.

MOUNTING.

CLEANING.

POLISHING.

NICKEL PLATING.

MOULDING & CASTING.

STOVE MANUFACTURE—WORKS OF FULLER WARREN & CO., TROY, N. Y.—[See page 340.]

years as a professional pattern maker, it is difficult to accept these statements as anything other than retroactive self-image-making. Although he may not have apprenticed as a cabinetmaker, he certainly had become well versed in both woodworking and carving. By suggesting that he had no earlier carving experience, Rohlfs perhaps hoped to make his furniture seem all the more pure, fresh, and impressive. In addition, Rohlfs might have found that playing up his former life as an actor helped create the persona of a gentleman dedicated to artistic expression rather than a laborer involved in mundane industrial production.

In the last quarter of the nineteenth century, the American artistic scene was dominated by the Aesthetic Movement, a loose umbrella term that now refers to the myriad initiatives in England and the United States that embraced the idea of "art for art's sake."[14] While Rohlfs was working as a pattern maker, these reformist ideals about art in society that he learned at the Cooper Union were gaining currency in the general populace. The largely academic writings of British theorists John Ruskin and William Morris had been printed in the United States when Rohlfs was a child but had mainly influenced educators and artists. Their ideas later reached the public through advice books and magazines that raised people's consciousness about artistic design in architecture and household goods. Charles Eastlake's *Hints on Household Taste*, printed in the United States in 1872, encouraged Americans to fill their homes with well-designed and well-produced objects of beauty. Likewise, Clarence Cook's advice articles, published in 1877 as *The House Beautiful*, persuaded Americans to furnish their homes in ways that expressed their family's taste and individuality. Art no longer was the purview of the rich and well educated but rather could be appreciated and created by all people to improve their lives and thus society as a whole.

Individuality and personal expression became more valued traits in the 1870s and 1880s. As architectural historian Clifford Clark has argued, "Having once stressed the importance of the household as a protected retreat from urban dangers, [advice manuals] now encouraged the family to be the vehicle for enhancing self-development and creative expression."[15] Magazines and books were filled with the word "artistic," referring to everything from curtains to party dresses. In the middle-class American mind, home was becoming less the reflection of family morals and more of a stage on which personal artistic taste could be developed and demonstrated.[16] The emphasis on art in the home spread into details of personal deportment and leisure-time pursuits, creating an "artistic lifestyle." An anonymous 1884 article in the *Decorator and Furnisher* suggested that this high-minded aesthetic impulse rose as a reaction to rapid industrialization and consumerism. "After all, in this busy age of ours, with its hurry and greed, its ostentation and petty ambition, its standard of gold by which it measures all things, what life is best to live? One in which there are high ideals—the life of an artist."[17]

The artistic energy that suffused the country during this time probably encouraged Rohlfs to follow his interest in stage acting. Between 1877 and 1883, Rohlfs had several jobs with traveling theater companies playing roles in different cities around the country. His passion for the theater captured him so powerfully that in one off-season, he wrote a poem asking the muse to "stir up my soul to feel." Because he was not acting, he complained of missing his Shakespearean friends. He wrote in prose, "This morning my longing to commune with my loved Iago was prevented by fatigue. . . . When I could not I found how much my soul yearned for sympathy with my master's [that is, Shakespeare's] creations—how much of my life these people have become!"[18] Rohlfs probably continued to work as a pattern maker when he returned home between shows, but in 1881 he changed his Brooklyn City Directory listing from "patternmaker" to "actor."

1.3 Cover of *Scientific American*, 29 May 1880. The University of Wisconsin–Madison, Wendt Library.

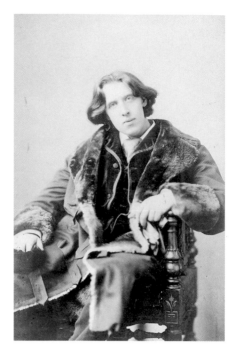

I.4

The artistic lifestyle received a dramatic boost in the United States in 1882, when actor, playwright, and critic Oscar Wilde toured the country to promote Gilbert and Sullivan's new musical *Patience*. The musical satirized precisely the sort of dandyish aesthete that Wilde was widely thought to be, a reputation that in no way diminished popular interest in his visit. Indeed, Wilde's tour took him to over fifty American cities where he lectured not on acting or drama but rather on the benefits of artistic design and taste. He was seen as the Apostle of Aestheticism and widely hailed as a "figure head . . . [of] a great movement."[19] When Wilde arrived in New York, Rohlfs had been acting for five years and certainly would have known of the celebrity's arrival in the city. Even if he did not attend Wilde's lectures, Rohlfs could not have missed the media flurry surrounding his visit. Newspaper articles around the country reprinted his lectures, debating their content as well as his dramatic clothing, his rich language, and—most important—his artistic persona.[20]

Wilde's appearance in New York and his message may have created an important link in Rohlfs's mind between drama on the stage and the drama of design. Wilde gave three lectures on his tour, in which he called England's aesthetic awakening a "passionate cult of pure beauty." He repeated the Aesthetic Movement's mantra, which he paraphrased from his teacher Ruskin and friend James Abbott McNeill Whistler, the American expatriate painter, that art "is a necessity of human life." Encouraging Americans that "the conditions of a real artistic movement" came not necessarily from painting but also from housewares and articles of daily life, Wilde emphasized the importance of individual imagination. Artistic items, he said, must have "the impress of a distinct individuality, an individuality remote from that of ordinary men."[21] For Wilde, artists existed on a higher plane, and art came from within their personal emotions. "The conditions of art should be simple," he said. "A great deal more depends upon the heart than upon the head."[22]

The importance of individual creativity and emotion so well communicated by Wilde seemed to leave an indelible imprint on Charles Rohlfs. Years later, after he had become a furniture-maker, Rohlfs spoke about his art in terms very similar to Wilde's. "Truth" in furniture, a topic about which Rohlfs lectured in 1900 and 1902, was "an individual matter." Seeing it required "an indulgence in the freedom of spirit" and the "unfettering of the wings of imagination."[23] According to Rohlfs, each person had "natural convictions" about art, which, for many, were "smothered and held in check" but could be released when channeled through the heart.[24] Rohlfs's sentiments not only echoed Wilde but also the Aesthetic Movement as a whole. Art historian Roger B. Stein has argued that one of the movement's most revolutionary elements was its declaration of "freedom from the limitations of style as a historically embedded form of expression." This liberation from the constraints of past precedent "made possible the kind of creative play with form and color and texture that helped to revolutionize our ways of seeing and knowing."[25] Indeed, the last quarter of the nineteenth century was the first time that Americans were encouraged to discover individual delight in all things beautiful. Accordingly, artists were no longer required to reach for some universal standard of greatness but rather felt free to create things that simply moved them and their beholders. As Rohlfs put it, truth in furniture "awakens a response in us."[26] These impulses to prioritize the individual aesthetic vision gave rise to Rohlfs's term "Artistic Furniture."

During Wilde's 1882 visit, while Rohlfs was acting as well as carving patterns, he may have been embarrassed to hear this celebrity figure's sarcastic commentary on the aesthetics of the cast-iron stove. "I came across the small iron stove which they always persist in decorating with machine-made ornaments, and which is as great a bore as a wet day or any other particularly dreadful institution. When unusual extravagance was indulged in, it was garnished with two funeral urns."[27] Perhaps energized by Wilde's scathing remarks but

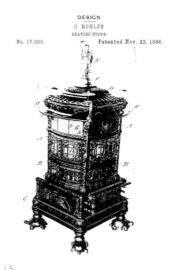

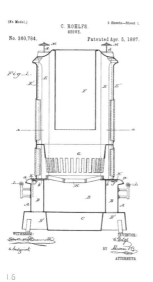

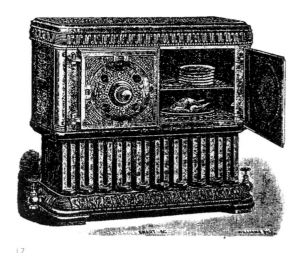

I.5 I.6 I.7

certainly driven by the growing national interest in decorative housewares, Rohlfs transferred the artistic impulses that he expressed on the stage to his stove designs.

Despite his absences during acting stints, Rohlfs advanced far enough in the found-ries to become involved not just in carving patterns but also in the design process. In 1886 and 1887, Rohlfs received three patents from the U.S. government for stove-making innovations, which seem to have been more related to the artistic quality of the stoves' decoration than their technical inner workings. Rohlfs received a design patent for a "heating-stove" or furnace that was decorated with a variety of cast-iron birds that he called the "leading features of my design." He wrote several paragraphs to specify the exact stance of the birds' feet, the angles of their beaks, and the shape of their outstretched wings. He also included atop the stove a Japanese figure holding a fan, a sure concession to the craze for Japanese design that heavily influenced Aesthetic Movement tastemakers (fig. I.5).[28] As was customary at the time, Rohlfs received a separate patent for the structure of the stove. Issued several months later, this patent suggests that Rohlfs brought dramatic flair even to his engineering innovations. Four pinwheels mounted atop each corner of this stove would spin to indicate the force with which the heat was escaping to heat the room. In addition to these kinetic additions, this stove fea-tured a hollow area toward the base of the tower that is "primarily for warming the feet" (fig. I.6). Rather than patenting technical features that improved the method of manufacture or the stove's efficiency, Rohlfs seems to have concentrated on adding aesthetic decoration and user-friendly elements to otherwise standard stoves.[29]

Rohlfs's success with these patents seems to have been the catalyst for bringing him and his family to Buffalo. The two patents discussed above were assigned to Josiah Jewett, the son of the founder of the Sherman S. Jewett Company in Buffalo, for which Rohlfs began working on 1 August 1887.[30] The circumstances under which Jewett made Rohlfs's acquaintance are unknown, but he may have traveled to New York City to recruit talented designers for his company. The Jewetts' company was the largest stove producer in New York State and among the largest stove factories in the country, outputting five thousand tons annually, more than five times as much as the largest factories in New York City.[31] By 1886, Jewett had branches in Detroit, Milwaukee, Chicago, and San Francisco. The company's scale indicates that Rohlfs's

I.4 Napoleon Sarony, "Oscar Wilde," January 1882. The William Andrews Clark Memorial Library, University of California–Los Angeles.
I.5 Charles Rohlfs, Heating Stove Design Patent, No. 17,000, 23 November 1886. United States Patent and Trademark Office.
I.6 Charles Rohlfs, Stove Patent, No. 360,784, 5 April 1887. United States Patent and Trademark Office.
I.7 Charles Rohlfs, Hot-Closet Steam-Radiator Design Patent, No. 17,197, 15 March 1887. United States Patent and Trademark Office.

move to Buffalo was not driven by the interests typically associated with the Arts and Crafts Movement—small-scale manufacture, personalized handwork, and communal production. Rather, Rohlfs moved to Buffalo for a job in a quintessentially industrial environment.

The third patent Rohlfs was awarded around this time was assigned to a different stove company in Jersey City, New Jersey. The A. A. Griffing Company may have been Rohlfs's employer before Jewett hired him away. Or Rohlfs may have been a contractor designing for several companies at the same time, an increasingly common arrangement in the industry.[32] Unlike the patents assigned to Jewett, the patent assigned to Griffing related directly to the heating coils and specially engineered shape of this "Hot-Closet Steam-Radiator," a home heating device with a compartment to heat dishes and food (fig. 1.7). It is tempting to imagine that his artistic inclination led Rohlfs to cease work with Griffing, where he was concentrating on technical innovation, and take a new position with Jewett, which had a huge production base that allowed its designers to focus on aesthetic concerns.

Indeed, Sherman S. Jewett Company designed and marketed its products to aesthetically minded customers. When Rohlfs arrived in Buffalo, the company had just celebrated its fiftieth year. In honor of its anniversary the company published a commemorative book that told its history and promoted its current products. The finest stoves being made that year were praised for their naturalistic ornament, nostalgic associations with the ancient world, and well-conceived professional designs.

> Oak branches and twigs with acorns and leaves twine gracefully over the mica in the door and appear in high relief upon other parts of the stove. With aesthetic appropriateness, the wise bird the owl peers sagely forth from among the foliage sacred to the mysteries of the Druids and the intellectual triumphs of the Greeks. . . . It is no jumble of meaningless ornamentation, wherein may be found fragments of a dozen ideas shaken together, as though the designer had caught up his pencil after throwing a summersault; but a series of beautiful and chaste ideas worked carefully out to their legitimate conclusion, with that happy result which follows really artistic work, quite as much in an iron stove as in a marble statue.[33]

Jewett claimed that its stoves avoided the "jumble" and fragmentary feel of eclectic revival style housewares. They were "worked carefully out" by educated professionals, not mean mechanics. The stoves were described as "chaste," a term loaded with associations of Victorian piety, and "legitimate," another word whose moral connotations weighed heavily on late nineteenth-century consumers. Comparing a cast-iron stove to a hand-carved marble statue may smack of over-the-top marketing, but the designs had "aesthetic appropriateness," which made them "artistic." Rohlfs presumably would have found colleagues at Jewett who, like him, wanted to raise the level of design in the United States.

Before long, Rohlfs moved on to more overtly artistic pursuits. Despite what seemed like a promising relationship with Jewett, Rohlfs left the company after less than three years and never returned to stove-making. In the spring of 1890, after the death of Anna Katharine's father and bouts of illness in their immediate family, the Rohlfs family traveled to Europe for six months.[34] The trip invigorated the couple's artistic energy. Their descriptions of stops on their tour, lovingly recorded in travel diaries and richly interpreted later in this volume, demonstrate a reverence for the architecture and design of Old Europe. The family visited castles, manor houses, and famous city squares, whose dramatic grandeur and palpable history excited the couple so much that Charles sketched swords, arched windows, and turrets in their diaries (see fig. 3.9).

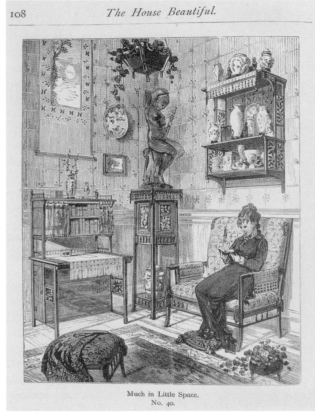

1.8 1.9

The trip to Europe launched Charles and Anna Katharine into a decade of explosive aesthetic production. During the 1890s, the couple lived a thoroughly artistic life, creating beauty and drama on all fronts. Charles returned to the stage in the dramatization of *The Leavenworth Case*, his wife's most popular novel, and later in a series of dramatic recitals. When at home, the couple invested particular energy into creating artfully appointed surroundings. Although no images of their homes from the 1890s survive, interiors dating from the early 1900s at their home at 105 Norwood Avenue, Buffalo, were photographed and demonstrate that they had fully embraced the values of the House Beautiful movement (fig. 1.8; see fig. 10.15). As the advice books suggested, their family lived among framed drawings and prints, ceramic and glass vessels, and other trinkets with personal meaning carefully placed around the rooms to represent the taste and individuality of the couple. Taking this artistic way of living a step further, Anna Katharine sewed velvet and lace outfits for the children that seemed to come right out of their European sketchbooks (fig. 1.9).

It was in this artistically charged environment that Rohlfs began to make furniture. The woodworking and design skills he had gained in the stove industry and his later dedication to artistic pursuits of all kinds combined to make furniture-making the perfect outlet for his passions. Furniture-making began as a hobby before the family traveled to Europe as

1.8 **"Much in Little Space,"** in Clarence Cook, *The House Beautiful*, 1881. The Winterthur Library: Printed Book and Periodical Collection.
1.9 **Rosamond and Sterling Rohlfs,** ca. 1892. Rohlfs Family Archive.

a way to bring the couple's unique flair to their home. "I wanted a certain kind of furniture and had seen nothing that particularly appealed to me," Rohlfs explained later.[35] The couple made furniture for their apartment in Brooklyn as early as 1887, according to a diary entry that described a chair and some shelves as collaborative efforts.[36] The two oldest surviving pieces of Rohlfs furniture, a *Settee* (see fig. 2.2) and *Trefoil Table* (see fig. 2.19), each made around 1888, while Rohlfs worked for Jewett, demonstrate the couple's unusual imagination. Though simply constructed, both pieces feature abstract carved decoration and imaginative silhouettes that Rohlfs certainly would not have been able to find in a furniture store.

The couple's idea to make their own furniture may have stemmed in part from a nationwide craze for home hobbies that ballooned after the 1870s. Domestic advice books overflowed with craft projects through which women could create more beautiful and individually expressive interiors. In addition to traditional needlework, pursuits like flower arranging, papier-mâché, and scrapbook-making arose as means to personal creativity. Men, as historian Clifford Clark has argued, were also "expected to be creative, self-expressive, and socially beneficial." They, too, were counseled to "reserve time for individual creativity."[37] Although fewer hobbies were suggested for men, husbands often took on the tasks around the house that women were considered too frail to complete. Given the strength needed to operate traditional hand tools, woodworking would have been a man's hobby, though it was not necessarily common at this time.[38] Within these Victorian social expectations, Charles and Anna Katharine may have collaborated on designing and making the furniture that fully expressed their remarkable tastes. Interestingly, one woodworking tool that Victorian propriety deemed appropriate for both men and women was the fretsaw. This fine, treadle-powered blade allowed hobbyists to pierce thin pieces of wood and cut decorative patterns in silhouette (fig. I.10). Charles must have owned or had access to a fretsaw when he "fashioned a desk for the use of his wife" around 1897–1898 (see fig. 4.3). Perhaps Anna Katharine helped with the fretsawing.[39]

After Rohlfs started making furniture as a hobby, why did he decide to make it professionally? The most obvious reasons were practical. His stage career suffered when critics began accusing him of overacting. According to one reviewer, his tragic scenes were "screamingly funny instead of sad."[40] By 1898, "actor" had disappeared from Rohlfs's Buffalo City Directory listing and he was, as he dramatized it later, "casting about" for another job.[41] His furniture-making hobby was attracting attention. His designs were so distinctive that neighbors, friends, and other visitors to the house requested objects for themselves. Once Rohlfs realized that people would pay for what had started as a private hobby, he changed his directory listing to "Artistic Furniture."

At this point Rohlfs's artistic endeavors coalesced to create furniture of remarkably individual design. In a 1900 interview, he acknowledged that "almost everything in my life seemed to point toward this work. I can but wonder and regret that it took me so long to find out that this was what I was truly meant to do."[42] He already had many of the skills he needed—woodworking, carving, drafting, and experience in stylish design. Most important, America's consumer base had become increasingly attuned to unique interior design. Now Rohlfs could channel his artistic inclinations into his woodworking skills and make imaginative products that people would buy. In a 1910 interview, Rohlfs was asked to compare furniture-making and acting as artistic outlets. "Ah my boy, that is somewhat problematical; there is much to be considered! . . . You can only consider acting abstractively I think; my present work is in the concrete. . . . It is important in both professions that the worker puts himself in such an attitude that the result of his toil creates a responsive throb which testifies to a singleness of purpose, a warm sincerity of feeling."[43] In furniture-making, Rohlfs felt the same "responsive throb" that had attracted him to acting.

I.10

I.11

The furniture Rohlfs produced after he opened his first shop in the late 1890s demonstrates the influence of his years in the foundry industry, his ongoing dedication to an artistic lifestyle, and his creative ability to combine historical design precedents with the emerging tastes of the turn of the century. As a result of combining these seemingly disparate influences, Rohlfs's designs vary considerably from one another and from other contemporary American furniture.

To build his furniture, Rohlfs essentially translated his stove-making knowledge into furniture-making, an experimental transition that can be seen in his earliest surviving piece of furniture, the *Settee* made for the family home in Buffalo around 1888 (see fig. 2.2). The *Settee* originally had a peacock blue cushion that hung on the pegs along the crest, but its absence reveals how simply the piece was made. Rohlfs used several boards of various dimensions to create a seat, a back, and legs. Each piece was attached to its neighbor with round-headed brass screws, but no two joints were the same. In some cases, he overlapped the elements and attached them with multiple screws, as he did where the legs meet the front rail. To connect the seat to the front rail, he drove screws downward, letting their brass heads decorate the seat. On the left side, where the arm has begun to pull away from the arm support, a dowel is visible (fig. I.11). Rohlfs seems to have been experimenting with a traditional mortise-and-tenon joint, which he secured not with the usual wooden pins but with small, shiny brass brads.

Even once Rohlfs had worked out more consistent construction techniques, his approach to assembling furniture revealed the mentality of a stove-maker rather than a woodworker. Stoves are made from individual iron plates arranged in boxes and assembled with mechanical fasteners and solder. Similarly, Rohlfs created furniture by shaping and carving individual oak boards, arranging them into squares or rectangles that would become case

I.10 **Treadle-driven fret saw,** in Edward H. Moody, *Catalogue and Price List of Scroll Saws and Scroll Saw Material,* 1884. The Winterthur Library: Printed Book and Periodical Collection.
I.11 **Charles Rohlfs and Anna Katharine Green,** *Settee,* detail, arm (see fig. 2.2).

1.12

pieces or the undercarriages of chairs and tables, and then fastening the boards together with screws. Rohlfs treated these wooden parts much like he treated iron parts—elements to be formed separately and connected by simple means. This labor-saving assembly technique allowed him to concentrate his time on design instead of woodworking.

In some of Rohlfs's furniture, not only the construction but also the overall form revealed his roots in stove design. This connection is especially clear in the *Standing Desk* of 1902/1904, which has a boxy form composed of rectangular doors and drawers that open and unfold in complex arrangements (see figs. 9.1, 9.6). As a young man, Rohlfs carved patterns for the geometric or floral decoration that adorned the rectangular panels and doors on stoves of all kinds. Later, as a stove designer, he arranged those decorated rectangular panels into functional and visually cohesive stoves. When he created case furniture he built pieces in much the same way, arranging decorated panels into forms that, like the *Standing Desk*, derive their visual power from the relations among interlocking panels. This *Standing Desk* is one of Rohlfs's most forward-thinking forms and features some of his most refined carving and sophisticated decorative details, yet it simultaneously suggests that Rohlfs's roots in stove design stayed with him as a furniture-maker.

In addition to Rohlfs's engineering mentality and training as a stove designer, his furniture was also influenced by his reverence for the designs of medieval Europe—an admiration

he shared with proponents of the Arts and Crafts Movement. By the late 1890s, artistic objects that had been exalted during the Aesthetic Movement were increasingly criticized for their elitist roots. Interest turned from an overtly "art for art's sake" emphasis toward the rejuvenative potential of handwork and the process of production—ideas fundamental to the Arts and Crafts Movement. Its proponents preferred pared-down ornament, simple lines, and natural oak. Heavily influencing tastes in furniture were the writings of English artist and critic William Morris, who argued that time-honored joinery methods could not only improve the well-being of workers but also uplift consumers downtrodden by poorly built machine-made furniture. As Morris's concept of "honest construction" gained currency in popular taste, Arts and Crafts furniture-makers began to use massive through-tenons with pins and keys to draw attention to the structural integrity of their furniture. Rohlfs developed a similar admiration for medieval handwork, but he expressed it more in appearance than in process.[44]

Incorporating the interest in visible construction and old-fashioned joinery he shared with Arts and Crafts enthusiasts, Rohlfs adapted the simple use of screws and boards that he worked out on the *Settee* to give his furniture a "handmade" look. The plugs he used to conceal the screw heads stood proud of the surface and were irregularly faceted to look roughly produced. These gave the impression that Rohlfs's furniture was constructed using traditional mortise-and-tenon joints, in which a narrow rectangular tenon was inserted into a hollowed-

1.12 *Desk with Suspended Gallery,* detail, back of gallery (see fig. 7.29).

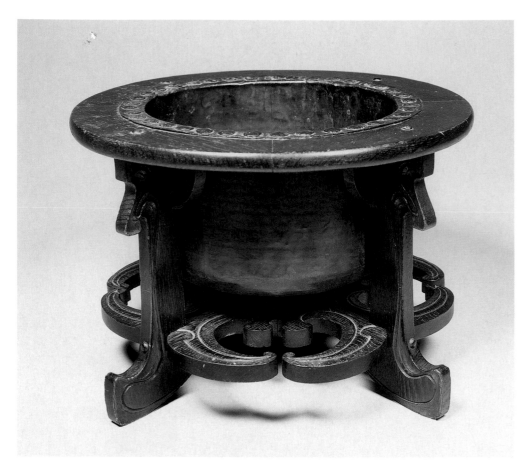

I.13

out mortise and was held in place with small wooden pegs driven in from the side. As antique furniture ages, the pins often begin to protrude, creating an appearance not unlike Rohlfs's screw plugs. Any woodworker, however, would have realized that most of Rohlfs's plugs could not have been structural pins because they were often driven into the wrong side of the joint. And sometimes Rohlfs's plugs covered screws in locations and patterns that had nothing to do with traditional joinery techniques but simply held the furniture together.[45]

Despite these inconsistencies, Rohlfs's work fooled a number of reporters and, presumably, the public. Charlotte Moffitt, in her 1900 *House Beautiful* article, wrote, "The pegs joining [Rohlfs's furniture] are unevenly cut and much in evidence." As Rohlfs had intended, she mistook the screw plugs for structural pins or "pegs." Rohlfs assembled some of his more substantial furniture, however, using enormous keyed through-tenons that were his exaggerated response to the new taste for exposed joinery. These pieces prompted commentator Will M. Clemens to write, "The weight of oak in the first place insures solidity and steadiness in the finished product, while the care used in fitting together the various sections of the articles insures them a long life."[46] Rohlfs's consistent use of oak, which was becoming the wood most associated with the Arts and Crafts style, and his cleverly deceptive "rough execution" combined to give his furniture an intangible look of quality. Yet another writer commented, "Strength through good material and good workmanship is the first impression I received from the furniture of Charles Rohlfs of Buffalo."[47]

In some pieces, Rohlfs used his simple screw-and-plug construction to his advantage to create a medieval appearance. In the large *Desk with Suspended Gallery*, for instance, he built two lower cabinets and an upper hanging cabinet with a latter-day version of board-and-batten construction that included numerous screws across thick horizontal braces (fig. I.12). This intentional overbuilding made the plugs seem more appropriate, as if their strength were needed to contain the mass of the piece itself. Along with the faux-armorial "F" on the lower left cabinet, the protruding plugs give this desk a strong medieval character perhaps inspired by ancient manor houses that Rohlfs admired during the family trip to Europe ten years earlier.

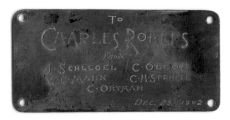

I.14

Even though Rohlfs had given up his foundry jobs years before, he revived his interest in metalwork to bring decorative details to his furniture. Whereas some of his competitors hired skilled metalworkers to create hardware to decorate their Arts and Crafts furniture, Rohlfs could make it himself.[48] One commentator praised the equal artistry that Rohlfs brought to both media. "Mr. Rohlfs works in metal as well as wood, and often combines the two: clasps, locks, hinges, handles. . . . The design of the wood plays about the metal and holds its own, always, with it."[49] As he did with wood, however, Rohlfs used simple means to manipulate the metal to create dramatic visual effects. Much of the metalwork is cut, shaped, and rolled from sheets, a quick and simple process requiring few tools and minimal heat. Sometimes Rohlfs's objects were hammered to appear as if they had been drawn up by hand from thicker bar stock, a common tactic among Arts and Crafts era metalworkers (fig. I.13). Interestingly, Rohlfs does not seem to have added any custom cast-metal items to his furniture, suggesting that he had not maintained his ties with iron foundries.[50]

Although Rohlfs embraced the Arts and Crafts Movement's interest in exposed joinery and hammered metalwork, he was too much of a businessman to espouse the utopian socialist ideology that drove some of the movement's leaders to resurrect medieval-type guild systems and create craft communities centered around handwork. His disdain was so strong that he poked public fun at figures like Elbert Hubbard, who ran the Roycrofters in nearby East Aurora, by joking in 1902 that in Rohlfs's shop "no profit sharing is practiced and none of us wear long hair."[51] Though Rohlfs's workshop was never a communal cooperative, it seems to have been full of men who shared his artistic inclinations. Since his passion in furniture lay in design rather than in production, Rohlfs hired professionals from Buffalo's large furniture industry to help him.

Little is known about Rohlfs's cabinetmakers, but a small copper plaque dated 25 December 1902 in the Rohlfs family archive provides one hint. The plaque probably was originally attached to a Christmas gift for Rohlfs from the five men whose names are engraved on it (fig. I.14). Four of the five can be identified as professional cabinetmakers or somehow related to woodworking in the first decade of the twentieth century. Joseph Schlegel, Charles H. Spencer, and Charles Ortman were listed in Buffalo City Directories as cabinetmakers. William C. Mahn was a wood finisher. "C. Olson" could be one of several men listed variously as "laborers" and "machine hands," both useful occupations in a carpentry shop. None of the men list specific employers, but between them their skills would have made a well-rounded shop.[52]

More is known about the men who helped carve the Rohlfs furniture. In his 1925 reminiscence "My Adventures in Wood Carving," Rohlfs wrote that at first, "I carved what I designed. Later on I couldn't do both, so I confined myself to designing, carried out under my supervision by carvers—Buffalo artists."[53] Of the four men Rohlfs named, all were listed in Buffalo City Directories as professional wood-carvers. Again, none of them ever listed himself as being employed by Rohlfs, but neither were they employed elsewhere during Rohlfs's peak production period, about 1898 to 1906.

I.13 **Plant Holder,** 1901. Oak and copper, 11 ½ × 19 in. diam. (29.2 × 48.3 cm). Crab Tree Farm Foundation, Lake Bluff, Ill.
I.14 **Copper Plate,** likely originally attached to a Christmas gift for Charles Rohlfs from his employees, 25 December 1902. Rohlfs Family Archive.

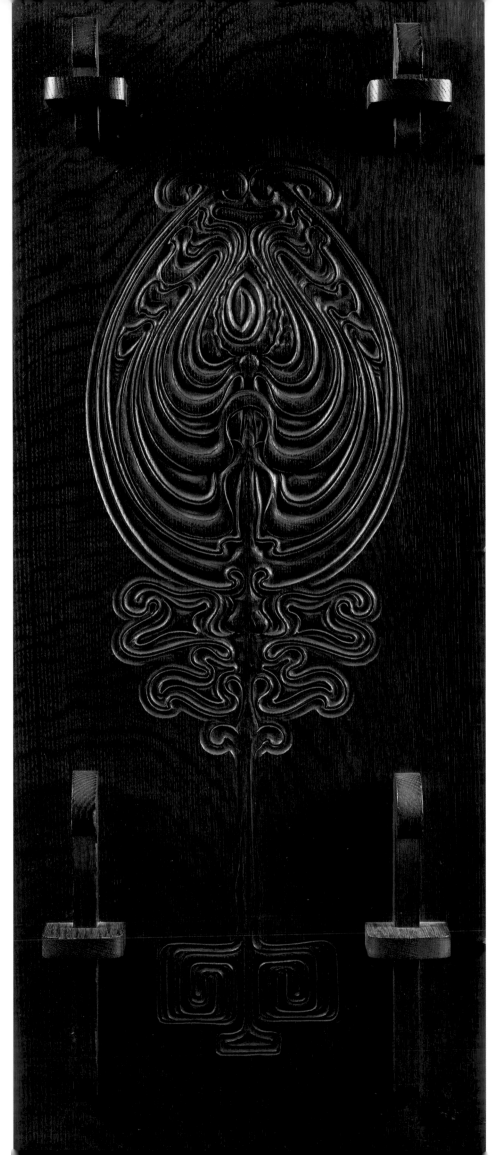

Two of Rohlfs's carvers moved in creative directions after they left Rohlfs's "Sign of the Saw." In the 1880s, Charles Reif was the foreman carver at the Buffalo Parlor Furniture Company, one of the many local industrial furniture companies. He probably had been carving crests for parlor suites of mahogany or rosewood with Rococo Revival floral patterns or other popular revivalist imagery. By 1896, he seems to have turned toward more specialized work, listing himself as an "architectural wood carver." During the height of Rohlfs's production period Reif listed himself as an independent carver with no identified workplace. In 1906, he opened his own shop and offered his services not only as wood-carver but also as "designer." It seems that he left Rohlfs's shop inspired with his own creative plans. Joseph Balk also harbored artistic ambitions. He first appeared in the directory in 1892 simply as a "carver." By 1902, Balk had his own workshop on Staats Street and listed himself as a "sculptor." In 1906, he tried to specialize in "ornamental plaster work" but returned to being listed as a "sculptor" in 1907.[54]

The interests of Rohlfs's other two carvers remain less clear. George Thiele worked for many years as a wood-carver for the Wagner Palace Car Company, a large train car manufacturer in Buffalo that competed with the Pullman Company until it was bought out in 1900. Thiele left Wagner by 1897 and was listed as an independent carver well into the twentieth century, but it is not clear during which years he worked with Rohlfs. Christian Gerhardt did not stay in the carving profession long after working for Rohlfs. He was a professional wood-carver in the 1880s and 1890s who may have helped Rohlfs start his shop. But by 1901, Gerhardt had become the bookkeeper for the Gerhard Lang Brewery, a job he kept for many years. Further research in Buffalo archives could certainly uncover more stories about the men who helped Rohlfs create his "Artistic Furniture."

The idiosyncratic furniture of Charles Rohlfs deserves continued research as much as admiration. His early career as a pattern maker and stove designer sheds light on the simple assembly of his furniture and expressive carving. Likewise, his choice to make furniture as a part of his pursuit of an artistic way of life helps to explain the individuality of Rohlfs's designs. Nevertheless, his unusual combination of curving silhouettes, rustic carved piercings, and faux-honest construction sets him apart from other turn-of-the-century furniture-makers. Indeed, his commitment to the primacy of personal expression may be the idea that most distinguishes Rohlfs from his contemporaries. His description of the carved swirls that decorate so much of his furniture eloquently reveals this difference.

Rohlfs described his carving as "embellishment." In "My Adventures in Wood Carving," he wrote, "I must embellish [the wood] to evidence my profound regard for a beautiful thing in nature." He spoke romantically about the natural imagery he saw when he looked at figured grain: rising smoke, blowing breezes, even Santa Claus. Rohlfs took inspiration from these visions in the wood, drew his own versions of the grain, and then carved his designs directly into the oak board (fig. I.15). In doing so, his decorative carving decimated the original grain, an approach that stands in distinct contrast with the ideals of Arts and Crafts makers, including Stickley and Hubbard. For these designers, the natural ray flecks exposed in quarter-sawn oak were the most important testament to wood's beauty. To show the splendor of oak grain, they left it alone. Rohlfs saw the same beauty in the grain of wood, but to express his love for it, he "embellished" it by carving into it. It is as if he needed to magnify the grain, emphasize it, and make his own version of it obvious to others. This dedication to his own individual vision, or "indulgence in the freedom of spirit," linked Rohlfs to his roots in the Aesthetic Movement but also led him to create some of the most innovative furniture of the early twentieth century.

I.15 *Chiffonier,* detail, side panel (see fig. 8.11).

CHAPTER 1

MEMORIES, PLEASURES, AND PROMISES

Charles Rohlfs arrived in Buffalo, New York, with his wife, Anna Katharine Green, and their children, twenty-three-month-old Rosamond and newborn Sterling, on 29 July 1887. Following Sterling's birth on 18 May, the family had made a temporary stopover in Anna Katharine's hometown of East Haddam, Connecticut, from 7 July to 27 July. They then sailed from East Haddam to New York City, whence they made their way by train to the "Queen City of the Great Lakes," which would become their home for the next five decades. On their arrival in Buffalo, the family stayed in a suite of rooms at the Fillmore Hotel, the former home of President Millard Fillmore. As Charles recorded in their diary, the Rohlfs family settled in August into "a beautiful home" at 471 Linwood Avenue, at the corner of Ferry Street, where they celebrated little Rosamond's second birthday at the end of the month.[1]

Charles and Anna Katharine's reputations so preceded them that local newspaper accounts from the time reported: "Mr. Rohlfs himself is a gentleman of culture, devoted to the highest ideals in literature and art, a charming converser, and with his gifted wife will be a valued addition to the social, artistic, and literary life of Buffalo, to which Ourselves and Company bid them a hearty welcome."[2]

Though the demands of family life were many for both Anna Katharine and Charles, their careers were simultaneously blossoming.[3] Anna Katharine's enormous literary success, especially as a mystery novelist, had earned her great recognition before the couple moved to Buffalo. She had been remarkably productive in the preceding years, publishing a number of successful novels, even while taking on the role of mother to two young children.[4] The rewards were great: "Each day has its memories, pleasures and promises. A pair of little arms cling about my neck and I forget looks, ambitions, fame, every thing but love, the love of my children the love of my husband. To live now means for me to be one of this happy group."[5] Many passages in the Rohlfs family diaries convey her pride in her writing and her adoration of Charles and the children.

Charles was a devoted father and increasingly successful industrial designer, engineer, and inventor. Having moved up through the ranks of the A. A. Griffing Iron Company in Jersey City, New Jersey, he began his employment at the Sherman S. Jewett Company in Buffalo on 30 July 1887. He noted in his diary that he was "in Sherman S. Jewett & Co.'s employ as Inventor designer and general superintendent of the manufacturing end of the business (Stoves, etc.)." Charles described the demands of the job in a diary entry: "I am away now all day at the Foundry leaving about 8 AM and returning about 6 PM. Rosamond comments on

1.1

1.2

1.3

my absence by saying, 'Papa gone to business' that explanation having been given her this morning at breakfast." Busy attending to work and family, Rohlfs reported on 31 August, "Rosamonds 'Papa' is very tired tonight but cannot let our little darlings second birthday go by without saying a word or two [recounts Rosamond's gifts]." Hard work at the foundry, collaborative work on his wife's mystery novels, and delight in his young children filled Charles with a sense of professional and personal accomplishment.[6]

Rohlfs's skills in chemistry, engineering, and ornamental drawing, which he had developed at the Cooper Union during the period 1867 to 1871, had prepared him well for the complex business of stove design and manufacture—an enterprise that is part science, part engineering, and part industrial design. Though later Rohlfs was often evasive regarding his debt to teachers and those who influenced him, about his education and experience at the Cooper Union, he later suggested, "My accomplishments I owe to Peter Cooper, who was my friend and teacher."[7] He put this even more strongly when he commended: "To Peter Cooper . . . I owe everything, my training, my art—for without the early training the art would have been still undeveloped—and my determination to succeed in every smallest thing undertaken."[8] It is worth noting that Rohlfs was cited at least once as "the best draughtsman of the school."[9] These drafting skills and others related to industrial design, developed at the Cooper Union, readied Rohlfs for his most important creative pursuit: the art and craft of furniture design and manufacture.

We see Rohlfs's first mention of the design and manufacture of furniture in a diary entry, dated 20 March 1887, in which he casually mentions a new chair designed and made when the family was still living in Brooklyn: "We have a mahogany chair in the corner of the stair-landing. Rosamond was the first to sit in it—it is her chair. . . . This chair together with the mahogany mantel-shelves in the dining room are specimens of designing and workmanship of Rosamond's Mother and Father, both pieces of furniture being recent additions to our stock."[10] Rohlfs referred later in the year, at Christmas time, to one of Rosamond's gifts: "a large sled on which I had put a highbacked seat." His creations for his family during this experimental period ranged from the full-blown design and execution of a mahogany chair to the retrofitting of a sled with a new seat. The informal, spontaneous character of his reference to the mahogany chair is notable. He neither declares it his first furniture effort nor makes much of such an addition "to our stock." By March 1887, Rohlfs (along with Anna Katharine) had quite possibly been designing and making furniture for several months, if not years.

The most important aspect of this quotation is the casual revelation that the chair and "mahogany mantel-shelves in the dining room are specimens of designing and workmanship of Rosamond's Mother and Father." Anna Katharine's contribution to these pieces is not emphasized, suggesting that this was by no means the first time that the husband-and-wife team had collaborated on the design and execution of furniture for their home. Aside from her literary career and general decoration of the family's homes, Anna Katharine's artistic pursuits ranged from watercolor painting and the illumination of poetry to participation in the design of furniture made by Charles Rohlfs. Who was this life partner and artistic collaborator of Charles Rohlfs, and how did her education, artistic mind, and creative spirit contribute to their life together and to the design and execution of the Rohlfs furniture?

YOUNG ANNA CATHERINE GREEN

She was born Anna Catherine Green on 11 November 1846, "on Orange St. under the very shadow of the Plymouth Church, [Cranberry Street,] in Brooklyn."[11] According to family records, in 1864, at age eighteen, Anna Catherine entered Ripley Female College in Poultney, Vermont. At college, Anna Catherine was involved in the Irving Society (or Iota

1.1 **Anna Katharine Green,** ca. 1880. Rohlfs Family Archive.
1.2 **Rosamond Rohlfs, age three,** September 1888. Rohlfs Family Archive.
1.3 **Sterling Rohlfs, age two,** 18 May 1889. Rohlfs Family Archive.

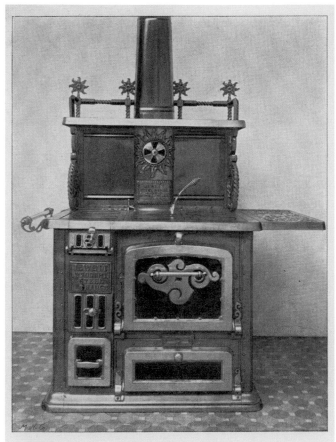

JEWETT'S WROUGHT STEEL RANGE.
FAMILY SIZE.

1.4

1.5, 1.6

1.4 Catalogue of Sherman S. Jewett Company, 1890, title page, showing a steel range possibly designed or engineered by Charles Rohlfs. The Buffalo and Erie County Historical Society.
1.5 Charles Rohlfs's Cooper Union student card, 1868–1869 academic year. Rohlfs Family Archive.
1.6 Reverse of Charles Rohlfs's Cooper Union student card, 1868–1869 academic year. Rohlfs Family Archive.

1.7

1.8

Sigma sorority, as it was also known), where she attended parlor meetings each Friday at 7:00 p.m.[12] An important early influence on Anna Catherine's understanding of gender roles and her place in society may have come when the Irving Association sponsored its first lecturer, Anna Dickinson. This energetic twenty-three-year-old spoke to the Irving students about abolition, abstinence, and women's suffrage. Family papers record that "some questioned the propriety of a woman speaking, but school officials compared her to Joan of Arc, given by God to do good work in the Civil War."[13] The school catalogue reported the "Speech By Miss Dickinson" in an apologetic tone, but later a typescript rephrasing of the report on her speech was pasted over the page before the book was published and distributed.[14] Perhaps this alteration to the published reception to the lecture was the result of the intervention of another burgeoning thinker and writer, Anna Catherine Green.

On 8 December 1865, Anna Catherine was involved with the Irving Association's "highly successful literary entertainment," which the students used to raise money to furnish and decorate their meeting rooms.[15] By the next year, she was listed in the Ripley Female College *Quarterly Journal* as a senior in the Collegiate Course and as president of the Irving Association.[16] In June 1866, Anna Catherine graduated with three classmates.[17] In these years, 1867 and 1868, her future husband, Charles Rohlfs, was beginning his own artistic education at the Cooper Union.

It was probably in the 1860s, perhaps during college, that Anna Catherine created a set of illuminated poems entitled *Songs from the Poets* (fig. 1.9). This beautifully rendered set of drawings with text was inscribed sometime after its creation: "These illuminations, made in my early youth, preceded the publication of my first book, The Leavenworth Case."[18] The work not only demonstrates Anna Catherine's familiarity with such nineteenth-century poets as Percy Bysshe Shelley and Alfred, Lord Tennyson, but provides a rare glimpse into her skills as a watercolorist and designer of ornament.

In college Anna Catherine's literary accomplishments had been limited to bits of publishing in the "college paper," but after graduation she grew more confident, corresponding with publishers Ticknor and Fields and Ralph Waldo Emerson about her writing.[19] In 1868, she wrote the manuscript that became her first publication, *Ode to Grant*.[20] The next year Anna Catherine Green moved to New York, residing at 39 East Twelfth Street.[21] In New York she continued to develop her writing skills, seeking criticism and encouragement from journal and book publishers, and changed her middle name to "Katharine."[22]

YOUNG CHARLES ROHLFS

Charles Rohlfs was born to parents Fredericka Wilhelmina Dorothea Hunte and Peter Rohlfs on 15 February 1853. Charles's father had been born in Denmark, though most of the generations of Rohlfs before him had lived in Germany.[23] Charles's parents, having both immigrated to the United States in the first half of the century, met in Brooklyn, married, and created a home for themselves and their children in an area near Prospect Park.

Despite his father's work in carpentry, cabinetry, and piano manufacturing, Charles was fascinated from his earliest childhood with the world of the theater rather than with more quotidian activities. Peter Rohlfs saw to his son's education, sending Charles first to the highly respected Grammar School No. 35 on Thirteenth Street in Brooklyn. Thomas Hunter, its principal, had established the school's preeminence in the years before young Charles attended and went on to become the first president of the college that was named for him in 1914. According to reports in the Rohlfs family archive, young Charles did well in school and was developing into a pleasant and responsible young man, but at age twelve, he was dealt a harsh blow when his father died.

1.7 Anna Catherine Green, age eight, 1854. photograph reprinted in unknown newspaper. Rohlfs Family Archive.
1.8 Anna Katharine Green, ca. 1880s. American Decorative Art 1900 Foundation.
1.9 Anna Catherine Green, title page of *Songs from the Poets*, ca. 1860s. Rohlfs Family Archive.

Songs from the Moo-by Anna nateo C. Green Poets

1.10

The death of Peter Rohlfs in 1865 forced Charles to subordinate his acting aspirations to working to support his mother, sister, Louise, and brother, Frank. He performed various banking-related tasks, including working for Stuckle, Becker and Company, where he made wages "bringing prices from the gold room, making deposits at the bank, carrying messages, etc." His work was praised, and he was called "intelligent, quick and honest." Charles also briefly held positions at a pilot-boat service and a malt extract shop. His work was valued, and he was regarded as "honest, industrious, steady, willing and obliging."[24]

In 1869, Charles entered the foundry business, and by 1872, at the age of nineteen, he had considerable experience as a designer of stoves and furnaces. During this transitional period, education played a central role for Rohlfs. During the late 1860s and early 1870s, he took Cooper Union night classes in, for example, algebra, geometry, trigonometry, chemistry, mechanical drawing, calculus, mechanics, oratory, and debate.[25] This education prepared Rohlfs for his careers as industrial designer, furniture-maker, and salesman.

While supporting himself and aiding his family, Charles still found time to pursue acting, studying the work of the great actors of his time and, above all else, the interpretation of Shakespeare and his greatest roles.[26] He was involved extensively in readings, amateur performances, and professional productions through 1877, when he joined the famed Boston Theatre. In the late 1870s, Rohlfs likely even supported himself for a period as an actor, but eventually he had to return to designing stoves and furnaces.[27]

Anna Katharine Green and Charles Rohlfs met in early 1877 at the home of a mutual friend. Charles is said to have been asked to "sing during the course of the evening." He obliged the partygoers with a "rollicking sea song, which seemed to please Kitty Green—at any rate she asked for an encore."[28]

Thirty-year-old Anna Katharine Green's literary career took off soon after she met Charles. Her novel *The Leavenworth Case*, published in October 1878, established her as a leading literary figure. The critical acclaim must have been thrilling. Her novel was an international bestseller and was recognized as a breakthrough in early American detective fiction. Based on firsthand court research and the product of more than two years' work, the novel astounded readers across the country. Oral history accounts like the following abound in the Rohlfs family archives: "Anna Katharine Green [was] walking down a street in Washington D.C. with Elizabeth Johnson, sister of a federal judge. They met Senator James G. Blaine. Miss Johnson said, 'Senator, permit me to introduce to you Kittie Green, the author of The Leavenworth Case.' The senator grasped her hand, and after a pause, said 'How did you do it?'"[29] Green's further prose accomplishments developed swiftly: her short story "Through the Trees" was published in *Scribner's* November 1878 issue, and the wildly popular novel *A Strange Disappearance* appeared in 1879. As she reported in December 1879: "My new book is out; my other one preparing for the stage, and all uncertain if success will attend the venture. As to *A Strange Disappearance*, I am quite encouraged, the first edition being nearly exhausted the first week."[30]

"Charles Rohlfe" made his first professional acting appearance in 1877, at the Boston Theatre, where he performed frequently, often in bit parts. Taking small roles in order to act with the great Edwin Booth, Rohlfs tread the boards as the "Old Man" in *King Lear* at the Boston Theatre on 6 March 1878. A little more than a week later, Rohlfs played Balthazar to Booth's Shylock in *The Merchant of Venice* and Pedro in Shakespeare's comedy *Katharine and Petruchio*, once more on the stage of the Boston Theatre. Again, just a week later, Rohlfs found himself on one side of a double bill, performing Pacolo in *Don Ceasar de Bazan*, with Booth in the title role.[31]

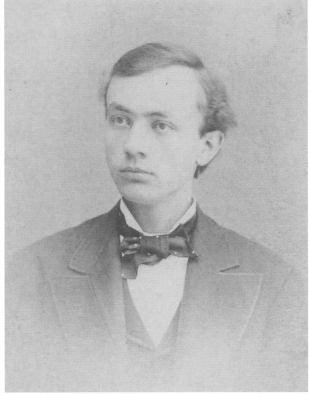

1.11 1.12

Rohlfs appeared again on the stage in 1880 and 1881 for a tour of the play *One Hundred Wives*, produced by and starring twenty-two-year-old De Wolf Hopper. Rohlfs had been cast "in a small and insignificant part, which, however, afforded him ample opportunity to display his talent for facial expression, and he made a great success of it. Under his treatment, it became a leading part, and the actor was brought so prominently to notice that several desirable engagements in dramatic companies were offered him. He accepted one to support Lawrence Barrett," an important Shakespearean actor.[32] He also portrayed a judge in *The Gilded Age* at the Boston Theatre.[33] In 1881, Rohlfs took the role of Philip with Barrett, who played the title role in *Yorick's Love*. Six months later, Rohlfs performed as a Knight of the Round Table in the New York premiere of *Pendragon* on 13 February 1882. During his stints touring with Barrett, theatergoers in St. Paul, Minnesota, were treated to his Rosencranz in *Hamlet*. Lodovico seems to have been a favorite role of Rohlfs; he repeatedly played it opposite Barrett as Iago in *Othello*.[34]

Documents in the Rohlfs family archive trace Charles's modest successes as an actor during this period, when his relationship with Anna Katharine was blossoming into a romance that seemed headed toward marriage. As he recounted much later, with melodramatic flair, their path toward a life together was not altogether simple: "By the time our interest in each other had progressed to the proposal point, I was on the stage. The family held a council and

1.10 **Charles Rohlfs, about age five,** ca. 1858, photograph reprinted in unknown newspaper. The Winterthur Library.

1.11 Charles Rohlfs, about age twelve, ca. 1865. Rohlfs Family Archive.

1.12 Charles Rohlfs, about age nineteen, ca. 1872. Rohlfs Family Archive.

PROGRAMME.

Moore's Opera House

W. W. MOORE, Manager.

=== TO-NIGHT ===

Lawrence Barrett!

The Eminent Tragedian, in Shakespeare's Play of

OTHELLO!

Supported by a Strong and Talented Company, under the management of

R. E. STEVENS.

CHARACTERS.

IAGOLAWRENCE BARRETT
Othello LOUIS JAMES
Cassio......OTIS SKINNER
Brabantio B. G. ROGERS
Roderigo CHARLES PLUNKETT
Montano.......F. C. MOSLEY
Lodovico............ CHARLES ROLFE
Gratiano............FRED. P. BARTON
Duke of Venice.J. W. THOMPSON
Antonio....ALBERT E. RIDDLE
Julio....CHAS. HAWTHORNE
Messenger............NESTOR SENNON
Desdemona............ MISS MARIE WAINWRIGHT
Emilia....MISS KATE MEEK

The following are only some of the attractions booked
at the Opera House the coming season:
Heywood's Minstrels.
Walter's Comedy Company.
Burham's Electric Light.
Fred Wade, Tragedian, 2 nights.
Buffalo Bill.
Cal Wagner's Minstrels.
Hartz, Magician.
The Two Medallions, 2 nights.
Maggie Mitchell.
Frank Mayo, Tragedy, 2 nights.
Leavitt's Gigantic Minstrel World, 2 nights.
Tom Keene.
Salsbury's Troubadors.
Rose Eytnge, in Felicia.
Fanny Davenport.
Anna Pixley, M'liss.
Sol Smith Russell, Edward Folk.
Sam Hague's English Minstrels from Europe.

STATE JOURNAL PRINT, Des Moines.

1.13

BROOKLYN, MONDAY, NOVEMBER 29, 1886

ACADEMY OF MUSIC.

WALLACK NIGHT.

THE ❖ VETERAN.

A Drama in six Tableaux, by J. LESTER WALLACK.

CAST OF CHARACTERS.

COLONEL DELMAR MR. CHARLES ROHLFS
LEON DELMAR, his son...... MR. DOUGLAS MONTGOMERY
EUGENE, the Colonel's protege.........MR. H. H. GARDNER
CAPTAIN BELMONT.............................MR. W. C. PRUDEN
LIEUTENANT MORTIER.....MR. CHARLES D. PLATT
LIEUTENANT LORIELLE...........................MR. C. D. OXLEY
LIEUTENANT JARDINE.......................MR. THOMAS F. McGIRR
THE EMIR MOHAMMED, an Arab Chief.........MR. WALLACE BARTON
OFL-AN-AGAN, Grand Vizier...................Mr. C. J. WILSON
THE SULTAN OF MYRA.....MR. FRANK NORRIS
OGLOW...MR. WM. T. ANGEL
HASSAN NOUREDDIN....MR. GEORGE R. LAMB
MUSTAPHA MOULRAD......................MR. ALBERT MEAFOY
SEYD..MR. WM. D. PRESTON
OSMAN....................................MR. CHARLES CORWIN
LOUISMR. FRANK CUDDY
SERGEANT BEAUCOUR.......................MR. EUGENE MORTON
SERGEANT SAMPAN...........................MR. GEORGE FORMAN
MRS. MacSHAKE.......................MISS ANNIE L. HYDE
GULNARE, Chief Sultana...................MISS JULIA W. REID
BLANCHE D'IRRY............................MISS MARIE BOWEN
AMINEH.................................MISS MARIE LAMB
ZAIDA.................................MISS GENIE ROBINSON
AURA, an Almeh..........................MISS FLORENCE TREMPER
KATY.................................MISS GERTRUDE CONRAN
HARPIST.................................MISS EMMA RITA
Soldiers, Arabs, Almehs, Entertainers, Slaves, Dancers, etc., etc.

STAGE MANAGER, - Mr. HENRY G. SOMBORN

Synopsis of Scenery.

ACTS I and II—England. Apartment in the Villa of Col. Delmar.
ACT III—Arabia. SCENE 1. Military Quarters of Col. Delmar. SCENE 2.
On the outskirts of the British Post. SCENE 3. Apartment of State in the
Palace of Hasn-al-dahr.
ACT IV—SCENE 1. Room in the Palace. SCENE 2. Gulnare's Zenana in Palace.
ACT V—Same scene as last.
ACT VI—Grand Hall in the Palace.
Between Acts 1 and 2 and Acts 4 and 5 there will be no intermission.

1.14

decided that it was best not to have an actor in an ancient Connecticut family, which had never gone in much for the drama. So we separated for a time and several years elapsed."[35] Despite these claims, Rohlfs's extensive touring during these years is more responsible for the delay in their marriage than any "council of a Connecticut family." The love and lives of Charles Rohlfs and Anna Katharine Green were always commingled with their passion for literature and the arts. As she wrote in a letter on 22 August 1880, "Art life has its advantages in what it does for our souls and our emotions. The world means more to the artist than to other people, for he is constantly following out the delicate threads of thought, feeling, and action, tangling and untangling them . . . searching for the secret heart of all."[36]

These lines reveal the role of artistic self-identification in the lives of Anna Katharine and Charles, both in its inspiration and motivation for "our souls and our emotions" and in its more troublesome presence in Anna Katharine's haughty claim that "the world means more to the artist than to other people." I certainly hope that the kinds of searching she ascribes to the artist are among the concerns of mere mortals as well. Her tone is more filled with upper-middle-class judgment than this critic would prefer, yielding in the end to a rather abstruse

1.13 Program from *Othello,* Moore's Opera House, Des Moines, Iowa, n.d., listing "Charles Rolfe" as Ludovico. The Winterthur Library.

1.14 Program from *The Veteran,* Academy of Music, Brooklyn, N.Y., 29 November 1886, listing Charles Rohlfs as Colonel Delmar. The Winterthur Library.

reference (without explanation) to "the secret heart of all," which is accessible only to artists. Perhaps she was just carried away with poetic language, but this suggestion is a strain that permeates much of her and Charles's thoughts about art and their roles as artists in society.

The years 1880–1884 were productive for both Anna Katharine and Charles. Rohlfs had been using his skills as an industrial engineer and designer to pursue new endeavors. The *Specifications of Patents* published by the U.S. Patent Office on 14 December 1880 lists patents under the name of Charles Rohlfs for a sheepskin stretcher and a tailpiece for strings, both for his beloved instrument, the banjo.[37] More pragmatically, in the early 1880s, Rohlfs worked at a foundry in Taunton, Massachusetts. His interest in the theater remained strong, and in April and May 1883, Rohlfs again explored his dramatic prowess, playing Pindarus in *Julius Caesar* on 30 April and Gratiano in a 3 May performance of *Othello*, both of which starred Barrett. The next day, Rohlfs portrayed the 2nd Actor in *Hamlet*, Barrett again playing Iago.[38]

Anna Katharine Green lived at various addresses in Manhattan and Brooklyn in these years, publishing *The Sword of Damocles* in 1881. The seriousness with which she approached her writing is nicely captured in a letter to a friend: "It is the fruit of much thought. I conceived its plot and general plan immediately after the publication of *The Leavenworth Case* and then gave it two years of thought before putting pen to paper. . . . [T]he first chapters have gone to press, and the last chapter of the book has not even been written. You see how I am driven and what a responsibility rests upon me."[39] As her literary reputation solidified, her social standing rose. In 1882, she visited Washington, D.C., staying with General and Mrs. Henry Elijah Alvord. She was received by President Chester Arthur, and Chief Justice Morrison Waite declared *The Leavenworth Case* the greatest work ever written by a woman.[40]

Anna Katharine's income gave her uncommon financial independence. Her book *The Defense of the Bride, and Other Poems* was published in June 1882, and Putnam's brought out a paperbound nine-by-twelve-inch, fifty-seven-page magazine-style edition of *The Leavenworth Case* for sale at 20 cents each. Putnam's was so pleased with its relationship with Green that on 17 May 1883 it extended her contract to include three more novels, *A Strange Disappearance*, *The Sword of Damocles*, and *XYZ*. Through the summer of 1883, Green worked tirelessly on publications for Frank Leslie's *Illustrated Newspaper* (three thousand words a week) as well as on the three contracted novels.[41] The overwhelming experience of sudden fame and fortune, and the attendant demands of storylines, deadlines, and endless editing, tempered the author's sense of success: "I am at work upon four parts of it all at once. It seems strange not to be among the groves and trees. I mean to have my outing yet."[42]

Perhaps even more significant to either Charles or Anna Katharine than their career advancement was their return to each other and the subsequent development of their relationship. As she confided on 12 April 1881, "Love has crept very close to me. My friend, who has been away, comes home for Easter Week."[43] She further divulged in this letter that she specifically wanted to visit the addressee in the week after Easter to tell her about her new love. Later in 1884, just months before the couple were to be wed, she praised the man she was to marry as "a great, strong, noble-hearted man who has won my deepest respect and most ardent love."[44]

Thirty-one-year-old Charles took thirty-eight-year-old Anna Katharine to be his wife on Tuesday, 25 November 1884, at 2:30 p.m. at the South Congregational Church in Brooklyn. Their wedding reception was at the residence of William H. Van Vorst, at 302 Union Street, where Anna Katharine had been living. After a brief wedding trip, the couple moved to Charles's home on Broadway in Taunton.

Professional and personal issues likely cut their stay in Massachusetts short, for the newlyweds soon returned to Brooklyn, where by the middle of 1885 they were listed in the

WELCOME. • • • •

FOR ANY KIND OF COAL.

No. 7—Four 7-inch Griddles; Oven 16x18 inches.........$12.00

No. 8—Four 8 " " " 16x18 " 12.00

The most stylish cheap Coal Cook on the market.

What is the good of handling antiquated patterns, when you can get the *latest style* for the same money?

Nickel Escutcheon on Oven Doors; Ash Pan; furnished with Iron Linings for Soft Coal; with Brick Fire Back when used with Hard Coal.

public register. Closer to their work contacts and their family, the couple lived at various locations in Brooklyn, including in rooms rented from Mrs. Fanny Marsh, a ninety-one-year-old landlady, who made a "pillow and basket liner for baby Rosamond," who was born to the new couple at 11:22 a.m. on 31 August 1885.[45] In September 1885, the couple relocated with their new baby girl, first to a Mrs. Langthorne's in Brooklyn Heights in the first block off Clinton Street at 35 Schermerhorn Street and then, on 25 March 1886, southeast to 323 Fourth Street, near Gowanus Basin in Brooklyn.[46] It was in this working-class section of Brooklyn that the couple had their "first experience at housekeeping" and parenting, celebrating little Rosamond's first birthday on 31 August 1886.[47]

The new mother did not let domestic concerns or pregnancy interfere with her career. On 14 December 1886, she wrote to noted poet, critic, and essayist Edmund Clarence Stedman, sending along a poem and copy of *Defense of the Bride*:

> *Having heard from Mrs. Elliott Coues that you would be interested in seeing my new poem*
> *when it appeared, I take the liberty of sending you a copy. With it I enclose a former volume of*
> *poems which I doubt if you have ever seen.*
> *With regards, yours, Anna Katharine Green*
> *Author of The Leavenworth Case*[48]

Before the close of 1886, Anna Katharine saw the publication of *The Mill Mystery*, which was followed in 1887 by the verse drama *Risifi's Daughter*. Anna Katharine gave birth to their second child and first son, Sterling, in Brooklyn at 12:56 a.m. on 18 May 1887. Her work *A Detective Story* was published in early June 1887, one month before the family embarked for Buffalo by way of East Haddam.

Designing and making furniture for their home was not Charles Rohlfs's only avocation as a married man. After providing his father-in-law with a grandchild, Charles seems to have forgotten that Anna Katharine's family had any objection to his ambitions as an actor. By 29 November 1886, just after the second anniversary of his marriage, Rohlfs played the leading role of Colonel Delmar in J. Lester Wallack's *The Veteran* at the Academy of Music in Brooklyn (fig. 1.14).

These years were also professionally productive for Charles in his burgeoning career as a designer and craftsman of iron metalwork. Patent Office records show several of Charles Rohlfs's contributions to technological, industrial, and design innovations in stove manufacturing. *The Official Gazette* lists three patents awarded to Rohlfs in 1886 and 1887: two for his work for the Sherman S. Jewett Company in Buffalo and one for his work at Jersey City's A. A. Griffing Iron Company.[49] Charles's notable work in industrial design yielded him a job offer from Jewett, which brought the family to Buffalo. Here the couple settled down to raise their children, occasioning their continued efforts to design and make for themselves furniture that was appropriate to their artistic taste.

1.15 Catalogue of Sherman S. Jewett Company, 1890, showing a model possibly designed or engineered by Charles Rohlfs. The Buffalo and Erie County Historical Society.

CHAPTER 2

A CORNER IN THE STUDY OF
ANNA KATHARINE GREEN

The period surrounding Charles and Anna Katharine's relocation to Buffalo was a creatively energized time for Rohlfs as an industrial and decorative designer. He was now finding an outlet for his imaginative and innovative impulses in the design and manufacture of stoves and other iron fixtures. Since as early as 1887, he and Anna Katharine were designing and making furniture for their own home. The family, eagerly welcomed by Buffalo society, was settling into their new hometown. The children were becoming familiar with their new surroundings: two-year-old Rosamond "charms us more and more" and "takes such good care of little Sterling."[1] The family needed furniture for their new home, and some of these pieces were being designed and built by Anna Katharine and Charles. Although their Brooklyn home had contained a mahogany chair and mantel shelves designed and made by the couple, it is a drawing for a "corner in the study of Anne Katharine [sic] Green" in their new home in Buffalo that introduced Charles Rohlfs's furniture to the public (fig. 2.1).[2]

The June 1888 issue of the *Decorator and Furnisher*—with no fanfare and almost without explanation—included a sketch by Charles Rohlfs that gave the public its first glimpse of his peculiar aesthetic.[3] It is unknown whether Rohlfs solicited inclusion of this image in the magazine or the publishers approached him about including the sketch showing a settee, pedestal table with vase, a carpet on the floor, drapes in a window or doorway, decorative wainscoting, and, possibly, wall covering. This rich image, from a graphite or ink rendering, provides critical insight into Charles Rohlfs's earliest forays into furniture-making.[4] Rohlfs's signed illustration of his wife's study is the first known appearance of his decorative art in any of the magazines, trade journals, or newspapers that would celebrate his work in coming decades. This sketch was an odd way for Rohlfs to introduce his work in the press because it consists largely of loosely organized rhythms of lines, dashes, squiggles, arcs, and curves that belie his extensive training as a draftsman. The walls with their corner perspective, partial doorway, and lined floor only suggest the space of the room itself. The partially rendered wainscoting and wall covering that trail off at their edges indicate that this sketch is not to be thought of as a finished interior but merely meant to give a sense of the room.

For some reason, rather than sketching an object or two of his own design, Charles chose instead to present an interior, complete with things designed by Anna Katharine and him, as well as a rug, textile, ceramic vase, and wall covering that the couple had nothing to do with designing or making. Are we to understand this as a casual presentation of an interior,

2.1

2.1 Charles Rohlfs, "A corner in the
study of Anne Katherine [sic] Green,"
in *Decorator and Furnisher*, June 1888.
2.2 Charles Rohlfs and Anna
Katharine Green, *Settee*, ca. 1888,
made for the Rohlfs home. Oak with
brass screws, 32 ¼ × 57 ½ × 23 ⅞ in. (81.9
× 146.1 × 60.6 cm). Private collection.

a serious staging of Rohlfs's furniture, or a snapshot of the lifestyle of a famous author and her less-known husband who made furniture in his spare time?

It is unclear which of the Rohlfs residences around 1888 is depicted, if any. In Buffalo, the family first lived at the Fillmore Hotel but moved to Linwood Avenue in the late summer of 1887 and again to 62 Tracy Street on 1 May 1888. At this moment in mid-1888, the Rohlfs family was "living opposite Mrs. Rumsey's park, which is enclosed."[5] It is impossible to know whether the drawing depicts a real room or an imagined space.

What to make of the magazine image qua illustration is puzzling. Text surrounding the drawing refers in passing to details of designs that "may readily be found suitable for reproduction of these woods, that if well executed are calculated to give a stately appearance to rooms that otherwise would perhaps go without notable adornment." There is even a discussion nearby of "smooth varnished surfaces, whether of wood or glass, in the way of gilded designs, by a process which imparts to gold a brightness which no oil gilding can equal," but nowhere is there any discussion of the works of Charles Rohlfs shown in the drawing or more generally.

Despite the peculiarity of the rendering and its presentation, the accompanying descriptions and rendering of the objects provide great insight into Charles and Anna Katharine's design sense, ornamental vocabulary, and attention to materials: "The coloring of the room is principally old gold. The settee is polished oak, and was designed by Charles Rohlfs of Buffalo. The cushions are of peacock blue plush, those at the back being held up by knobbed

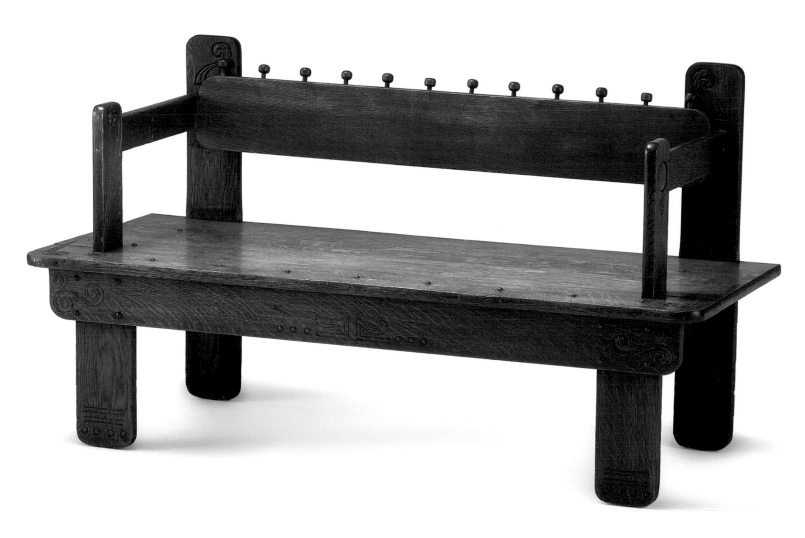

DIVAN Nº 170
HEIGHT 27" LENTH 52" DEPTH 28"

2.3

pins in the loops. The pieces of the settee are fastened by round head brass screws, no glue being used." The gold coloration for the room may refer most directly to the wall and doorway coverings and carpet. By the same token, the elaborately carved or fretted slats and border of the wainscoting might have been rubbed with gold or bronze leaf or pigment to give them a shimmering reflectivity, a technique Rohlfs used on decorative objects later in his career. The intricate systems of branching verticals terminating in fiddlehead-like finials and border curves are certainly complex enough that one might wonder whether Rohlfs used gold highlighting on their surfaces to call attention to their decorative motifs.

The "polished oak" of the *Settee* raises another question regarding the surface finish of the earliest furniture by Rohlfs. Both the description and the current condition of the *Settee*, which until recent years never left Rohlfs's home, indicate that the initial fumed or dye-stained surface of the oak was covered in shellac, lacquer, or a similar material to preserve the color and texture of the underlying finish. This material, typically used to seal finish on late nineteenth-century furniture, likely gave the *Settee* a certain sheen, reflected here in the use of the word "polished." This likely does not refer to any kind of abrasive process, which would have been at odds with Rohlfs's approach to furniture finishing and with more general furniture-making practices around 1887.[6]

One can imagine the beauty and dazzle of the play between the gold of the room and the cushions of "peacock blue plush," which both in bird and in palette call to mind James McNeill Whistler's celebrated Peacock Room, circa 1876. The beauty and breathtakingly detailed craft of that fabled installation may have been for Rohlfs a paragon of interior design. The *Settee* is set with what are described as "knobbed pins," which originally suspended the pillow from the backrest as shown in the drawing. These charming pins create a lovely rhythm across the crest of the bench, alleviating its severity. Rohlfs's pride in his technique is likely responsible for the statement that "the pieces of the settee are fastened by round head brass screws, no glue being used."

THE SETTEE
The simplicity of joinery captured in the quotation reflects the formal qualities of the *Settee* (fig. 2.2). The piece is notable as an early work by Rohlfs, especially in how it integrates

2.4 2.5 2.6

rather massive plank construction with a strangely diminutive sensibility—at once uncomfortable in its own lack of compositional resolution and yet strangely elegant in line and proportion. Its straightforward presentation of quarter-sawn boards has the effect of both opaquely screening off and more loosely demarcating spaces. Their presence from the front or the back of the *Settee* shifts to near absence as one moves around to its sides.

The bold structure of the *Settee* and its modernist, fully abstracted ornamentation may have struck those visiting Rohlfs's home at the time of its making, around 1887, as either revolutionary or bizarre. Its straightforward design and unrelentingly honest construction anticipates the 1901 and 1902 furniture of Gustav Stickley, especially, for example, Divan No. 161, Divan No. 170 (fig. 2.3), and Hall Seat No. 180. The subtly shaped feet of the Rohlfs *Settee* (fig. 2.4) are closely related to the similarly shaped feet on Stickley's iconic Hexagonal Library Table No. 410 (fig. 2.5). Perhaps even more remarkable than this connection to Stickley's works is the relation between the almost primitivist, brutal quality of the Rohlfs *Settee* and the similarly slat-constructed 1934 "Crate" Easy Chair of Gerrit Rietveld (fig. 2.6). This masterpiece of Art Brute design, which consists of eighteen rectangular slats of brown-stained pinewood, joined together with metal screws, owes a debt to the boldness and severity of pioneering designs like that of Rohlfs's *Settee*.[7]

An odd assemblage of ornamentation adorns the simple planks of oak that form the legs, arms, back posts, and apron of the *Settee*, providing a fascinating glimpse of Rohlfs's earliest decorative motifs in furniture. The carved ornamentation on the *Settee* is whimsical, charming, and virtuosic but notably unintegrated with its overall structure. Largely kept to the periphery of the object and the center of its seat apron, the ornaments seem to float in space on the boards they adorn, unanchored in relation to the overall composition of the piece. Carved on the surfaces of the *Settee*'s various members are seven individual decorative gestures, each with its own late nineteenth-century vocabulary and its own peculiar placement in relation to the overall formal structure. These disjointed motifs are unusually derivative, pointing squarely to Charles's, but even more strongly to Anna Katharine's, debt to the two dominant design styles in America at the time—Victorian and Beaux Arts, the latter of which was especially dominant in larger New York cities in the last decades of the nineteenth century.

2.3 Gustav Stickley's United Crafts, **Divan No. 170,** in Stickley, *Chips from the Workshops of the United Crafts,* 1901.
2.4 ***Settee,*** detail, left proper front leg.
2.5 Gustav Stickley's United Crafts, **Library Table No. 410,** detail, ca. 1901–1902. Private collection.
2.6 Gerrit Rietveld, "Crate" Easy Chair, 1934. Pine, 24 ⅜ × 22 ⅞ × 29 ½ in. (61.9 × 58.1 × 74.9 cm). Courtesy of Galerie Ulrich Fiedler, Cologne.

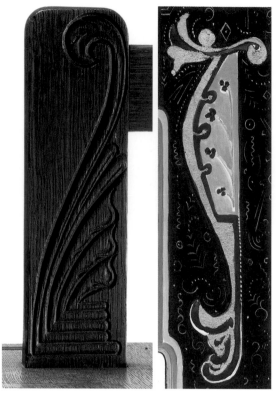

2.7 2.8

The survival of both the published drawing and the *Settee* itself provides an extraordinary opportunity to understand Charles's and Anna Katharine's aesthetic in the earliest days of his furniture-making. Among the seven motifs carved into the *Settee*, we can isolate two general categories of ornamentation. The first is a set of more ornate late Victorian and Beaux Arts ornaments, likely designed by Green, that appear on the upper posts, the interior surfaces of the arm supports, and the ends of the seat apron. The second group includes the more severe geometric abstractions, likely designed by Rohlfs, that embellish the exterior of the arm supports, the front corners of the seat, the center of the seat apron, and the feet of the *Settee*.

The watercolor illuminations in Anna Katharine's *Songs from the Poets*, created before she published her first novel, provide a means of connecting the first set of motifs to her aesthetic vision.

Beginning with the examples of ornamentation most clearly influenced by late nineteenth-century styles, we can observe the quite clear peacock (or other bird's) feather imagery on the right and left interior surfaces of the arm supports (fig. 2.7). Rising from sets of parallel lobed bars, the individual carved plumes ascend dramatically upward, adorning almost the entire vertical board, before turning back downward and spiraling inward. The feather motif, a favorite Victorian design, connects closely to the nineteenth-century styles in which Green had been steeped, as is manifest in the similarly arced ascent of her "I," which begins "The Indian Girl's Song" by Shelley (fig. 2.8). There is a similar connection between her design for the lower "plumage" of this "I" and the smaller feather motif that decorates the upper right and left posts of the *Settee* (fig. 2.9). Here the textural shaping of the carved element relates closely to the watercolor illumination, which has alternating lobes of unevenly hued brown and yellow that

create almost three-dimensional, ridged imagery, beautifully anticipating the elegance of the carved decoration of the *Settee*. Similarly, the spiraling flourish in Anna Katharine's calligraphy below the "B" in "Break, Break, Break" by Tennyson (fig. 2.10) has a nuanced rippling texture that relates to the feathered spiral motif on the *Settee* (fig. 2.11).

2.9

 The case for Anna Katharine's role in the decoration of the *Settee* strengthens as we turn our attention to the apron below the seat, where the tripartite scrollwork spins two secondary curves off a central spiral (see fig. 2.4). This triple-curve motif figures prominently in her design vocabulary, playing an especially important role in the heroic "T" that begins "The wandering airs they faint" from the second stanza of "The Indian Girl's Song" (fig. 2.12). Here, in a naturalistic way, Anna Katharine presages the form of the triple decoration on the *Settee*. The sinuousness and looping character of this carved ornament was foretold in the descent below the "L" in "Late, Late, So Late" from Tennyson's poem "Guinevere" (fig. 2.13). Perhaps the most compelling of all the comparisons, though, can be made between Anna Katharine's delicately meandering scrollwork below the "T" in "Take, O take those lips away," from the opening line of act 4 of *Measure for Measure*, by her and Charles's beloved Shakespeare (fig. 2.14). Here an almost identical configuration of arcs and curls spirals downward from the base of the "T," matching in form and number the formation on the *Settee*'s apron.

2.10

 Though the more modernist geometric designs are likely by Charles, it is worth pointing to a few other interesting connections between Anna Katharine's illuminations and the carving of the *Settee*. The center of the seat apron is carved with a bisected mirror image (fig. 2.15). This symmetric central motif may be the design of either husband or wife, but its trailing rhythmic dotting appears frequently on the watercolors of Anna Katharine. In *Songs from the Poets*, in the ornament framing the small watercolor seascape at the bottom of "Break, Break, Break," the three circles drift toward the bottom of the page (fig. 2.16), just as the circles at the center of the apron of the *Settee* drift off toward right and left. A similar pattern of spaced dots is illustrated at the bottom of the first page of Tennyson's "Idylls of the King: Song from the Marriage of Geraint" (fig. 2.17). Based on the analysis of these comparisons, it is clear that Anna Katharine Green played an essential role in the ornamentation of this earliest known Rohlfs object. This secures the claim that the couple collaborated on designs for Rohlfs furniture previously attributed to Charles alone.

2.11

 The *Settee*'s remaining ornamental motifs reveal Charles Rohlfs's own early aesthetic and approach to decoration. Bold patterns of simple geometric forms embellish the exteriors of the arm supports, the seat edges, the center of the seat apron, and, especially, the feet. This remarkably straightforward system of bars, circles, and simple stylized abstractions demonstrates Rohlfs's early ability to use subtle, sophisticated patterns to great effect.

2.12

 Let us begin with the odd, yet confident, circular form at the top of the exterior of the arm supports (see fig. I.11). The circle is perhaps used here both for its simple decorative completeness and in lovely opposition to the overall rectilinear structure of the bench. Furthermore, the circle may express or contradict something under the surface—namely, the joinery lurking beneath the carved decoration. The carefully beveled impression contributes to the "honesty" of the *Settee*'s construction, calling attention to the juncture upon which it is carved, while simultaneously delineating with a sphere what is likely to be rectilinear joinery below the surface. Similarly elegant is the strangely restrained and modernist arced teardrop form that seems to spin off below the circle. This motif, carved with an external frame enclosing an internal pinched teardrop, is one of the only ornaments on the *Settee* that will recur on later models of Rohlfs furniture.[8]

2.13, 2.14

 Moving to the seat, at the left and right edges of its front expanse, we can observe among the most sublime of Rohlfs's early ornaments. Although these spiral motifs relate

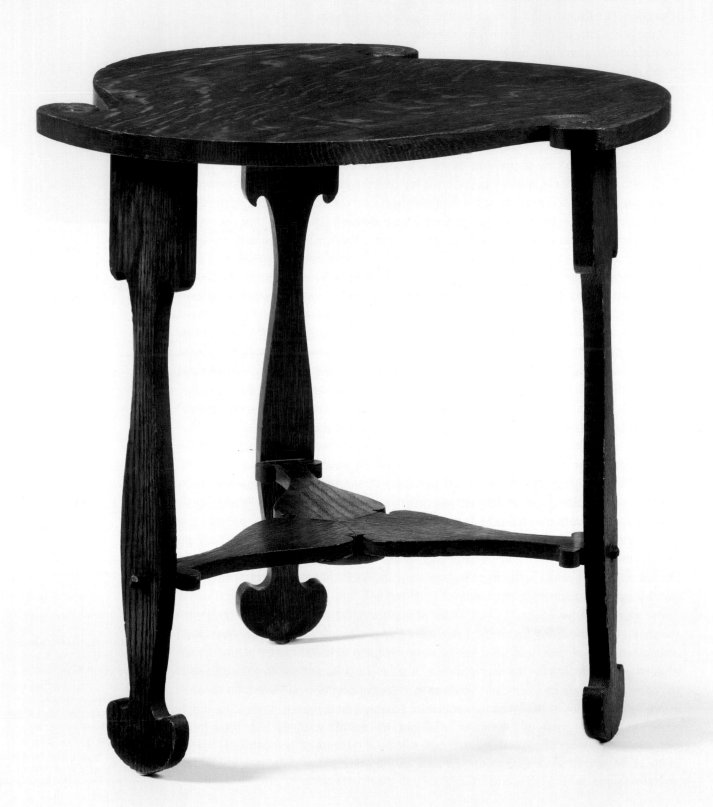

2.19

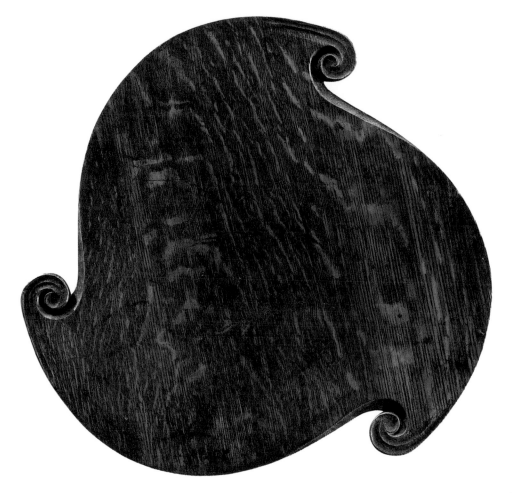

2.20

2.19 *Trefoil Table,* ca. 1888, made for
the Rohlfs home. Oak, 18 ⅞ × 19 ⅜ in.
(47.9 × 49.2 cm). Private collection.
2.20 *Trefoil Table,* detail, tabletop.

2.21

TABLE WITH SCROLL DECORATIONS.

2.22

Exact correspondence cannot be established between Rohlfs's *Trefoil Table* and *Table with Scroll Decorations* and the various models of Stickley's "tabourettes," "tables," and "tea-tables," all named for the flower by which they were inspired. Nevertheless, Rohlfs's early small tables can be shown to have profoundly influenced the development of Stickley's earliest furniture designs. The imprint of Rohlfs's works on Stickley's line, as it first emerged in mid-1900, was covered in "The New Things in Design" in *Furniture Journal* on 25 August 1900: "It is not possible to reproduce in these pages the quaint things which have come from Mr. Rohlfs' factory, although some of the things which were shown by the Gustave Stickley company have been shown in these pages. There are suggestions all through the Stickley line of the things made by Rohlfs. It is stated that Mr. Stickley got his first idea from the Rohlf [sic] furniture, but let it be said to his credit that in adapting it to practical production in a factory such as he commands, he added materially to the merit of the furniture."[11] It seems likely that the "first idea" mentioned here refers to the particularly Rohlfsian table form, the Bellworth Tabourette, No. 1, in Stickley's 1900 "Catalog No. 1 'New Furniture'" (fig. 2.23)

Starting with the tabletops, Rohlfs's delicately shaped *Trefoil Table* can be linked to the carefully beveled corners of Stickley's Sunflower Tea-Table.[12] Although the tabletops of all the other Stickley flower tables feature carved plank-top construction, the Sunflower Tea-Table features three-dimensional beveling, which Rohlfs beautifully foreshadowed on his *Trefoil Table.*

The *Trefoil Table* is perhaps more sophisticated than the more charming Stickley flower tables. The Stickley forms are each stylizations of a different flower form, but the *Trefoil Table* has a peculiarly provocative three-point asymmetric design that opens its composition onto an interpretive framework of visual instability that denies the viewer a definitive point of reference. The *Trefoil Table* challenges the viewer to conceptualize its composition while actively denying a clear point of reference that would make such an analysis possible.

The tabletop of Rohlfs's *Table with Scroll Decoration* features a much more elaborately carved surface, complete with six swirling, scrolled abstractions and an overall unity of design that more obviously resolves the composition for the eye. Its regular geometry and expressive carving relate it most closely to Stickley's Twin-Flower and Foxglove Tabourettes (fig. 2.27) and Mallow Tea Table. The composition of each of these Stickley models keeps the decoration at the tabletop's edges, which exhibit heavily stylized ornaments at periodic intervals around the table's perimeter. Stickley's development of less periodic, more continuous designs can be noted on Stickley's Bellworth model (fig. 2.26), as well as on the Adder Tabourette (fig. 2.28).

Turning to the legs and lobed cross-stretchers, Rohlfs's *Trefoil Table* and *Table with Scroll Decoration* are virtually identical. Stickley's Twin-Flower, Foxglove (fig. 2.24), and Adder Tabourettes (fig. 2.25) and Sunflower Tea-Table exhibit the most similarity to Rohlfs's models in the slight flaring of their legs immediately below their tabletops. The simple bowed expanse of the leg midsection in the Rohlfs tables is directly related to Stickley's Foxglove and Adder Tabourette models. A number of the Stickley models exhibit through-tenons and pronounced wooden plugs at the junctures between their legs and stretchers. The lobed foot of Rohlfs's tables is echoed in Stickley's Pansy Tea Table, which has a similar terminus. Finally, the lobed and mitered cross-stretchers of the Rohlfs tables were likely influential on Stickley's similar shaping of the cross-stretchers on some of his flower tables, particularly the Mallow and especially the Twin-Flower, whose stretchers are nearly identical to those on Rohlfs's tables. It is perhaps not too far a stretch to draw a relation between Rohlfs's exploration of the possibilities of simply shaped, three-legged tables and Stickley's early masterpiece, the Chalet Table, No. 403 (fig. 2.29).

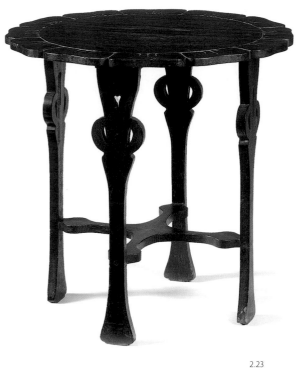

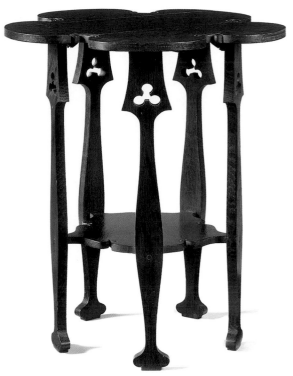

2.23

2.24

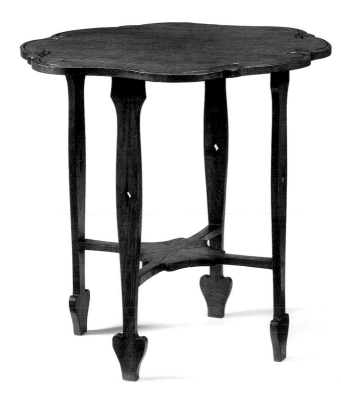

2.25

2.26

2.27

2.28

2.29

THE PEDESTAL TABLE

Returning once more to the corner in the study of Anna Katharine Green, we can discuss the remaining piece of early Rohlfs furniture, the pedestal table to the right of the bench in the drawing in the *Decorator and Furnisher*. This object was known to scholars and curators only through the drawing until a recent discovery connected it to a photograph taken in the home of Roland Rohlfs in 1930. This *Pedestal Table*, shown along with a rocking chair also from the Rohlfs family home, bears a fascinating resemblance to the one Charles Rohlfs drew in 1888. While the *Pedestal Table* does not match the drawing in every detail, there is good reason to believe it is the one drawn, both because of its provenance within the family and because of its striking structural likeness to the 1888 rendering.

The *Pedestal Table* is composed of a simple, elegant, thin-slab tabletop supported by severe columnlike legs that rise from a base made of sets of slabs and finished with beautifully and subtly shaped feet. This configuration looks rather more like a creation of Charles Rennie Mackintosh, Josef Hoffmann, or Koloman Moser, from at least a decade later, than it does an object made circa 1887. The principal difference between the 1888 drawing and the photographed table is the rhythm of lines and circles that compose the legs in the rendering and the smooth, rectilinear surface in the photographed model. This can be attributed to the same kinds of reinterpretation that Rohlfs made in delineating the *Settee*.[13]

Three forward-looking—indeed modern—objects designed by Charles Rohlfs in collaboration with his wife, Anna Katharine Green, can now be confidently dated to the remarkably early date of circa 1888. Charles Rohlfs, an industrial designer by day and actor by night, was by this date a fledgling maker of artistic furniture. Charles Rohlfs and Anna Katharine Green created this early furniture to fill their home with beautiful objects of decorative art. Even these works of limited ambition show glimmers of design genius that would later place Charles Rohlfs, an actor of modest accomplishments, on the world stage as a furniture-maker and designer.

2.26 Gustav Stickley, Bellworth Table, detail, tabletop.
2.27 Gustav Stickley, Foxglove Tabourette, detail, tabletop.
2.28 Gustav Stickley, Adder Tabourette, detail, tabletop.
2.29 Gustav Stickley, Chalet Table, ca. 1900. Ebonized oak, 22 × 24 ¼ in. (55.9 × 61.9 cm). Private collection.

CHAPTER 3

GRANDEUR NEVER BEFORE EXPERIENCED

By the summer of 1888, the Rohlfs family was settled into their home on Tracy Street, near Rumsey Park in Buffalo. They were prospering in their respective careers and growing in the esteem of the social circles of the bustling city around them. A 17 July 1888 diary entry by Charles mentions, "Mr. C.T. Chester called this evening to give me a ride. I was late in keeping my appointment causing him to wait. While doing so he was handed the book illuminated by Sweetheart (some choice poems)."[1] Charles and Anna Katharine clearly took great pride in her *Songs from the Poets* and kept it as a part of their daily lives. Her literary pursuits continued to occupy her time along with her family responsibilities. She even engaged, during the summer of 1888, in the political-literary debate regarding the possibility of establishing "international copyright."[2]

In late summer 1888, Anna Katharine recounts, "Mr. Bok spent a day with us."[3] The young journalist, Edward William Bok, was to become a Pulitzer Prize–winning author, a pre-eminent American editor, and one of the most important patrons and champions of American design and decorative art in the early twentieth century. Like Anna Katharine's and Charles's ancestors, Bok's family hailed from northern Europe, in his case, Den Helder, Netherlands. Like Charles, he took his early education in Brooklyn, held a similar series of odd jobs in the 1870s, including a stint as an office boy in the Western Union Telegraph Company in 1876, and attended night school. In the early 1880s, Bok worked for Henry Holt and Company but soon became associated with Charles Scribner's Sons, where he eventually became the advertising manager. In 1884–1887, he was the editor of *Brooklyn Magazine*, and in 1886, he founded the Bok Syndicate.

This precocious publisher visited the Rohlfs just months before he became editor of *Ladies' Home Journal*. Under his leadership, this magazine became one of the most successful and influential American serial publications ever, the first in the world to have more than a million subscribers. Bok later became a great supporter of America's premiere wrought-iron artisan, Samuel Yellin, whose decorative metal formed an important part of several of Bok's residences and other buildings. It is more than plausible that Bok took an interest in Rohlfs's handmade furniture and perhaps provided one of Rohlfs's first points of entrée to publications concerned with design and the decorative arts.

Despite Anna Katharine's literary achievements, Charles's career as a stove designer, and their family's success in making a new home in Buffalo, neither parent seemed to be personally satisfied in these years. Self-doubt, depression, and illness beset the family. In January

1890, Anna Katharine's father, James Wilson Green, died while visiting the family in Buffalo; "he had been ill for a long time."[4] In a letter of 12 March 1890, she wrote of her grief. "This year of special trial and strain . . . I appreciate all your trials in the full, have been so weak myself, sometimes so despairing because I saw no prospect of doing my duty again as wife and mother. But the patience of my husband is inexhaustible."[5] To reengage their creative spirits and repair their minds and bodies, the couple decided on a European tour. Anna Katharine wrote to a friend and suggested meeting in New York on the family's way to Europe, expecting to leave by 20 April 1890, but cautioned that the possibility of meeting at a hotel or somewhere would depend "on my strength which is anything but satisfactory right now."[6]

In March 1890, she reported, "We have our house to dismantle and our furniture to store. . . . [I]t leaves us independent you see. We have some letters of introduction to Americans in London and we hope that we shall meet some nice people."[7] By 28 March, Anna Katharine told five-year-old Rosamond that the family "would go to church four times and then sail for Europe," a necessary period of rest and relaxation for mother and a chance for Rohlfs to experience the art, theater, and culture of Europe.[8] As the source and setting for so many of their favorite works of classical literature and theater, Europe seemed almost mythical to Charles and Anna Katharine. Their vacation was an aesthetic journey that would profoundly influence the artistic pursuits of Charles Rohlfs as a furniture designer.

The Rohlfs family's "Travel Journal," which Anna Katharine began on 21 April 1890 and in which Charles later took over recording their adventures, opens with the simple lines, "Left Buffalo on the D.W. & W. The children well. Pleasant Journey. Found that it paid to take a stateroom." The family first stayed near Gramercy Park in Manhattan, where they entertained various distinguished guests and visitors, took in some theater, and enjoyed a bit of New York club life.[9] One day, Charles took the children out to Brooklyn to the neighborhood where he grew up while Anna Katharine enjoyed lunch with a friend on Fifth Avenue.

Anna Katharine continued her convalescence and reported on young Rosamond's "bad attacks" of asthma. She characterized her own physical condition as "tired and weak."[10] By 28 April, young Rosamond's condition had worsened: "there was danger that heart failure might set in at any hour." The young girl's condition eventually caused a number of days' delay in the family's embarking for Europe, giving little Ros and mother much-needed rest before their journey. At last the four members of the Rohlfs family set out from the dock in Manhattan's Greenwich Village on the steamship *Aurania*, at 2:30 p.m., on Saturday, 3 May 1890: "The day is fine and our first impressions of the ship are favorable . . . the night is calm."

The eight-day trip at sea seems to have provided a welcome respite from daily life back in Buffalo. As Anna Katharine reported in the Travel Journal, "An exquisite morning. The sea! The sea! Charles rises early and goes on deck, I lie somewhat later. All our meals are enjoyable. Each moment is a delight and when evening comes we sit and watch the moon break its way through a belt of horizon cloud."[11] As the ship neared arrival in England, she delighted in the attention the children were getting on the cruise, as well as the time Charles was getting to read plays and other fiction, and exulted, "Our voyage is drawing to a close. We try to enjoy every hour."[12] They arrived in Liverpool, then the second most important port in England, on Sunday, 11 May, reaching the North Western Hotel at 8:00 p.m. that evening. The quaint European charm of this hotel, built in 1867, likely pleased the couple.

Near the hotel was the impressive Oriel Chambers office building, built in 1864. Designed by the little-known Liverpool architect Peter Ellis, the structure marked a significant departure in English urban architecture. Its innovative plan, which likely caught the eyes of Anna Katharine and Charles, features a skeletal framework of brick supporting an almost entirely glass facade. The building's absolute defiance of standard approaches to office

3.1 3.2

building design make it one of the most significant buildings built in Europe during the last half of the nineteenth century. The building aroused great controversy in Liverpool after its completion, and it seems unlikely that the couple would have missed an opportunity to examine its extraordinarily functional cast-iron and brick design and revolutionary incorporation of glass.

 The family traveled by train the next day to the famous walled city of Chester, where they took in "the walls" and the River Dee and its mill, about which Sterling knew a children's song (fig. 3.1). They enjoyed sightseeing among the remnants of Tudor, Stuart, Georgian, and Victorian design periods scattered about the well-preserved city. Strolling through the city, they caught "glimpses of quaint homes" on their way to exploring the Chester cathedral. The couple's observations are keen and detailed: "A rich day. We take the children first to the old church of St. John the Baptist, the original walls of which were supposed to have been erected by the son-in-law of Alfred the Great. The pillars supporting the main roof and which date back to the 13th Century are huge cylindrical stone. The place has a desolate empty look but is highly interesting from its antiquity."[13]

 The emphasis in this journal entry on the historic importance of the site was likely influenced by the substantial work that had been done to restore the church in the decade before the family's visit. Following the devastating collapse of the important West Tower of St. John's Church, little time was lost in restoring the structure. The restoration was overseen by John Douglas, who worked hard to preserve the integrity of the site using the old stones wherever possible and incorporating exact reproductions of the early English originals where materials were lost. The couple gloried in the veracity of the site and the care with which it had been restored.

 Later in the day the family took in "Eaton Hall, seat of the Duke of Westminster" (fig. 3.2). Charles and Anna Katharine were stunned by the beauty of this country house set within a large park in the village of Eccleston. "The row up the river is delightful and the sight of one of the great interiors of England affects us with a sense of grandeur never before experienced."[14] The estate had been in the Grosvenor family since the reign of Henry VI in the fifteenth century. The house was rebuilt several times, including at the end of the seventeenth century, when Sir John Vanbrugh built a brick house on the site. William Porden reconstructed and expanded the house in a Gothic style between 1804 and 1812. In the years before the Rohlfs family visited Eaton Hall in 1890, the residence was even more grandly expanded in a heavier

3.1 Old Dee Bridge and Dee Mills, Chester, England, pre-1895. Courtesy of Don Mason, Nanaimo, B.C.
3.2 Francis Bedford, Eaton Hall, Eccleston, England, pre-1894.

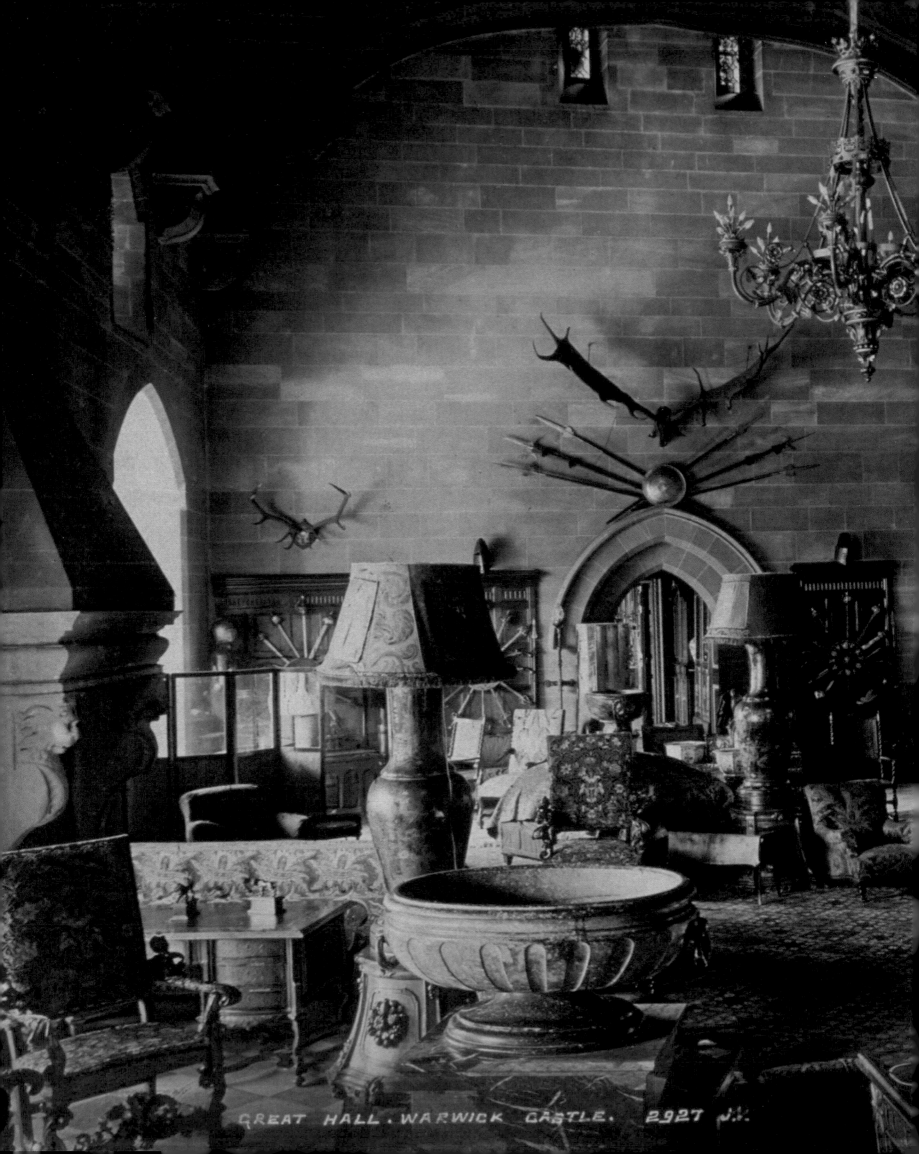

GREAT HALL. WARWICK CASTLE. 2927 J.V.

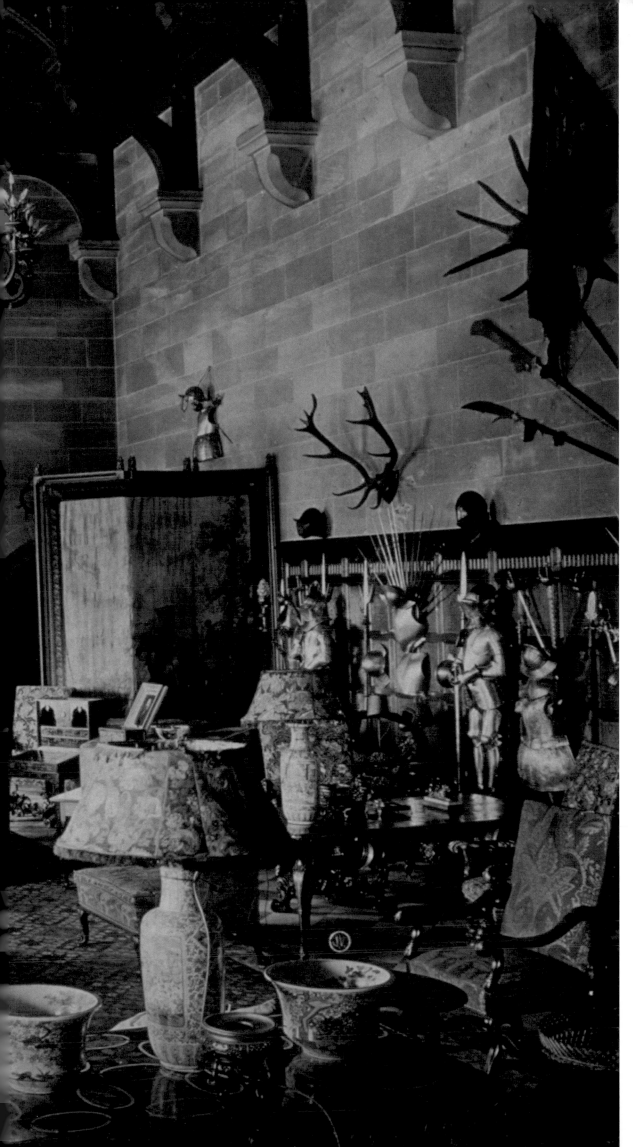

3.3 Great Hall, Warwick Castle, England, 1882. Courtesy of University of St. Andrews Special Collections Department, St. Andrews, Scotland.

3.4

version of Gothic by Alfred Waterhouse. As reconstructions and additions amassed, the house became irregular and asymmetrical, but at each juncture, some of the old structure was retained, amalgamated with the English country vernacular and Gothic revival of the late nineteenth century. Although Eaton Hall had lost its architectural purity, its grandeur made a lasting impression on Anna Katharine and Charles.

The family's next stop was in Leamington, southeast of the industrial center of Birmingham. On 15 May 1890, the family made their way to the medieval masterpiece Warwick Castle, where they "enjoyed to the full the sight of the historic pile," and "Charles ascended to the top" of the tower (fig. 3.3). Their travel journal elaborately recounts their viewing of fine and decorative art in "Queen Anne's room, the Green room, the Cedar room, the state dining room and the Banqueting hall." The couple described the decorative and fine art objects in the castle in detail. "The cabinets in all these rooms are exceedingly choice, and the paintings are most of them by Rubens and Vandyke." Anna Katharine and Charles clearly reveled in these first experiences of the great art of Europe, while their children "were chiefly interested in the peacocks of which there were a great number in the courtyard."

Early the next morning, the family set off for Kenilworth, where they met up with Nelly Buckley, whom they hired as the children's nurse. Anna Katharine and Charles were titillated by "the spot from which Lady Godiva started on her famous ride." The couple shared an interest in sketching, drafting, and drawing. "The quaint old houses scattered here and there interested us very much. We longed for paper and pencil to perpetuate them." At this time, Anna Katharine was as likely to grab pencil and paper and jot down an architectural form they admired as was Charles.

On 17 May they made a pilgrimage to Stratford-on-Avon. "We came by cars, walk to Shakespeare's birth-place and see it under very favorable auspices. Rosamond and Sterling sit in the chimney nooks on either side of the fireplace probably in the very places Shakespeare sat as a child. We visit next the church where his remains are laid and are surprised to find that the celebrated bust in the wall about his tomb is colored." From there it was on to the "historic place," Oxford, where they stayed at the celebrated Milre Hotel. The couple's mutual interest in design and in objects of age and character was again reflected as Anna Katharine celebrated "the chapel at New College with its famous stained glass designed by Joshua Reynolds" and noted "the chapel of Trinity College . . . with its exquisite wood-carving by Gibbons."[15]

The wood carving Anna Katharine mentioned is of the school of Grinling Gibbons, which was dominant in the seventeenth and eighteenth centuries. Although Gibbons carved many more restrained decorative moldings of more stylized conventional form, his name is usually associated with a leaden form of ornamentation that is copied largely from nature. Charles the designer must have marveled at the lush expanses of drapery, exotic floral and vegetative foliage, and fully three-dimensional fruit and birds, all hand carved in thick lime and oak boards. Charles, the aspiring wood-carver, must equally have admired the technical virtuosity of these passages: each grape fully rounded, each thin stalk of vegetation and bird's legs fully articulated. These images will resonate deeply as we analyze Rohlfs's later carved motifs against the backdrop of the kinds of influences he absorbed while in Europe. On 18 May, as the family spent another day walking among the college buildings and cathedrals of Oxford, little Sterling Rohlfs turned three. That evening the family traveled to London.

Callers, recitals, theater performances, trips to the zoo with the children, and literary business kept Anna Katharine and Charles busy during their first days in London. Without delay they visited Parliament, Westminster Abbey, and the National Gallery of Art, while Anna Katharine pursued her literary interests, sending a note to London's Incorporated Society of Authors. In response, Walter Besant, chairman of the society, invited Anna Katharine to visit

3.4 School of Grinling Gibbons, Carved Panel, detail, ca. 1890s. Various woods. Wren Library, Trinity College, Cambridge, England.
3.5 The Hague, Ridderzaal, postcard, ca. 1900.

3.5

on Thursday, 29 May. She spent that day at home, resting for the meeting. Continuing their sightseeing and tourism, the family took in the National Portrait Gallery, the Tower, and the British Museum, all the while fitting in shopping and receptions. In late June Anna Katharine was again extremely ill, seeing doctors and spending a week in convalescence.

On 10 July, in Anna Katharine's words, "Mrs. And Miss Coues . . . bid us goodbye," and the family traveled to Canterbury, where they "walked through the park and rambling narrow streets" and "visited the cathedral," marveling at its breathtaking Gothic styling. Then it was on to Dover, where they rested overnight before embarking midday on 11 July for Ostende, on Belgium's western coast. Sterling and Nelly the nurse were the only ones in the party who made the passage across the Channel without seasickness. On arrival in Ostende the family traveled to Bruges.

In Bruges they admired the cathedral and Hôtel de Ville, Belgium's oldest town hall, begun in the fourteenth century, as well as the "great fire-place in the Palais de Justice" and the "pointed facades varying in height width and color but similar in formation." The chimneypiece of the Palais de Justice, with its exquisite early Renaissance design, dazzled Charles and Anna Katharine. This mantelpiece, one of the largest ever constructed, is a splendid example of just the

3.10

editing the *Case of Leavenworth* dramatization. The family rode up and down the Grand Canal, while Charles and Anna Katharine sketched the architectural wonders of Venice, visiting Tintoretto's house among other notable residences. Charles's or Anna Katharine's unsigned picturesque drawing in the family's Travel Journal on 6 October 1890 is a testament, not only to their intense interest in Venetian architecture, but also to the drafter's skill (fig. 3.10). In this case, it may be the hand of Anna Katharine Green rather than Charles Rohlfs. Absent are the short marks, squiggles, and rapid parallel lines characteristic of his sketching style. This well-composed scenic drawing has a much more fluid style. The careful treatment of perspective and animation of the picture is related to Anna Katharine's picturesque watercolors in the *Songs to the Poets*.

The family traveled to Lido in the afternoon of 7 October, and the next day they visited the Palazzo Contarini, which they found "charming."[30] Back in Venice, they bought some of the glass creations they found for sale. By the end of the week they started for Padua, which they reached in less than a day, walking the streets of this historic city and enjoying its architecture and design before moving onto Bologna. The Rohlfs family enjoyed the arcades and gardens of Bologna on route to the cathedral and picture galleries, where they admired works by Raphael and Guido Reni while the children played ball. In fact, the couple "visited the palace and Cathedral again" and noted that "fences in Italy [are] like gravestones . . . supported

by stone slabs—Loggias in Florence, overhanging roofs to gables in Zurich. Courts in Milan Arcades in Bologna."[31] Visiting Florence in mid-October, the family strolled through the city in the evenings, taking in such sights as the Duomo, Giotto's bell tower, the Palazzo Vecchio, and the Loggia dei Lanzi.

During this time in northern Italy, Charles found a "frame in Bologna Gallery" so noteworthy that he sketched the painting very roughly but articulated its frame quite clearly, in a fashion reminiscent of the drawing examined in chapter 2 (fig. 3.11). This documentation of Charles's fascination with decorative art connects his earlier design and execution of domestic objects for their home to his later career as a designer and maker of artistic furniture. Around 16 and 17 October, in the midst of walks along the Arno and seeing the court of the Palazzo Vecchio and San Lorenzo and other churches, the couple was able to "finish the play," after which they commenced on 19 October to "make their way home"[32]

3.11

THE LEAVENWORTH CASE

Consumed as they were with producing the dramatized *Leavenworth Case*, Charles and Anna Katharine stayed in New York in the early part of 1891. Planning for the show, auditioning actors, interviewing workers, and continuing to edit the play took over the lives of both author and actor. They engaged the producer Frank Carlos Griffith to coproduce *The Leavenworth Case*, which opened 15 September 1891 at the Chicago Grand Opera House.[33] The partnership selected Joseph S. Haworth to head up the cast as villain James Trueman Harwell, but he left the production early on and was replaced by none other than our own leading man, Charles Rohlfs.[34] The dramatization of Anna Katharine's most successful book achieved critical and popular success in Chicago and in its subsequent performances in various midwestern and northeastern cities and towns, including Columbus, Cleveland, and Buffalo.

Theatrical success was not the couple's only joy during this period. On 10 February 1892, "a little baby boy came into our family." Charles, who was in New York, "received a telegram at 8:15 AM and arrived by N.Y. Central road at 5:40 PM, arriving at home 186 Morgan Street Buffalo at 5:50 about 2½ hours before the little one came to light. Rosamond and Sterling were awakened by the baby's crying."[35] As Anna Katharine reported in Roland's diary, commenced in Buffalo on the day of his birth:[36] "He has very dark hair and much of it. His cry is not peevish. When put to his mother's breast about 11 PM it was delightful to see with what avidity he attacked this loving source of sustenance."[37]

Charles put pen to paper two days after little Roland's birth to report: "I bought 2 of the new coined half dollar pieces from N.Y. fresh from the Treasury and gave them to our little boy." The proud father also recounts the typical well-wishing commemorations of the event, ranging from the utilitarian shoes for little Roland to the "silver gilt and enamel spoon" that Anna Katharine received from "The Magazine Club." The birth of Roland Rohlfs occasioned the second extant rendering of a piece of furniture, a crib, designed and made early in 1892 by Charles Rohlfs, perhaps with the assistance of Anna Katharine Green (fig. 3.12). Between the 1888 sketch for the *Decorator and Furnisher* and this exquisite little drawing there is no drawn, photographic, or textual documentation whatsoever of the couple's efforts in the decorative arts. Charles wrote of the *Crib* on 24 April 1892, "This is a sketch of [Roland's] crib. Bellied canvas holds pillows, etc. Frame is cherry mahogany stain screwed together. D. M. Maycock thought it excellent for use and all who see it like it in its merits. The baby has a good time in it and is overall pleasant."[38]

This odd, yet attractive form has a highly unusual and innovative design. Four rectilinear legs ascend from small ball-shaped feet (possibly rollers) to form the posts to which the bellied canvas is attached. A spare and elegant set of similarly restrained cross-stretchers form

3.10 Anna Katharine Green or Charles Rohlfs, "Venice," Travel Journal, 6 October 1890. Graphite on paper. The Winterthur Library.
3.11 Charles Rohlfs, "Frame in Bologna Gallery," Travel Journal, 1890. Ink on paper. The Winterthur Library.

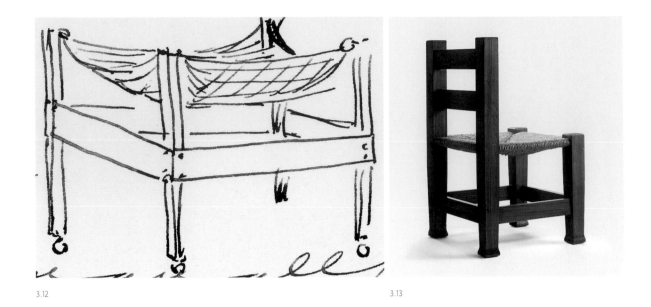

3.12 3.13

a boxlike apron supporting the structure of the *Crib* and giving a skirted sensibility to its mid-section. This boxed cross-stretcher is a formation that A. Page Brown and Bernard Maybeck were to use, the very next year, near the foot of their celebrated "Mission Chair," designed for the Swedenborgian Church, San Francisco, 1893 (fig. 3.13). The severe minimalism of the *Crib* is mitigated only by the inspired use of decorative screw heads, gracefully placed in vertical pairs immediately near the corner joints of each post. This merging of joinery and decoration calls to mind the shaped wooden plugs Rohlfs used extensively on later furniture and anticipates the decorative ebony pegs featured fifteen years later in the furniture of the architects Charles Sumner Greene and Henry Mather Green. Finally, the pillowed canvas holding the child was ingeniously hung from rings that apparently looped onto the posts at the four corners.

This loop-on-pin feature is an essential design element. Charles had previously used this device in hanging the pillow backrest from the crest of his *Settee*. It is also featured in the ring-hung sack suspended from the pin-topped posts of an undated *Wastebasket* (circa 1898–1906; see fig. 10.18), as well as, in a modified form, in the hanging metal bucket hung from the shaped arms of his masterful *Plant Stand* (1903; see fig. 9.19). This 1892 reference point is invaluable in understanding the development of Rohlfs's designs and craft before he embraced furniture-making as a career.

This was a time of great joy and excitement for the Rohlfs family, with the birth of Roland and the successful staging of *The Leavenworth Case*, but it was not a time of stability. As Charles reported in Roland's journal on 6 May 1892:

> We have been stopping at "The Fillmore" and Niagara Square since Apr. 29th. Our furniture is stored & we are in great perplexity to know where the next year of our life is to be spent. I (Roland's father) am looking forward to going on the stage again either to "star" in his mother's drama-tization of her first great novel "The Leavenworth Case" or to play in Shakespearean roles. The

uncertainty of our whereabouts is occasioned by my not knowing just what can be done and where. We have made decided changes in our lives at or near the arrival of our babies. Roland seems to be no exception for we are planning to go to the vicinity of New York as soon as we can decide where it will be comfortable for our little family to live during my expected absences.

3.14

Indeed, Charles and Anna Katharine's attention was focused on the upcoming fall theater season during summer 1892, which the family spent in East Haddam, Connecticut.[39] During this time, Charles honed his starring performance, and he and Anna Katharine worked to improve the play. In fall 1892 and early the next year, this work paid off as *The Leavenworth Case* played to a range of audiences in the Midwest and eastern United States.

Rohlfs family scrapbooks include many references to the success of the play and its star performer, Charles Rohlfs, ranging from mere mentions of his performances to rave reviews. The *Brooklyn Standard Union* referred to Rohlfs's performance as "careful," even "earnest," whereas the *Brooklyn Evening Sun* called his performance merely "able."[40] According to the American Press Association, Charles Rohlfs was poised "to take high rank among the celebrated actors of America." The *Syracuse Courier* and *London (Ontario) Advertiser* went so far as to call his portrayal "masterly" in their April 1893 editions.[41]

In Cincinnati on 29 April 1893, however, *The Leavenworth Case* met a sudden end after a performance at the Grand Opera House. Though a two-month tour of more than ten midwestern cities beginning in early May had been planned, contracts were abruptly canceled and a sheriff detained the company's property. The possessions of the Leavenworth Company and its partner producers—namely, Charles and Anna Katharine and Frank Carlos Griffith—were seized by contract under the thousand-dollar forfeiture clause enforced by New York theatrical manager M. B. Leavitt.

3.15

OVERACTING AND POLITICS

The Rohlfs family returned to Buffalo "May 1st and settled in Highland Ave. 29."[42] The efforts to tour the dramatization of Anna Katharine's wildly successful novel *The Case of Leavenworth* had taken its toll. The couple simply stopped keeping a journal for their first two children after returning from Europe, and they failed to mention little Roland's first birthday in his yearbook. They admitted, when finally making an entry, after more than seven months, "we have not written about our splendid boy for a long time, yet have our hearts been full of his beauty, intelligence and boundless good nature."[43]

Despite their ultimate failure to tour their play as they had intended, the couple remained devoted to their respective pursuits of literature and the theater, as well as to the idea of partnership in joint projects. In the summer of 1893, Anna Katharine's novel *Cynthia Wakeham's Money* was published by Putnam's, and a newspaper article from August 1893 in the Rohlfs family archive reports on her financial success: "At one time, when she first turned her pen to account, this estimable woman enjoyed but few comforts of life, but her industry has borne rich fruit and today she enjoys an annual income from the sale of her writings estimated at $15,000."[44]

The exposure of the dramatization of *The Leavenworth Case* brought requests for new plays by Anna Katharine, and Charles decided that his return to the stage would be lasting.[45] He resolved to "devote himself to creating character parts, as he considers that his personal make-up is better adapted for that line of business."[46] Edward Bok reported in *Book News* in September 1893 that Anna Katharine Green had turned her attention "to playwriting, and before again writing a book, the public will have another play from her pen, or pencil rather," and that this drama would be composed "expressly for her actor-husband, Charles Rohlfs."[47]

The couple spent the fall of 1893 in New York City and Brooklyn, Anna Katharine working on various literary and dramatic works and Charles continuing to improve his portrayals of characters and readings from various dramatic works. For much of 1894 and 1895, the couple divided their time between New York and Buffalo, which was again home to the family. Anna Katharine continued to enjoy publishing success. Charles delighted in presenting dramatic recitals from his beloved Shakespeare, as well as Molière, Browning, John Hay, Bret Harte, and, especially, his wife's poetic and literary works (fig. 3.16).[48] Rohlfs's Shakespearean characterizations were well received by audiences and critics, and his presentation of excerpts from Molière's *The Physician in Spite of Himself* proved especially rewarding (figs. 3.17, 3.18). Playing Sganarelle, Charles rather inhabited the role, brilliantly offering from his act 1, scene 1 monologues: "There is no need of stage setting or scenic effect, one's entire attention is centered on the speaker, who carries you with him and introduces you to himself under so many guises that you are puzzled to know what becomes of the entire company as you see in the end only the great artist himself."[49] "As the absurd 'Sganarelle,' with his drunken moods and daredevilry, his piratical guise and his weird gesticulation, Mr. Rohlfs did work that actually had a 'lift' to it."[50]

Still, not all the critics agreed, and especially as 1895 led into 1896, reception for Rohlfs's melodramatic flair grew increasingly unfriendly. About his Chicago and Saginaw, Michigan, performances, critics suggested that he was "working too hard" and "inclined to overact" and, worst, that his performance was "actually painful to witness."[51] He was altogether destroyed by a particularly vicious review by Peg Woffington of the *Chicago Times-Herald*, who referred to Charles's portrayals as laughable and to Anna Katharine's dramatic attempts as "awful."[52]

Faced with few, if any, further theatrical engagements or offers for new roles in the remainder of 1896, Charles Rohlfs took his dramatic skills to the political stage. Anna Katharine's father, James Wilson Green, had been a prominent force in the Republican Party from its early days.[53] In 1896, Rohlfs became an ardent and active supporter of William McKinley's bid for the presidency. Campaigning for McKinley in the New York primary, he aggressively attacked New York political boss Thomas C. Platt.[54] Rohlfs was one of several speakers who addressed a mass meeting of workingmen at The Cooper Union on 10 September 1896.[55]

He was then dispatched, with Terence Vincent Powderly and A. W. Wright, as part of a team of orators to campaign for McKinley in the Midwest.[56] Among their stops were Chicago, Peoria, and Rock Island, Illinois. The rivalry between McKinley and William Jennings Bryan was intense and divisive, and Charles Rohlfs did not shy from the controversy. For example, at the Central Music Hall in Chicago, where Rohlfs served as chairman of the speakers, he opened with an aggressive attack.

> *Chairman Charles Rohlfs prefaced his introduction of Mr. Powderly with an address of considerable length, in which he made vigorous attack upon Mr. Bryan, and eulogized Maj. McKinley. Referring to the Republican Presidential candidate he said:*
>
> *"The speakers on the Republican side are not going about making apologies for their candidate's record, for we consider it a great privilege to advocate a pure man, a statesman of tried value and known worth, and above all a broad, sound Christian gentleman, William McKinley of Ohio.*
>
> *"No censure is too severe for a man of Bryan's stamp. He is a shallow falsifier of such facts as he knows, and a blundering spouter with facts he does not know. Even if it were a good thing, as he says, to coin silver in unlimited quantities, Mr. Bryan has proved himself to be absolutely unfit for holding any office of great responsibility, by virtue of his ignorance,*

3.16 "Charles Rohlfs' Dramatic Recital," printed flyer, 1894. American Decorative Art 1900 Foundation.
3.17 "Charles Rohlfs as Sganarelle: Act I, Scene I," in *The Physician in Spite of Himself,* 1895–1896. The Winterthur Library.
3.18 "Charles Rohlfs as Sganarelle: Act III, Scene I," in *The Physician in Spite of Himself,* 1895–1896. The Winterthur Library.

3.17 3.18

egotism, and insincerity, and his lack of experience. This, any man can know if he will take
the trouble to read even carelessly any of his 300 speeches. Read them, read them all, then
think, and then compare what he says to what McKinley has said. Compare their records,
compare their characters, compare the promises of Bryan with McKinley's achievements:
with what he has already done and is bound to do over again, and do it better than before,
and then tell me if you would not rather follow a statesman to defeat than a demagogue
to victory."[57]

As at other venues, the McKinley partisans met with jeers, hisses, and interruptions,
and "so great did it become at times that a row seemed imminent."[58] At the end of Rohlfs's
speech, union leader W. C. Pomeroy responded from the audience with a "savage attack."[59]

The campaign was ultimately victorious, but Charles then found himself without an
obvious career. So, at forty-four, he increasingly turned from the stage and toward another
artistic pursuit, the design and creation of domestic objects of exquisite beauty. As his aspira-
tions for a future in the theater faded, Charles Rohlfs turned to furniture-making for a new
artistic outlet and a new career.

CHAPTER 4

FROM CASTING ABOUT TO A GRACEFUL
WRITING SET

While Rohlfs variously tried a career as stove designer, took the grand tour of Europe, and again sought to make his name on the stage, his interest in design and decorative art was abiding. The drawing of the "corner in the study of Anna Katharine Green" in 1888, the drawings of European art and architecture in 1890, and the exquisite small rendering of Roland Rohlfs's *Crib* in 1892 attest to his talents as an amateur designer. Although details of Rohlfs's transition, around 1897, from actor to cabinetmaker and wood-carver are not entirely clear, a general account of this career change is presented here. Rohlfs's new endeavor in art furniture culminated in his first and only great achievement in production furniture, "A Graceful Writing Set," a number of examples of which he produced in 1898 and 1899.

Charles and Anna Katharine overtly created and perpetuated the story, still widely accepted, that Charles forsook acting in deference to her family's objections to that career. This romantic story is myth. As we have seen, the only career Charles ever tried to replace for acting during Anna Katharine's father's lifetime was stove design and manufacture, and these pursuits in industrial design never displaced his interest in being on the stage. Two years after marrying Anna Katharine, he performed in *The Veteran* at the Brooklyn Academy of Music in 1886. Anna Katharine's father, a widower, died shortly before the couple's European tour, after which they openly put Charles's acting at the forefront of their concerns. Even years after James Wilson Green had died, Charles was still vigorously pursuing the very career in acting he claimed to have given up at Green's demand.

Though Rohlfs's later accounts of his career are perhaps as theatrical as his wife's novels, his own words are the necessary foundation in piecing together the development of his new vocation. Several years after his bad theatrical reviews in late 1895 and early 1896, he described this period of transition as a complex time for him: "Chronologically, the circumstances which determined him in his present occupation should come near the end of this story, but logically they should be set down near the beginning. Four or five years ago, having just closed a theatrical road season (which, like nearly all similar ventures that year, was not very successful), Mr. Rohlfs found himself temporarily without occupation. While casting about for something to do he fitted up a little workshop in the attic of the Rohlfs' residence in Buffalo and went to work."[1] As Charles honestly admitted, it was simply his failure as an actor that precipitated the beginning of his career in furniture-making. These remembrances in a newspaper article of 1904 would place the beginning of his career as a cabinetmaker "four or five years ago" in around 1899 or 1900, but his mention of "having

VIEW OF RESIDENCES ON ORTON PLACE.

4.1

just closed a theatrical road season" suggests that the origin of his formal furniture-making enterprise was in 1896 or 1897.

During this pivotal time Rohlfs likely did rather a bit of "casting about," but he was soon ensconced in his newfound artistic outlet: designing and making artistic furniture. As journalist Lola Diffin reported some years later, "It was at the close of an unsuccessful theatrical season that he opened up a tiny workshop in his attic and went to work at his bench. I think the time has come when thousands will feel glad that that season was for him unfortunate. Had it not been—we might never have had Charles Rohlfs, designer."[2]

Modest to say the least, the first "workshop" to be maintained by Rohlfs was located in the attic of the family's home at 10 Orton Place (fig. 4.1). As Charles admitted, "it is hardly probable that there ever was just such another workshop." He confessed that "for a bench" he "used an old box." For cabinetmaking and carving tools, he used a saw, a plane and "two or three implements such as wood carvers use." Even at this early date, around 1897, his aesthetic concerns are revealed in his assertion that he used "some pieces of oak, selected because of their beautiful grain and evenness of texture." Rohlfs's devotion to the raw material of his art and its inherent qualities of figure and texture prove consistent across the next decade of his design and construction of furniture. It is of particular interest that Charles Rohlfs mentions in this context one of the first pieces he worked on after leaving acting and taking up furniture-making as a profession.[3]

In this first "professional" attempt at the design and execution of decorative art, Charles seems to have "fashioned a desk for the use of his wife."[4] First at 10 Orton Place and later when the family first rented a full house at 105 Norwood Avenue, Buffalo, in 1899 (fig. 4.2), they needed furniture for residences, much of which Charles created between 1897 and 1904. Already concerned with domestic usefulness as well as beauty, Rohlfs asserted that "the leading notion in its design was utility," which makes sense insofar as he was making

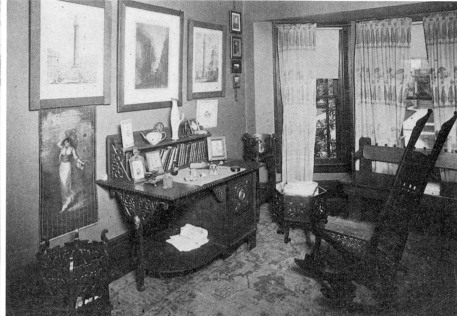

4.2

4.3

the piece for his wife to use as a writing desk (fig. 4.3). According to analysis of the object and period accounts of the *Writing Desk*, Charles tried to make it ergonomic, designing a place where Anna Katharine would write her novels and poetry. When the desk was finished, Rohlfs "gave the natural surface a transparent dressing." This phrase is a bit perplexing, given that period images of Anna Katharine's study show a darkly finished desk, which is very likely the one Rohlfs described.[5]

"Natural surface" might refer to a fumed but unfinished surface to which Charles had applied a transparent shellac or varnish. It is also possible that the wood surface remained unfumed but received applied finish in the form of a transparent colored wash, perhaps even quite dark in color, which would have allowed the grained figure in the wood to be visible through a rich wash of color. The desk in this period photograph is, unfortunately, not extant. Given its stylistic kinship with other pieces Rohlfs made around 1898, its having been illustrated in *Book News Monthly* in a photograph titled "Mrs. Rohlf's [sic] Study,"[6] and the absence of any other desk forms known in the Rohlfs family, the desk in the photograph must be the desk to which Charles referred.

This *Writing Desk* provides clues about Rohlfs's earliest experiments in professional furniture-making. Given the date of 1897 and the couple's predilection toward all things Victorian, it is not surprising that the *Writing Desk*, in both form and decoration, relates closely to this prevailing late nineteenth-century style. Nicely imbalanced, with a small cabinet on its left proper side and a single leg opposite, its form demonstrates the late nineteenth-century propensity for this sort of composition. The *Writing Desk* presents beautifully from the front and from either end. The decorative motif on the right proper end satisfies the eye with balance and unity, while the front aspect agitates the viewer with a sense of instability, leading finally around the panel front on the left proper end, which (though it is not visible in period photography) likely featured either open shelving or the door to an interior cabinet.

4.1 "View of Residences on Orton Place," 1890. (10 Orton Place, later the Rohlfs home and the location of Charles Rohlfs's first workshop, is the first house on the left.) The Buffalo and Erie County Historical Society.

4.2 105 Norwood Avenue, ca. 1901. Reverse reads, "Charles Rohlfs." (The figures on the steps are very likely Anna Katharine Green and Rosamond Rohlfs.) The Buffalo and Erie County Historical Society.

4.3 "Mrs. Rohlf's [sic] Study," in *Book News Monthly*, September 1906, showing *Writing Desk*, ca. 1897.

The fretwork on the *Writing Desk* is both ornamental, in the flourish adorning the crest of the right proper leg where it meets the desktop, and utilitarian, in the supports for the book rack and shelf attached at the rear of the desktop. Decorative nail heads, sometimes structural but often merely ornamental, adorn the desk, featured especially in its panel at the front left proper, where the metal of the nail heads and the inset metal medallion call to mind Rohlfs's designs for cast-iron stoves.

4.4

Where the decorative scrolls meet the right proper leg there is a Beaux Arts image, a bearded godlike character with flowing locks. Similar visages adorn many instances of late nineteenth-century Beaux Arts and Victorian architecture and design. Curator and scholar Kevin Tucker has suggested that the figure may be Vulcan.[7] The bearded fellow on the desk's leg and the decorative boss at the upper center of the shelving on the desktop are clearly not carved from the oak on which they sit but rather are attached, and they appear to be made of metal rather than wood. Tucker intelligently connects the boss or medallion at the desk's center to the "bosses from iron stoves," which provides a tempting connection to Rohlfs's former career as a stove designer. He suggests further, "Vulcan, god of the forge (iron, fire, etc.), is a likely decorative element from the leg or base of a 'fancy model' stove," which may explain not only its connection to Charles and stove design but also how it ended up featured in this location on a desk.

Another explanation has been put forth by Sarah Fayen, who argues that the bearded man should be understood as a version of the "Green Man," a "bearded face that shows up at various times in western design history and carries associations of naturalistic mystery, a sort of pagan hold-over fascination with the power of the natural world."[8] This motif, prevalent throughout Europe, would have been especially apparent in Charles's and Anna Katharine's travels through England, where such "Green Man" imagery is ubiquitous and would have been included in the decorative schemes of many of the churches and other public buildings the couple visited. Polly Rubin suggests that Anna is "Green" and Charles is "Man."

Though in keeping with popular taste for the period, the *Writing Desk* was an early effort by Charles Rohlfs to find his own style and hone his skills as a professional furniture-maker. As it turned out, the desk appealed not only to Charles and Anna Katharine, but likewise to a neighbor, Louis B. Hart. This correspondent for *Dramatic News*, who knew the couple from their theatrical exploits, was also living at 10 Orton Place in Buffalo. Charles recounted the story almost forty years later: "'We needed furniture, so I began making it,' Mr. Rohlfs said. 'Supreme Court Justice Louis B. Hart, then surrogate and correspondent for the *Dramatic News*, came up to the attic one day and watched me work. Then he asked to buy a piece I had made. I would not duplicate Mrs. Rohlfs' desk, but I made his desk. He was my first customer.'"[9]

Closely related to the desks Charles made for Anna Katharine and the young jurist were other pieces, perhaps made en suite with the desk or shortly thereafter in 1898. A large rectilinear table stands out for its bold modernist structure, with its fretted boxlike cabinet base and large overhanging top (fig. 4.5). Its companion bookcase has identical fretted door panels, which were likely created from the same template as the panels in the base of the table. In both cases, patterns of nail heads again enliven the designs with rhythms and shapes that hide joinery beneath the wood surface while adding to the decorative scheme. It is possible, but less clear, that a small book or magazine holder and similar plant stand stem from the same period of production (see fig. 4.3).

SETTING UP SHOP

Within a year of these early attempts at furniture for his home and with his first outside commission complete, Charles Rohlfs faced his situation: dramatic engagements

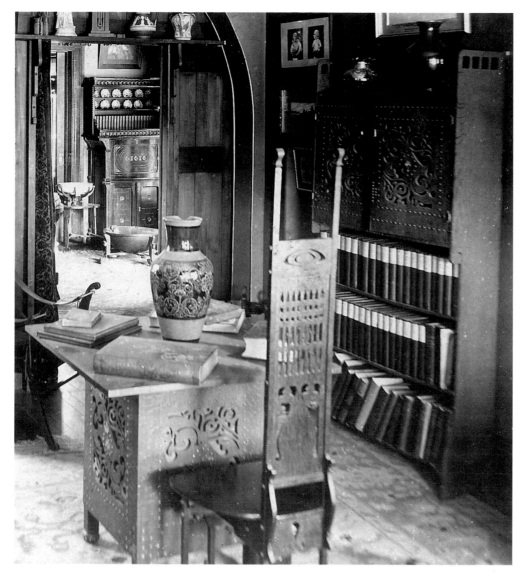

4.5

were not forthcoming, whereas his prospects for furniture clients were growing. The decision seemed clear: he would become a furniture designer and craftsman. To pursue his artistic craft as a profession required more suitable working space. Thus, in 1898, Rohlfs leased an upstairs space at 451 Washington Street and opened his first shop. As journalist Charlotte Moffitt reported in 1900, although the studio was perhaps an improvement on the attic, it was still modest: "It is a way out . . . in a spacious attic, and a first sight of the building is very likely to sweep away any limitations one's fancy may have previously imposed upon the artist in the way of environment. If, having in mind all the beautiful things that come out of this lowly place, the visitor's surprise bears the least tinge of scorn, inquiries below are in vain, and he is left to find his way as best he can up flights of dark stairs and along dim odoriferous corridors."[10] Located downtown in the bustling industrial city of Buffalo, Rohlfs's small furniture operation was situated among various other enterprises, including a bicycle factory, a livery, and coal and wood suppliers. Moffitt joked that "the wise visitor is affable, and interested in

4.4 "Green Man" exemplar, fireplace mantel, Dakota Apartments, New York, 1884.

4.5 Interior of the Rohlfs home on Norwood Avenue, detail of photograph, ca. 1905. The Winterthur Library.

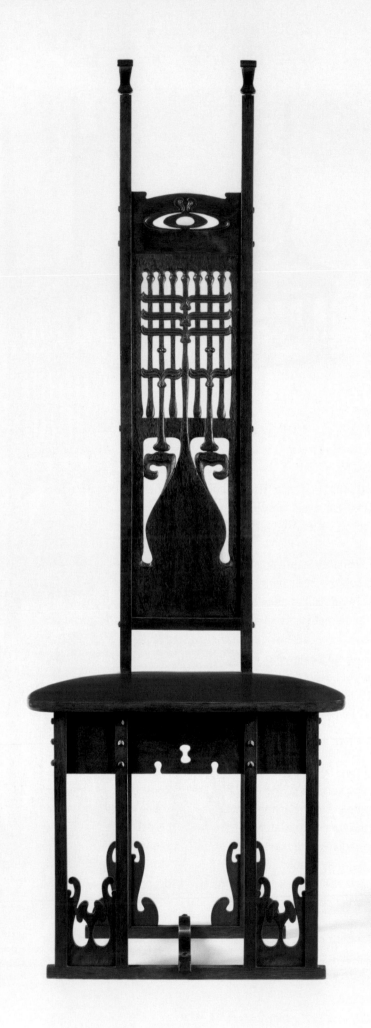

4.11

attempt structural designs that a trained cabinetmaker might never have conceived, let alone executed.[36] The desk rests on a footed platform, which forms the center of gravity for the case and provides an anchor for the metal bolt that is screwed down into its center, providing the fulcrum on which the lower cabinet spins on a system of small wheels, which are embedded in the footed base. The piercing on the lower cabinet's front face (and repeated on its rear face) is very likely a stylized floral motif. The fretted lower cabinet door, behind which four shelves provide storage, exhibits decorative double-scroll forms that call to mind late nineteenth-century British ornament, especially the medallion decorations of Thomas Jeckyll. Elegant hinges join the door to carved oak flourishes on the right proper door edge.[37] An equally sophisticated oak and metal latch mechanism clasps the opposite side to the right proper face of the cabinet, all locked in place with a delicately shaped oak tusk descending from a chain. Completing the lower cabinet on its left proper face is a series of four gracefully proportioned drawers complete with beautiful wooden pulls, which are complexly shaped and beveled not only for appearance but in order to fit the user's hand perfectly.

Ascending above the midpoint of the desk is a stunning enclosed gallery that stylishly completes the overall cabinet structure while providing more storage as well as a writing surface when the desk's drop front is opened. Rohlfs intelligently distracts us from the midsection joining of the top cabinet to the base by carving along the edges of the overlapping oak and decorating the midsection with lobed corner flourishes, which nicely match the lobed feet. From the midsection, the sides of the gallery arc upward while the drop front and its stationary reverse-face each angle toward the apex. Carved in the sides of the desk are some of Rohlfs's most inventive motifs, including embellishments that improvise on everything from medieval coats of arms to flame imagery in both curvilinear ribbons of carving as well as rectilinear shapes.

The front face of the desk falls open to reveal an interior cabinet with a lower shelf and upper shelf from which two exquisitely proportioned drawers hang. Its exterior is adorned with one of Rohlfs's first attempts at the carved rendering of smoke rings, the likes of which were perhaps puffing up from his pipe as he rendered the stylized medallion of interlocking lines, rings, and ribbons, pinned at its center with an oak rod. Adorning the full ascent of the upper section are carved and fretted flames, made of seemingly interlocking strands of oak that are all actually carved from a single piece of wood (fig. 4.13).[38] The flames are rooted with rectilinear bulblike junctures that also conceal joinery. These flames were likely designed by Charles or Anna Katharine or perhaps as a collaboration between the designer and the author: the graphic image on the cover of her novel *Doctor Izard* (1895) bears an unmistakable resemblance to the design (fig. 4.14). At the arced dome of the two side panels, these flames complete the top of the desk with a dramatic gesture while showcasing at eye level Rohlfs's mastery as a woodcarver.

Function still plays a role in the design of this odd, yet useful piece of decorative art. By swiveling the cabinet around a central pivot point, one can access several of the storage shelves and drawers, as well as the sloped surface on the back side of the upper cabinet, which could be used as a book holder. Conceivably, all this could be accomplished while sitting on one of the carved chairs. Rohlfs was surely fascinated by the range of perspectives on the desk that were possible while rotating it. Although these various concerns may have influenced Rohlfs's design of this inventive desk, the proximate source of its unusual complexity may have been the gimmicks frequently employed in multifunctional Victorian furniture in the late nineteenth century.

The *Rotating Desk* has often been described incorrectly as a "Chalet Desk" or "Swiss Chalet Desk." In her early article on Rohlfs for *House Beautiful*, Charlotte Moffitt suggested that the desk "looks like nothing so much as a miniature Swiss cottage." This is hardly an art historical

4.11 *Hall Chair*, 1904. Oak, 54 ½ × 19 × 19 in. (138.4 × 48.3 × 48.3 cm). Milwaukee Art Museum. Gift of American Decorative Art 1900 Foundation in honor of Glenn Adamson.

CHAPTER 5
THE ROHLFS FURNITURE

In the very month that art entered what Barbara Haskell has termed the American Century, Charles Rohlfs began to receive public recognition for his artistic furniture. In its January 1900 issue, *House Beautiful* presented Charlotte Moffitt's article on "The Rohlfs Furniture." This descriptive assessment and photographic survey of Rohlfs's works ranges from beautiful but rather utilitarian objects, such as a "Small Table" and "Corner Cabinet," to extremely unusual works such as a marvelous and odd "Chair with Leather Seat and Back" and exceptional "Calendar-Rack," as well as examples of both the *Hall Chair* and *Rotating Desk*. The broad range of works shown included objects with intriguing design, novel construction, and creative use of materials. Some pieces have notable carved surfaces, while others show Rohlfs's earliest experiments in stylized pierced design motifs. Moffitt's article provides a window into the designs and decorative styling of some of Rohlfs's early works as well as insights about his and his critics' understanding of these objects, just three years into his career as a designer and maker of furniture.

Moffitt opened rather poetically—"The 'making of stuffs at a thousand yards a minute does not make men happier or stronger'"—suggesting that such efficiency does not bring the greatest results.[1] Instead, she grandiloquently proposed a different goal: giving concrete manifestation to ideas, conceived in harmony with particular universal laws, through the design and execution of a work of decorative art. Moffitt suggested that domestic objects should be made with utter reverence for the value of the ideas that inspired their designs, stripped of fairly useless poetic flourishes, leaving simple, elegant designs inspired within the maker's mind, carefully considered and executed with great commitment to the spirit of the original inspiration. These lofty sentiments about the careful working out of ideas and their role in making decorative arts is characteristic of the turn-of-the-century American design press, which often sought to make the ideas of John Ruskin and William Morris central to their interpretive structure.

Gustav Stickley, Elbert Hubbard, and even occasionally Rohlfs found their ideas in alliance with their contemporaries in the Arts and Crafts societies and associations that were springing up from Boston to Rochester to Chicago (where *House Beautiful* was published) to San Francisco. All of these philosophical approaches invoked the standards of good design, careful handiwork, and virtuosic craft espoused by the British Arts and Crafts reformers. Although the American designers and would-be reformers were quick to quote their British idols, they rarely seem to have understood these thinkers deeply, let alone critically. While tidying up her ideas,

drawing to a close her awesomely long sentence, Moffitt pointed out that if the entire model she has laid out is meticulously followed, the maker "can only produce a result that is beautiful and consequently a source of joy to artist and possessor." Very inspiring, but a bit of talent, training, and luck might not hurt either. Though Moffitt was a passionate advocate of design reform (more on this later), Rohlfs proved himself a formidable orator and writer on matters related to design, craft, and the dignity of labor. Given his later public lectures and writing, one wonders how much these ideas were Moffitt's own and to what lengths Rohlfs had gone to supply her with a transcendental talk-track of his own.

Returning finally from the realm of obscure "greater truths" and other points "demonstrated beyond question," to the ostensible topic of the article, Moffitt traced the good influence of design reform à la Morris, which she likened to "leaven … beginning to work," to the "tiny workshop" of Charles Rohlfs. There she found an artist of true Arts and Crafts merit at work with his hands creating objects that "preserve ideas that to him seem worthy."

Although Rohlfs's furniture may have inspired Charlotte Moffitt, she was taken aback by the workshop's inauspicious location. She was rather averse to the gritty shops beneath his large loft-like attic space. We can easily understand Rohlfs's need for a reasonably priced but large rental space and his willingness to labor for his art amid less than ideal circumstances. Moffitt expressed surprise that such beautiful objects emerged from such a lowly work environment and was clearly offended by the lack of gentility shown her by the workers downstairs. Her good nature prevailed, and at the end of her industrial journey she found herself "in the presence of the presiding genius of the place, Mr. Charles Rohlfs." Always the charming host and promoter, the resident artist more than made up for the challenges of reaching his design laboratory with his warm welcome.

Though Moffitt catalogues the uses of space in the loft workshop, as well as Rohlfs's various tools, methods, and processes, what struck her most was the workshop's ambiance: "that inexplicable, intangible something in the atmosphere of the place that proclaims the presence of the creative spirit." Brushing aside the puffery, there was something of substance in Charles's achievement, even just three years into this career. On what may have been a cold, snowy day in Buffalo, Moffitt had found herself in the workshop of a man who had found his artistic calling, an inspired artisan whose work seemed somehow to embody the quirks of his personality, the genius of his vision, and the passion of his heart.

Moffitt immediately sensed Rohlfs's devotion to the materials of his craft, especially the oak and metal, imbued with what she called the "delightful possibilities of all this raw material" that constantly reveal themselves. Still, another raw material was at play: the artist's creativity and passion for his work replaced what could have been an atmosphere of "drudgery" and "ennui" with pleasure in celebrating the potential of oak. Rohlfs's excitement about his enterprise seems to have been contagious, which explains in part why the design press was so enthralled by him and so eager to promote his work, often with his own pitch.

Moffitt also noted Anna Katharine Green's contributions to the shared endeavor of the Rohlfs furniture, suggesting that "the furniture is not turned out rapidly, for, excepting for the assistance of his wife, who is better known as Anna Katharine Green, Mr. Rohlfs does the work himself." As we established earlier, Anna Katharine likely collaborated with Charles on the design and execution of some of the earliest pieces of furniture for their own home. Here, even after Rohlfs had taken up furniture making as a profession, Anna Katharine clearly remained involved. Among the objects Moffitt examined, the design signature of Anna Katharine is particularly evident in the decorative medallions for a "Coal-Box" and detailing on the base of the "Calendar-Rack, with Swinging Frame." Furniture design and production was an outlet not only for Charles's energies and imagination but also for Anna Katharine's artistic vision.

The impetus for Charlotte Moffitt's visit to Rohlfs's shop may have come from exposure to "the collection shown in Chicago," where *House Beautiful* was published and where Rohlfs's works were for sale at Marshall Field. The department store provided the photographs of Rohlfs objects to *House Beautiful*, and quite possibly someone at the company encouraged Moffitt to make the trip. Though she found the objects strange, brooding, and "mediaeval," Moffitt found something compelling about their intricacy.

Taken with the mechanistic workings of pushing and pulling the *Rotating Desk*'s drawers, shelves, and doors, Moffitt reacted with childlike fascination. Pieces like the *Rotating Desk* were impressive and mysterious in their construction, "not exactly as if they were adjusted with ball-bearings," but secure in their movement and of excellent overall structural design. This is part of the wonder and soundness of Rohlfs's early designs, especially a form as convoluted as the *Rotating Desk*. The elegant handling of complex joints and hinges contributes to the usefulness of the admittedly peculiar object as well as to its overall aesthetic merit. An object as elaborate as this desk requires a careful working out of all constructive details to convey the sophisticated, intricate composition without becoming bogged down in its own complexity.

UNKNOWN OBJECTS

Period publications provide valuable information on the objects illustrated or mentioned that are not known to exist today. One work table, not illustrated, ingeniously integrated a spacious work surface with a large, depressed bowl in its center, designed to hold needlework materials, along with another removable, carved and handled bowl that is set between two lower shelves and is attached to its three legs. Elements of this table form may have been influential on Charles and Anna Katharine's development of the design for coal hods, described later. Anna Katharine's involvement with this table form would make particular sense, given the table's use as a station for the feminine pastime of needlework. Connected to traditional work tables, Rohlfs's innovative form, equally functional as a sewing table and as a cabinet, was a model of design convolution. We can only imagine what exactly it looked like, but Moffitt seemed dazzled by its unexpected practicality.

Also practical is a *Corner Cabinet*, which the author describes as rigorously composed and yet attractive. Though this object is not extant and was not shown in *House Beautiful*, it was shown in a 1901 edition of *Dekorative Kunst*, where it was similarly labeled as an "eckschränkchen" (little corner cabinet; fig. 5.1). As Moffitt described, this form is an odd take on a traditional triangular corner china cabinet. The case piece stood tall and narrow on "queerly fashioned legs," with angled side panels and shelves above and below a cabinet with a central door. The design replaced the more customary windowed configuration with a face of oak panels with "a few simple lines of steel-headed nails on the doors, and the rough heads of the wooden pegs with which all Rohlfs furniture is joined."[2] (Whether Rohlfs misleadingly suggested this to Moffitt or she simply misinterpreted the construction of the piece, the wooden pegs on Rohlfs's furniture *do not* function as joinery but merely obscure from view the metal screws that hold his furniture together.)

Three other exceptional designs, unknown today but shown in beautiful photos in this article, demonstrate the wide range of objects, "from the simplest to the most elaborate," that Rohlfs was then producing. At opposite ends of the design spectrum are his "Small Table" and "Calendar-Rack, with Swinging Frame," both shown in *House Beautiful*. The simplicity of the *Small Table* and complexity of the *Calendar Rack* are nicely captured, perhaps unconsciously, in their respective titles.

The *Small Table* (fig. 5.2), circa 1898–1899, is an ultra-rectilinear study in the elegant tradition of late nineteenth-century British occasional tables and provides our first glimpse at

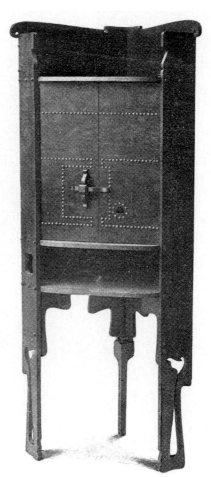

ECKSCHRÄNKCHEN

5.1

5.1 "Corner Cabinet," 1897–1899, in *Dekorative Kunst*, 1901.

5.11 5.12

Katharine Green's illuminations of initial letters in *Songs from the Poets*. The disconnection of the ornamental carving suggests that it may have been designed by Anna Katharine, whose talent with ornament does not seem to have extended to integrating patterned designs on decorative art objects. As in her contributions to the *Settee*, lovely ornamentation in the early coal hod models is left unanchored by appropriate relations to their overall structure.

A more exciting and satisfying example of this form is the 1901 variant *Coal Hod* in the collection of the Los Angeles County Museum of Art (fig. 5.11). This stunning object, which retains its original black finish, reddened "R in bow saw" mark, and 1901 date, is the most heavily carved of any extant coal hod model. In contrast to the other models, where decoration was added simply as framing for hinges and the handle on the lid of the bucket, the *Coal Hod* features ornaments that are fundamentally integrated with its overall design. The carved pattern on the lid achieves a sublime unity with the overall design while showcasing some of Rohlfs's most virtuosic woodworking (fig. 5.12). As in the earlier models, Rohlfs employs carving that borders the two hinges, but instead of standard late nineteenth-century three-point shields, he originates a design that beautifully suits the shape of the hand-hammered hinges. Sprouting from the lobed, rectilinear shape adorning the hinge is a cluster of curvilinear strands that appear squeezed from a bottleneck whence they emanate. The central strands surrounding the hinges erupt as a lobed floral or spade form that has the medieval sensibility Charles and Anna Katharine so loved, while clearly springing from the designer's mind rather than merely reproducing historical precedent. These two three-lobed spades interlock visually with the decorative motif of opposite trajectory, which passes them, having enveloped the lid's hornlike handle. A fantastic object of putatively utilitarian value, the coal hod models are a fascinating study in Rohlfs's ability to originate a design and then evolve it, in this case not just once but twice, yielding in the final *Coal Hod* a work of complete harmony and artistic integrity.

5.11 *Coal Hod,* 1901. Oak, 15 × 30 ½ × 29 ½ in. (38.1 × 77.47 × 74.93 cm). Los Angeles County Museum of Art. Gift of Max Palevsky and Jodie Evans.
5.12 *Coal Hod,* detail.
5.13 *Bench,* ca. 1898–1899. Oak and copper, 45 ½ × 37 ¾ × 24 ½ in. (115.6 × 95.9 × 62.2 cm). Museum of Fine Arts, Boston. Gift of a friend of the Department of American Decorative Arts and the Arthur Mason Knapp Fund.

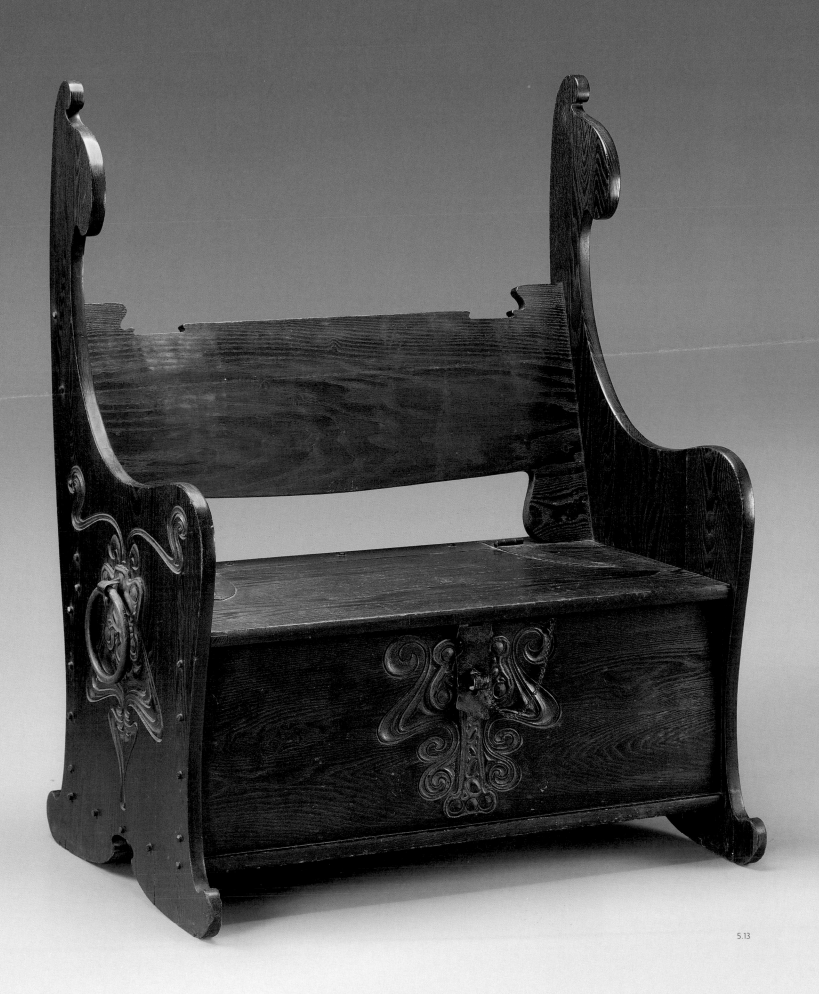

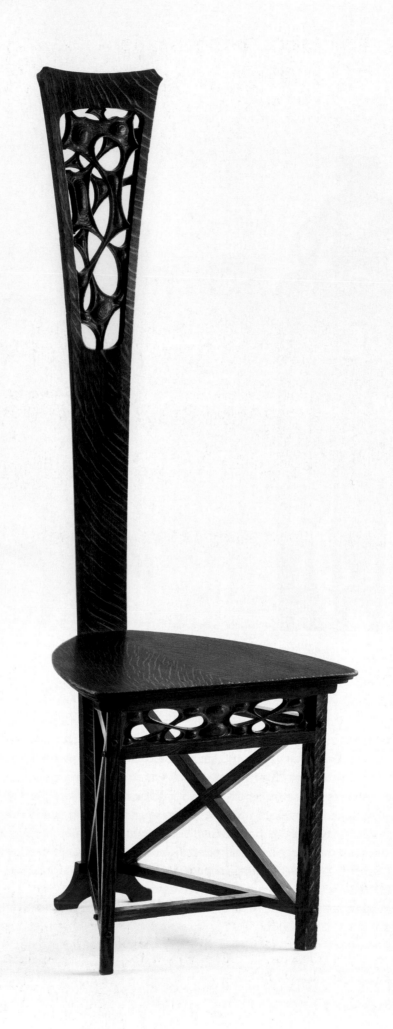

5.24

DESK CHAIR

Perhaps the only object Rohlfs created that could eclipse the beauty of the *Tall Back Chair* is the *Desk Chair* he made likely around the same time, circa 1898–1899, with a radically different design but carving that is similarly lavish, virtuosic, and sublime (fig. 5.24). Contrary to earlier assertions regarding the authorship of this design, the *Desk Chair* may actually have been the result of Rohlfs's collaboration with Anna Katharine. Michael James labeled this a "Ladies Desk Chair," and showed a period photograph of it. But an eight-by-ten-inch sepia photograph on cloth paper of this chair from the Rohlfs family archive reads on its reverse:

> 15 [in blue pencil]
> Desk Chair [in pencil]
> Anna K. Rohlfs [in pencil]
> BLISS BROS.,
> Commercial Photographs
> 295 Oak St., Near Genesee,
> BUFFALO, N.Y.

A number of things are notable about this documentation, aside from the first correction, that it was called simply "Desk Chair" rather than "Ladies Desk Chair."

Not unlike the *Tall Back Chair*, which had been known as "Chair made for his own home" but in fact has a model number, the *Desk Chair* is numbered "15" on the reverse of the period photograph but labeled "#4 Carved Desk Chair" on a Rohlfs Workshops paper label attached to the underside of its seat. With a model number in hand, Charles was clearly prepared to sell this chair model, and he did. Though he likely used an overall template from the *Desk Chair*, Rohlfs compromised the purity of the original design in a later custom-ordered mahogany version, adding disharmonious carving to the central motif, perhaps at the client's request.[20]

Last, and most important for our discussion of authorship, the *Desk Chair* is not inscribed, as Michael James suggested, as "made for" Anna Katharine but instead is simply inscribed "Anna K. Rohlfs." Tellingly, this is not a name by which Charles or Anna Katharine herself ever referred to her. Not in letters, diaries, or other communications is the wife, mother, author, or furniture-maker ever referred to this way. Charles and Anna Katharine's great-granddaughter has pointed out that she was always "Anna," but "Catherine" by birth, "Katharine" as an author, and "Rohlfs" by virtue of her collaboration with Charles in the design and manufacture of furniture. Rather than "made for" her, the inscription "Anna K. Rohlfs" indicates her role, perhaps a significant one, in the design of this stunning piece of decorative art.

The overall design of *Tall Back Chair* is largely conventional, but the *Desk Chair* is a design revelation. Virtually identical in height (approximately fifty-four inches) and with seats set similarly low, both chairs have a dramatic presence and an almost human charisma. Whereas the *Tall Back Chair* features a standard arched crest, conventionally symmetrical backrest, and customary square seat with stretcher below, every design detail of the *Desk Chair* sets it apart as a wonder of expert joinery, carving, and surface finishing. Both chairs are pierced and carved with similarly complex, layered, virtuosic decoration, but the *Desk Chair*'s jarringly forward-looking shape and ornamental patterns establish its place at the top of Rohlfs's creations. To my eye, the *Desk Chair* stands as the most inspired piece of decorative art created by Rohlfs.

The *Desk Chair*'s stature gains unity and force because of Rohlfs's decision to create the backrest, which reaches almost all the way to the floor, from a single exquisite piece of oak (fig. 5.27). The board's continuity offers structural stability to an otherwise understructured

5.24 Charles Rohlfs and Anna Katharine Green, *Desk Chair*, ca. 1898–1899, from the Rohlfs home. Oak, 53 ¹⁵⁄₁₆ × 15 ¹⁵⁄₁₆ × 16 ⅞ in. (137 × 40.5 × 42.9 cm). The Metropolitan Museum of Art, New York. Promised gift of American Decorative Art 1900 Foundation in honor of Joseph Cunningham.

5.25

object while creating a dramatic effect. One's eye follows the wood's sinuous line, elegant grain, and articulated form down from the crest almost to the floor, where it joins a beautifully shaped foot. The wishbone-shaped rear foot balances the chair's back and mirrors the taut two-point band that forms its uppermost silhouette.

More conventional is the shape and joined construction of the central structure of the *Tall Back Chair*, which is largely carved and pierced from a single oak board but which has small moldings that complete it at the seat rail and join it with the understructure of the chair. On the *Tall Back Chair*, a significant shape change immediately below the seat rail disjoins its elements, sacrificing the overall unity that might have been possible. Though Rohlfs went to the considerable trouble of carving and piercing the central design of the *Tall Back Chair* from one board, the unity made possible by the overall design is disrupted by his decision to add unnecessary fused wood parts and to draw back the joined boards from the chair's side supports onto what could have been an uninterrupted single plane. The superior design for the *Desk Chair* has no wood members from in front of the backrest joined to it anywhere but on its face, thus preserving the unity of its planar surface.

The *Desk Chair*'s crest, formed from a similarly Elmslie-influenced "X in box" formation, which was featured in a variety of locations on the swirling design of the *Tall Back Chair*, gives a first indication that elements of the *Desk Chair* relate to decorative art from the Prairie School Movement. This beautifully taut, bowed crest with subtly clipped corners belies the complexly shaped details lurking just behind the unified front oak surface. The *Desk Chair*'s polydirectional tapered angles at its crest points, which relate to the Sullivanesque starlike formations on the *Tall Back Chair*, brilliantly foil the unrelenting simplicity of the *Desk Chair*'s uncarved surfaces. Below the crest, inscribed in an unusually inventive inverted lobed trapezoid, is some of Charles's most inventive carving. Inspired by the cellular structure of oak as seen through a microscope, the circular and oval nodes, their echo-carved reverberations, and the weblike overall design engage in a scientific metaphor that must have amused Rohlfs considerably (fig. 5.25). In keeping with the late nineteenth-century fascination with scientific discovery, he did indeed own a microscope, which can be seen sitting at the right proper front edge of his workshop table in a circa 1902 picture (see fig. 6.1).

From a width of seven and three-fourths inches at its crest, the *Desk Chair*'s exquisitely shaped central totem tapers to just two and three-fourths inches in width at its juncture with the seat, yielding a dramatic ratio between them of nearly three to one. This V-shaped tapered formation is related to a similarly shaped dining chair designed by Elmslie for the T. B. Keith House (1910) in Eau Claire, Wisconsin (fig. 5.28), and is especially closely related to Elmslie's "Surprise Point" Chair, designed around 1913.[21] The *Desk Chair*'s carefully shaped seat, made of two oak boards with book-matched grain, relates closely to the shaped seat of Rohlfs's production model *Hall Chair* from the *Graceful Writing Set*, though in the *Desk Chair*, the fairly regular U-shaped formation of the *Hall Chair* is replaced with a more pronounced parabolic configuration, contributing to the vertical effect of the design. Immediately below the top surface of the *Desk Chair*'s seat, the bowing parabolas of its front surface step back in a highly unusual format, adding depth from yet another perspective. This step formation meets with a molding, with edges that mirror the curve in the frame of the ornamental section above. Immediately below, the carved panel, though similar in its nodal points and layered web, is more symmetrically curvilinear, perhaps again as a nod to Louis Sullivan.

In keeping with the unusual overall design of the *Desk Chair*, its front legs are carefully shaped as parallelograms to meet at sympathetic angles to its triangular understructure. The resulting shapes are radical as a pre-1900 structural device, though the architect-

5.25 Cellular structure of oak, magnified detail.
5.26 *Desk Chair*.

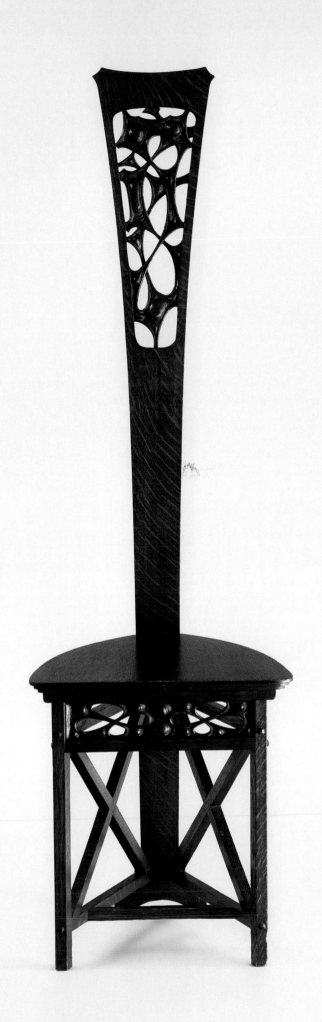

5.26

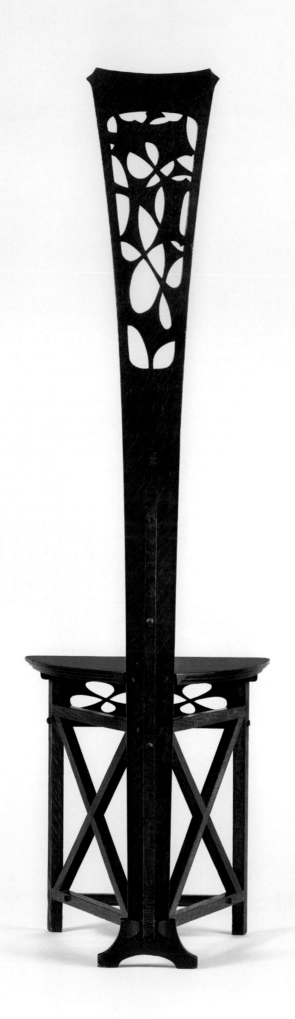

5.27

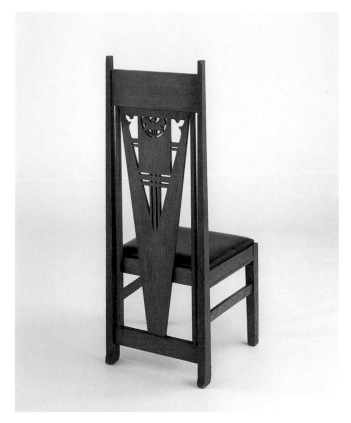

5.28

designers Charles and Henry Greene used this formation in their designs some years later.[22] Because of the significant depth of the *Desk Chair*'s seat, the stretchers joining the legs to the backboard draw the observer's eye into the lines created by the vertical central plank, heightening its soaring effect.

Elegantly placed and inventively composed X-shaped lattice stretchers provide even more visual complexity as well as structural stability to the chair's otherwise scant construction. Although these X-shaped supports may be purely Rohlfs's invention, they may indicate his familiarity with the work of Joseph McHugh, a successful Arts and Crafts furniture-maker based in New York City. McHugh was "the self-proclaimed originator of 'Mission' style furniture in America" (a designation that would be bestowed on Charles Rohlfs in his obituary). In 1898, McHugh was producing and advertising "The Princeton Study Table," which prominently featured remarkably similar X-shaped supports as its most notable design motif. This motif was subsequently employed in many later McHugh furniture designs.[23]

The *Desk Chair* is obviously rather more than a piece of furniture. It functions as a purely abstract aesthetic object, not unlike a sculpture. It is a masterpiece in which Rohlfs introduces new design structures and experiments with ornament. Openly punning on his fascination with the grain of wood, Rohlfs invented a design motif: oak's cellular structure, wildly magnified. Rohlfs's genius here translates the mysterious, yet wondrous world of science back onto what were perhaps for him more concrete and palpable truths—those of furniture design and craft.

5.27 *Desk Chair,* back view.
5.28 George Grant Elmslie, Dining Chair from the T. B. Keith House, Eau Claire, Wis., 1910. Oak, oak veneer, synthetic upholstery, and jute webbing, 50 ⁵⁄₁₆ × 20 ⁵⁄₁₆ × 19 ½ in. (127.5 × 51.6 × 49.5 cm). Minneapolis Institute of Arts. Gift of T. Gordon and Gladys P. Keith.

CHAPTER 6

THE TRUE AND FALSE IN FURNITURE

Around 1900, Charles Rohlfs began theorizing in a number of public addresses and papers about the nature of design, the creation of decorative art, and the dignity of these pursuits. The origins of his ideas and theories about furniture-making, design, and artistic labor can be traced to a number of sources, including the British and American Arts and Crafts movements, certain popular late nineteenth-century strands of Christian and other spiritualist or transcendental ways of thinking, and those that sprang rather singularly from Rohlfs's own Germanic, middle-class moralist perspective, with a twist of theatricality. Often inconsistent, sometimes illuminating, these novel thoughts, complicated hypotheses, deeply held beliefs, philosophical speculations, and full-blown aesthetic theories provide new perspectives on Rohlfs. In this chapter, we will critically assess his thoughts on topics ranging from industrialization and the plight of the worker to theories of ornament and good design.

Rohlfs's first address to the public on topics of design, ornament, and industrial labor, "The True and False in Furniture," was presented to the Arts and Crafts Conference in Buffalo on 19 April 1900. Rohlfs used a title with philosophical (if not moral) implications and opened by exhorting the audience to "go back a few years," to recall the genesis of documented "plans and specifications given to a great man by the Architect of Architects."[1] In this speech Rohlfs gave his perspectives on the true and false in the design and craft of furniture-making, fearlessly claiming to base these propositional claims not just on a foundation of good reasoning or even a moral framework but on the master plans given to Moses by God. Talk about setting unrealistic expectations! By master plans he meant the structure and provisions for the Tabernacle, as given in Exodus. As a reasonable and reverent Presbyterian, Rohlfs did not intend to place himself among the great creators and organizers of time, space, and the world we know; instead, he argued that the nature of the artistic creation in the Tabernacle "left [nothing] to chance . . . no extras." This phrase is central to Rohlfs's understanding of the relation of decoration and design, surface and structure.

It is *planning* as a step in the process of creating truly artistic furniture that most concerned Rohlfs: "carefully and minutely each dimension and color was specified and faithfully carried out; a grand purpose [underlay] the whole great plan." Planning was fundamental for Rohlfs not only as a practical design matter (late in life he claimed that drawings, often revised, of both structures and ornament were always part of his process of developing furniture designs; see figs. 6.2–6.5) but also because of the overriding moral implication of *careful planning*. The importance of vigilantly and devoutly following precise specifications, including

6.1

proportion and palette, took on a spiritual character for Rohlfs. His Presbyterianism, late nineteenth-century transcendentalism, and devotion to artistic furniture converged in a new realm that combined the foundational beliefs of all three.

Rohlfs's use of drawings and models is not well understood, mostly because there are so few examples extant. Still, it should be noted that rather than the kinds of technically rendered designs typical of, for example, architect designers such as Frank Lloyd Wright and his interior designer, George Mann Niedecken, most of what we know of Rohlfs's drawing style are sets of quick dashes, squiggles, and lines (fig. 6.3). These renderings are often hastily put down, on the backs of sheets of Anna Katharine's manuscripts (see fig. 7.22) or even on wood boards. A descendant of the designer recently discovered the drawings shown here on hidden secondary wood panels of an uncarved standard Rohlfs picture frame. Rohlfs even modeled metal elements of his furniture in this way, indicating scrolls of copper with quick spirals and heavier gauge nail or screw heads with simple circles (fig. 6.4). Perhaps the only clue we have about the drawn models used by Rohlfs to develop a design comes from an evolving series of versions of a bookcase or tall chest form (fig. 6.5).

Rohlfs's language in his address betrayed his belief in a moral component to design. Almost as quickly as he pointed to the importance of design and aesthetic matters, he invoked his parallel concern for the "specific use" for which the Tabernacle was planned, presided over by the "character" of those who were to use it. The word *character* here suggests everything from Rohlfs's theatrical past (the playing of "characters") to the late nineteenth-century Pragmatist notion of a "bottom *nature*" and concepts like quality, disposition, and moral fiber or even spirit.

The "needs" of the users of the Tabernacle are compared to the needs of the users of the Rohlfs furniture, both of which should be evaluated by "the one most competent to know them." This bold comparison seems bizarre in relation to current standards of ergonomics and good design. Thus, Rohlfs asserted, the designer of decorative art must actively consider the general use of the object being created, as well as the specific class of actual users. This calls to mind one of the great transcendental first lines in literature, by Gertrude Stein: "I write for myself and for strangers," by which Stein emphasized the reader's importance in the process of making meaning. So, too, for Rohlfs the specific requirement of the user was crucial in considering the design of an object of decorative art. He implied that this guiding principle led him to a position of special competence and sensitivity in understanding his clients' needs.

Rohlfs connected his artistic furniture enterprise to the hallowed mobile temple that Moses constructed for the worship of God, according to the structure shown to him on Mount Sinai.[2] Rohlfs defined great design as useful, well planned, beautifully executed objects of decorative art imbued with spiritual power. Domestic objects that endure—stand the test of time and use—and prove visually attractive and intelligently composed are more than good design; they are inspired, spiritual objects with the power to change the lives of those who live with them.

Rohlfs was eager to distinguish his decorative art efforts from those of his contemporaries, complaining that they "have erred and strayed," following trends, creating mass-produced, machine-made furniture to fill large homes with uninspired and ill-made objects. The price of bad design, Rohlfs suggested grandiloquently, is nothing short of our "immortal souls." As an alternative to this empty model, he suggested that we seek a design scheme that would replace homes designed to establish the standing of individuals with homes where individuals could represent themselves with objects of good design. Rohlfs even suggested that if the domestic environment is lacking, so, too, the individual may be lacking, for "representation through our surroundings is only approximate, but even so the false and true are almost in

OUTLINE FOR RAISED PANEL

6.2

6.1 Charles Rohlfs in his workshop with George Thiele, wood-carver (far left), and Roland Rohlfs (right), ca. 1901–1902. The Winterthur Library.
6.2 Charles Rohlfs, "Outline for Raised Panel," in *House Beautiful*, February 1901.

the great artist found himself, but even in the cruder buildings, said Rohlfs, are the touches of the rugged strong artistic hand of the master."[21] Rohlfs spoke of Richardson's Trinity Church in Boston, suggesting that it had combined all things beautiful and, chief of all, feeling.

AT CHAUTAUQUA

Rohlfs turned his attention to the American Arts and Crafts Movement in addressing an interviewer in Chautauqua, New York, on 14 July 1902.[22] In distinguishing his philosophy from that of his western New York contemporaries, including Gustav Stickley and his *Craftsman Magazine*, and especially Elbert Hubbard and the Roycrofters of East Aurora, Rohlfs claimed not to be a "reformer." Rohlfs exaggerated his naïveté in this context, claiming, "My ideals are so absolutely beyond my reach, that I seldom talk of them in their utmost scope." Here he is playing rather less introspective than previously, unless this is taken as parodying, for example, the often indecipherable ramblings of Stickley and, particularly, Hubbard. Rohlfs suggested self-effacingly, "My aim is to develop myself, not that I am worth developing." He then immediately contradicted this, saying, "Ideals are a necessity and they are my only school." And a sentence later, "I know nothing of schools, and after all, it is feeling that is the essential."

These rambling answers to the questions of his interviewer, Grace Pierce, may have been meant to mock the Arts and Crafts Movement's obsession with pat answers to deep questions and well-developed theories of the importance of decorative art and interior design to the well-lived life. Alternatively, they may simply indicate that Rohlfs was unsure of his position, conflicted between aesthetic concerns and those with deeper social and moral meaning. He seems to have been more sincere and on better logical ground when he suggested that what is essential in his art form is forging a union between facility and feeling. More generally, Rohlfs suggested, again perhaps mockingly, since his production was small in quantity, that "the Arts and Crafts movement of today is doing a great work, making it gradually possible for us to produce things that are responsive to the growing desires of the people." Though for obvious reasons Rohlfs attempted to bring his thinking and way of working on furniture into accord with the popular Arts and Crafts mode, his words here ring rather less true than the impassioned rhetoric discussed earlier.

Rohlfs delivered a more sustained account of the Arts and Crafts Movement and his endeavors in artistic furniture in his "Address to the convened Arts and Crafts Conference," also in Chautauqua on 14 July 1902. In the interview, Rohlfs had hinted at the country's general lack of fondness for the Arts and Crafts Movement, its ideas and its wares, and he opened this address by suggesting that "there have been those who sneer contemptuously at the arts and crafts people."[23] This comment is fascinating because it gives a rather different impression from Stickley's *Craftsman Magazine*, which at the same moment would have had us believe that Arts and Crafts was sweeping the nation, signing up subscribers by the bushel and furnishing full interiors far and wide. As a member of the western New York furniture-making community, Rohlfs was well aware of Stickley and Hubbard, but he shared neither their tendencies toward mass production (in Stickley's case, of furniture, and in Hubbard's, metalwork) nor their desire to cloak commercialism in a mantel of domestic design reform and good living.

Rohlfs admitted to being both an "amateur" and an "enthusiast," which suggests that though he was trained in engineering, mathematics, and drafting, these were not the skills that, for him, accounted for his success. He explained what he saw as the parallel contributions of amateurs in photography: "Once we had amateur photographers, who increased in number while photography as a commercial enterprise was at a standstill. It was the amateur photographer who has forced art into photography, and has given to the

6.10 Henry Hobson Richardson, **Buffalo State Hospital,** 1869–1880. Undated photo. The Buffalo and Erie County Historical Society.

6.10

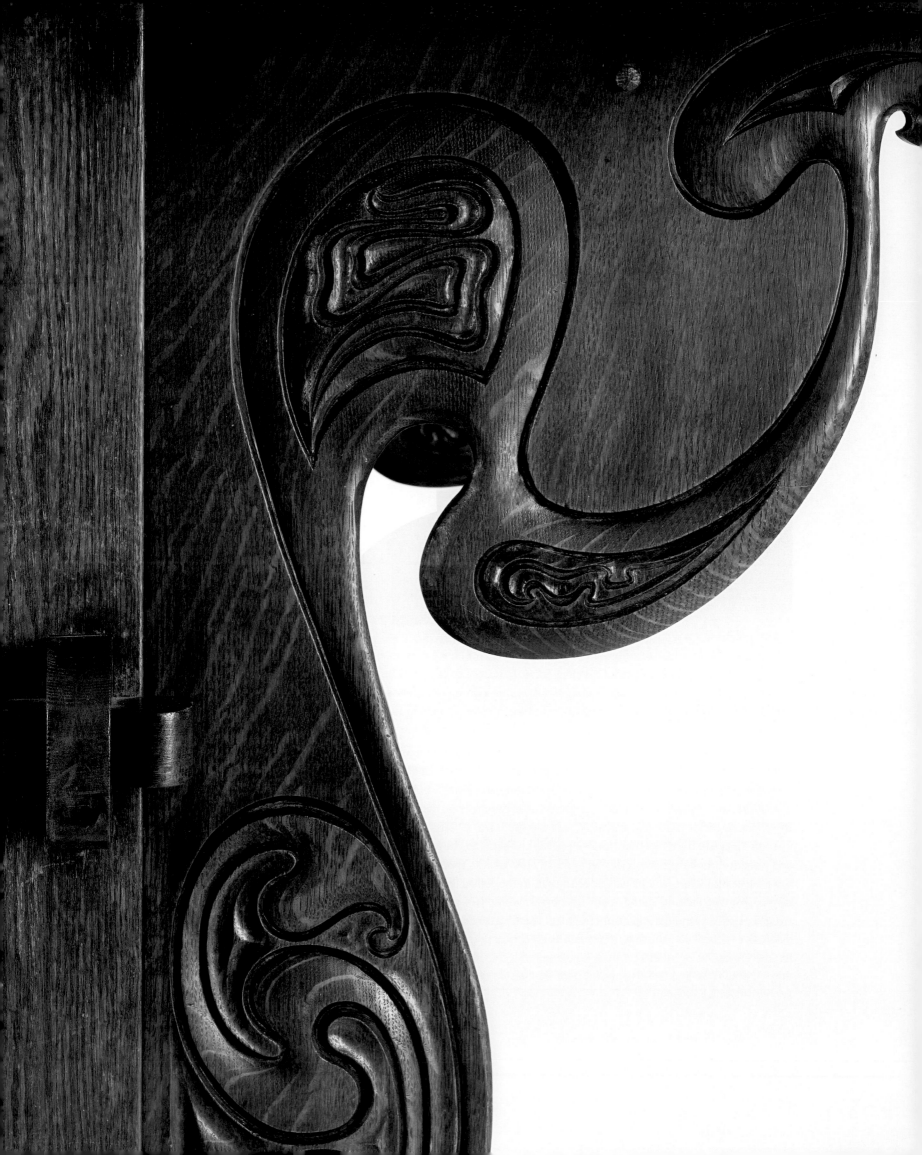

CHAPTER 7

A NEW ART AND A NEW ARTIST

Following the success of the first sustained account of his work in *House Beautiful* in January 1900, Rohlfs was the focus of local attention in April 1900, when the *Buffalo Courier* ran an article called "Artistic Designing of House Furniture," describing a "Visit to Charles Rohlfs Designer" and offering a glimpse of "His Shop and His Work." Not unlike journalist Charlotte Moffitt of *House Beautiful*, the author, Lola J. Diffin, had considerable trouble finding "master wood carver" Charles Rohlfs, whose shop she came upon "purely on accident."[1] Rohlfs seems to have been cultivating the persona of the aloof genius in a white linen coat and slouch hat, working tirelessly at his art while eschewing the niceties of an accessible shop, let alone a fancy display. "Mr. Rohlfs has no showroom; he doesn't need any; his work is not of the kind that needs a display window to sell it." Suddenly appearing, the vision of gracious hospitality, at the end of the path of bicycle, livery, and other shops, and the famous elevator ride upstairs, Rohlfs swept interviewers off their feet before setting them down on the seat of one of his genius designs.

Rohlfs, the production in his workshop, and his furniture designs were all thought sensible by Diffin. Useful objects were constructed intelligently in the rear of the shop, while staining was done in the little room at the front. An artist with words as well as with the carver's tools and saw, Rohlfs was an impressive host, ready to speak on anything from his designs to his labor practices to wider political and moral topics. Part of the experience of buying the Rohlfs furniture was the entertainment provided by the retired actor turned furniture-maker. More than a character study, the article gives valuable information about his artistic practices and how he developed designs, in his mind, on paper, and with wood. Although the Rohlfs furniture might appear improvisational to some extent, each piece was in fact carefully thought out: "A pattern is made [for each object] and it is carefully looked over and criticized, and if wrong, there is time to make another and to make that one right."

Regrettably, almost none of Rohlfs's preparatory drawings are extant. Though sometimes a number of drafts were made of each form Rohlfs executed, all but a handful have been lost, likely at his death or later. In the case of the interior sketch from the *Decorator and Furnisher* (see chapter 2), little can be understood about Rohlfs's design or construction methods from the forms shown, since the sketch was drawn by Rohlfs after the objects were executed and became part of the family furnishings. For these reasons the survival of a single drawing of a significant object is compelling. A library table made in 1898 or 1899 provides important insights into Rohlfs's process as a designer of decorative art. As Diffin suggested, "When the plan is right, the rest is easy and things seem to grow in the night there."

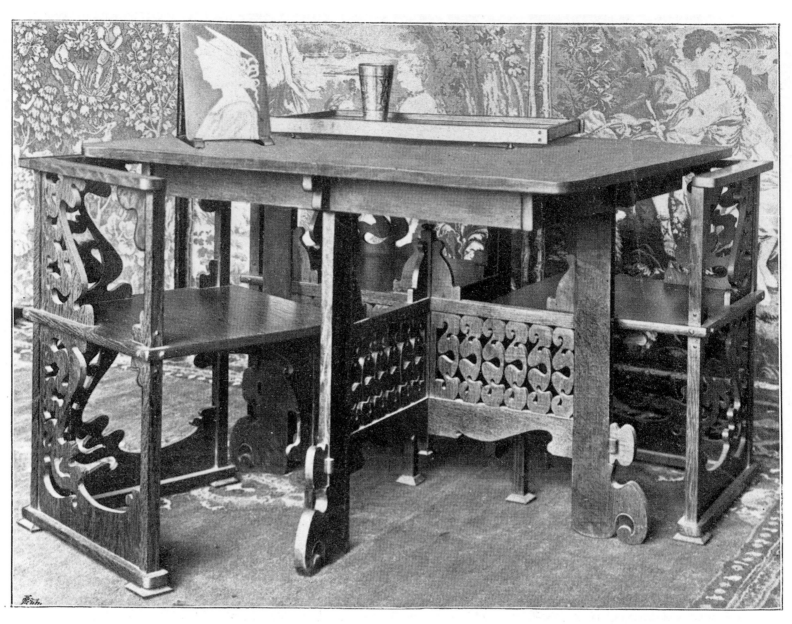

7.4

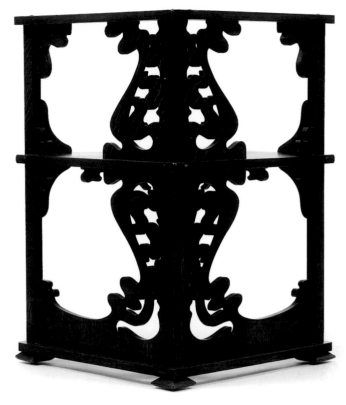

7.5

Likely in 1898 or 1899, Rohlfs created a fascinating table and four chair set, which was illustrated in 1901 by *Dekorative Kunst* in its coverage of Rohlfs's participation at the Pan American Exposition in Buffalo (fig. 7.4). Probably based on Chinese and Japanese designs for interlocking chair and table forms, this general form was beginning to play a role in Viennese design, especially in the work of Josef Hoffmann and Koloman Moser. Though there is no direct evidence that Hoffmann or Moser based their designs on Rohlfs's *Table and Chairs*, it is tempting to speculate that the coverage of Rohlfs's work in the German design press might well have influenced the Viennese models for interlocking table-chair and desk-chair forms.

The table that provides the top of the boxlike *Table and Chairs* construction is largely traditional, but Rohlfs ingeniously placed its four legs at the midpoints of each side of the table rather than at its four corners. The table's shaped legs are joined by cruciform cross stretchers, pierced in a repeating fretwork pattern. The table's four corners remain empty, which accommodates sliding the four *Corner Chairs* entirely under the tabletop. Rohlfs's inventive design adds decoration to the screened cross-stretchers and brilliantly employs fretted patterns to create positive and negative spaces that reveal and conceal themselves as one moves around the table. Though the table itself may no longer be extant, analysis of two surviving *Corner Chairs* from among the four provides an excellent sense of Rohlfs's methods and aims in this complex design (fig. 7.6). Each *Corner Chair*'s basic square framework provides structural stability and fits perfectly under the companion table, so that when all four chairs were slid under the table, the *Table and Chairs* ensemble formed a box with elaborate fretwork.

7.4 "Table and Chairs," ca. 1898–1899, in *Dekorative Kunst*, 1901.
7.5 *Corner Chair*, back view (see fig. 7.6).

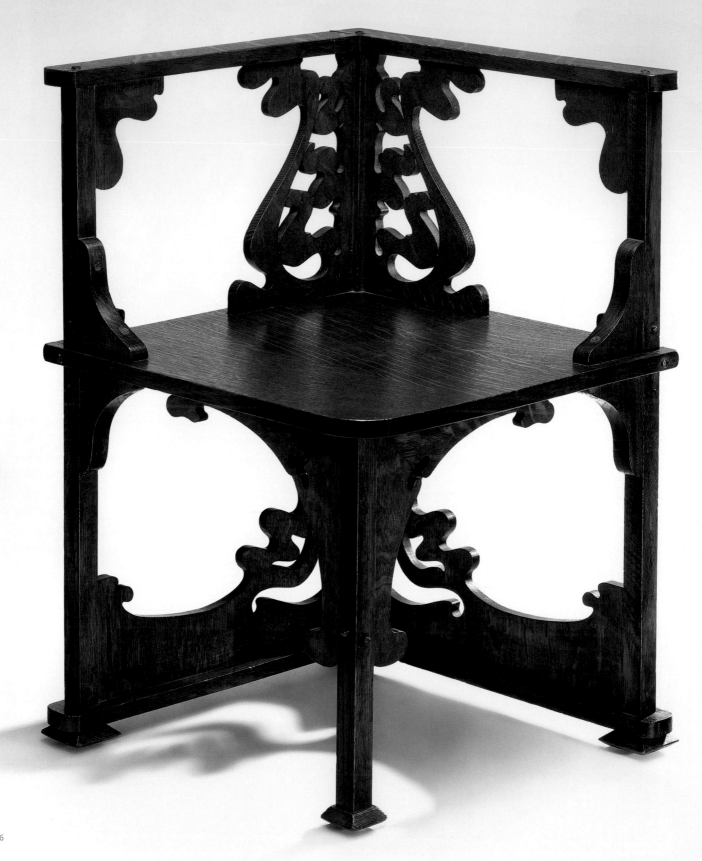

7.6

Standing alone, each of the four *Corner Chairs* in the *Table and Chair* set puns openly on the American and British traditions of corner chairs, which were popular throughout the seventeenth, eighteenth, and nineteenth centuries. Though at first seemingly symmetrical, each *Corner Chair* employs a variety of fretwork designs both above and below the inset seat, enlivening the overall form while providing undulating patterns of screening around the table. The *Corner Chair* sits on four faceted trapezoidal feet, which Rohlfs frequently used, attached to the three rear legs and diminutive arched front leg. The visual effect of the *Corner Chair* stems most directly from its complex interrogation of perspective. Seen from either the front or rear center view, the *Corner Chair* features a central scrolled fretwork passage, which, though angled because of its placement at the back corner of the seat and framework, appears two dimensional (fig. 7.5). The inventive manipulation of Victorian fretwork designs, not unlike the decoration on Anna Katharine Green's writing desk, made by Charles around 1897, gives the *Corner Chair* a sense of forward-looking modernism while grounding it solidly in the nineteenth century.

7.7

Two large open spaces near the base of the *Corner Chair* give rise to billowing ribbons and folds of pierced oak, which ascend its center post, meeting at its seat with a mirrored image above, which is a variant of the lower portion rather than an identical match. Small moldings placed around its framework provide stability and echo the central design motif's curved and lobed forms. Unified in its design, the *Corner Chair* playfully disrupts our expectations of such forms, resetting them within the harmony of its own fully resolved design, as well as in the synthesis, in form and function, of the table and chair set.

In 1900, Rohlfs executed another cube-shaped chair with decorative fretwork, which was first shown in 1901 in *Art Education* (fig. 7.7). Although this *Cube Chair with Medallions* has a similar structure to the *Corner Chair*, it is considerably more forward-looking in its austere framework and abstract ornamentation. Both chairs are constructed with a spare framework of posts and lintels that unite to form the overall box composition. In the *Cube Chair with Medallions*, the sitter has been placed back into phase, with a backrest and right and left armrests all at the same height. Central to its design are three large oval medallions, supported by a vertical framework, that adorn the three semiclosed sides of the design. These elements give the *Cube Chair with Medallions* decorative interest while creating a sense of opacity and space within the structure, not unlike the effect of the positive-negative spaces of the enclosure created by the four *Corner Chairs* pushed under the table just examined.

In the *Cube Chair with Medallions*, the extremely thin post construction conveys a severe sensibility that stands among Rohlfs's earliest truly modernist forms and calls to mind Gerrit Rietveld's works with post frames, some thirty years later. Rohlfs's strange decision to employ seven feet at the base of the chair harks back, rather like the *Corner Chair*, to the nineteenth century. The Rohlfs design can be closely tied to a Josef Hoffmann design for a 1902 settee and circa 1905 armchair, complete with a similar framework construction and large ovals decorating its sides.[4] The structural and stylistic connections here make it highly likely that the Rohlfs chair influenced the development of Hoffmann's famous models. Less modern in their decorative quality are Rohlfs's wondrously composed ovals, which consist of four separate half-lunette formations joined to the framework of the chair's sides and back. Simple whiplash designs, in the hands of Charles Rohlfs, spin outward in Sullivanesque ribbons of intricately interlocking arcs and curves. A study in both restraint and exuberance, the *Cube Chair with Medallions*, at least one example of which is extant, helps us to understand more about Rohlfs's early chair designs and sets up our analysis of a very different rocking chair, the correct date of design of which can now be established.

7.6 *Corner Chair,* ca. 1898–1899. Oak, 28 ⅞ × 19 × 19 in. (73.3 × 48.3 × 48.3 cm). Dallas Museum of Art. Promised gift of American Decorative Art 1900 Foundation in honor of Joseph Cunningham.
7.7 *Cube Chair with Medallions,* ca. 1899, in *Art Education,* January 1901.

7.24

7.25

7.26, 7.27

7.28

to swing or otherwise move.[13] Complete with weighty oak interior drawers, internal metal index card mechanisms, and a suspended row of cubbyholes accessible via a clever system of small sliding doors, the gallery cabinet was monumental. Given the strange inclusion of a microscope atop the upper cabinet (shown in the circa 1901 photograph) and the copious drawers for research materials, specimens, and the like, the *Desk with Overhead Gallery* might have been commissioned by a doctor, scientist, or other researcher.

Unfortunately, the large gallery case proved unsupportable in its original configuration. It was simply too heavy for the slight sideboards that supported it.[14] At some point, these sideboards either snapped or weakened, and they were apparently replaced and the structure was reengineered to support the gallery with less inventive, hidden joinery rather than the original chains.[15]

Faced with the problem of supporting the gallery cabinet, someone retrofitted the desk so that the horizontal boards that supported the gallery are secured to the posts, added internal tongue-in-groove joinery that anchors the sides of the gallery to the posts, and secured the top board of the gallery to the posts.[16] The chains now hang loose, completely nonfunctional, a vestige of the original design, a mere decorative device. Although disappointing in their uselessness, these elements do visually complete the design almost as Rohlfs intended.

A complete account of the structure of the *Desk with Overhead Gallery* would not be possible without the survival of the only other known version of a Rohlfs desk with suspended gallery, which heroically succeeds in suspending its cabinet from two posts, as intended in the original circa 1899 design. Rohlfs was brave enough to give this form another try in 1904, possibly aware of the structural instability of the earlier model. This *Desk with Suspended Gallery* (see chapter 10) is far less fantastical but succeeds in hanging a significantly smaller, less massive gallery case from chains suspended from the vertical posts down to the support boards below (fig. 7.29). Although Rohlfs may not have had the training or skills of other Arts and Crafts cabinetmakers, his inventive mind and perseverance allowed him to improve on and remedy earlier designs.

The *Desk with Overhead Gallery* exhibits a green finish that likely matched the finish of the *Library Table* when they were originally made for the same buyer.[17] Again, Rohlfs may have applied this color to highlight the elaborate ornamentation scheme or to lighten the appearance of the massive form.

Proof of Rohlfs's creativity and skill as a furniture designer and wood-carver, the carving in the *Desk with Overhead Gallery* also reveals the influence of late nineteenth-century German design on the development of his patterns of ornamentation. First, note the remarkable similarity, as shown here, between the decorative motifs adorning the front surface of the sets of drawers in the lower cabinet and examples of pattern designs from *Dekorative Vorbilder* (figs. 7.24, 7.25). Charles and Anna Katharine may have purchased a copy of this influential book when they visited Munich in 1890, the year it was published there. In this catalogue of late nineteenth-century German patterns, we can observe the precedent for Rohlfs's method of stylization of floral and vegetal imagery as well as similar explorations of symmetry, geometry, and semi-abstract composition. Although Rohlfs's use of such patterns of repeated imagery is perhaps significantly advanced beyond these European design books, the precedent for these stylized vegetal and floral elements is clear. The bilateral vertebral motif that is repeated thrice in the side panels of the cabinets (fig. 7.26) can also be traced to *Dekorative Vorbilder* (fig. 7.27) and to the similar "Sacred Tree from Nimroud" motif in Owen Jones's *Grammar of Ornament* (fig. 7.28). A variety of centrally bifurcated vertebral formations recur in Rohlfs's work, perhaps reflecting his desire to represent the human form in his decorative carvings and piercings. This is perhaps nowhere as clear as in his 1902 design for a wall shelf (see fig. 9.16).

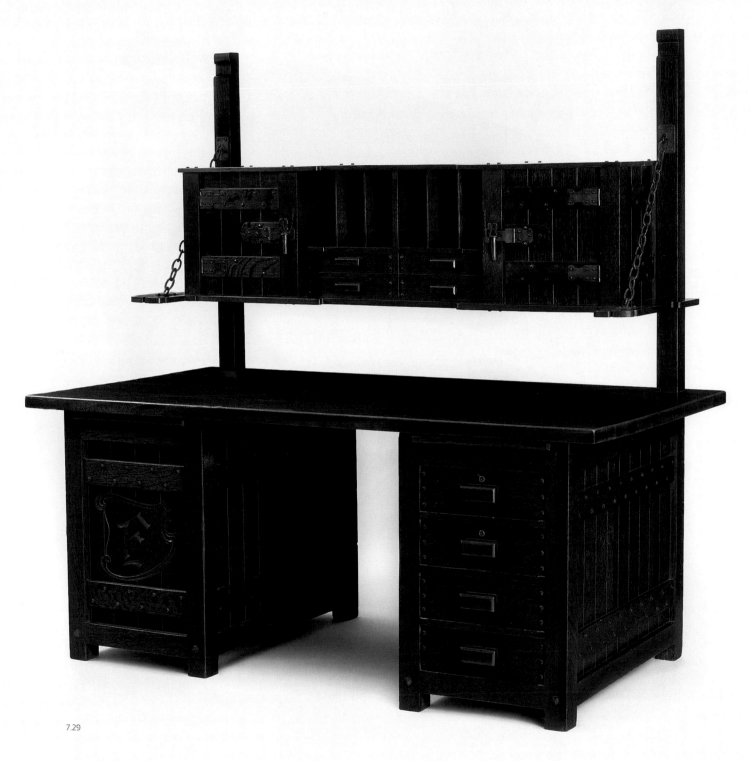

7.29

7.29 Desk with Suspended Gallery, 1904.
Oak and copper, 71 ½ × 70 ¹⁵⁄₁₆ × 36 ⅜
in. (181.6 × 180.2 × 92.4 cm). Private
collection.

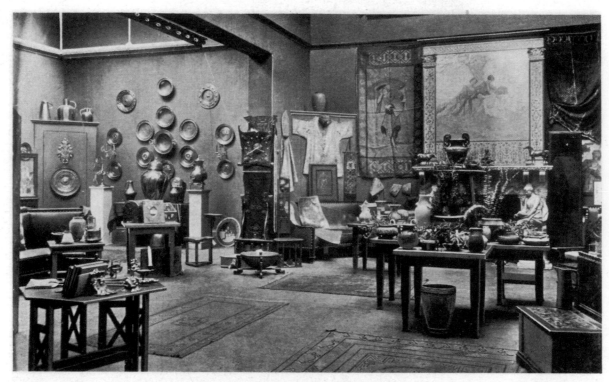

GALLERIES, NATIONAL ARTS CLUB
Arts and Crafts Exhibition

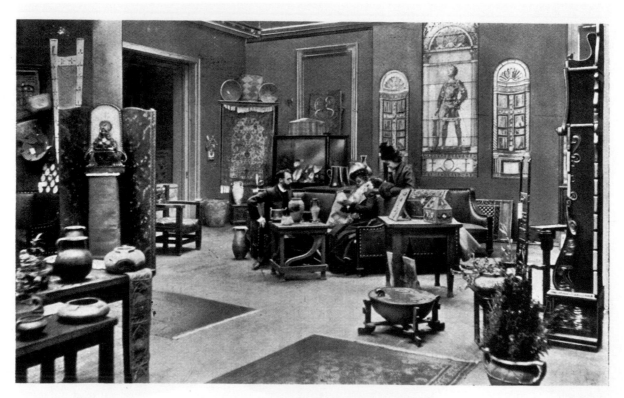

GALLERIES, NATIONAL ARTS CLUB
Arts and Crafts Exhibition

on the back of the lowest left proper carved panel. A severe and modernist form, the *Folding Screen* may have influenced Stickley's development of a line of simply shaped folding screens beginning in 1902.[19]

The *Folding Screen* features an extraordinary vegetal or floral motif extending from the base to the crest of each of the four panels which is not known on any other work by Rohlfs. Beginning at the foot of the screen, we can follow from the roots up through the first coiled leaves to a pair of elongated leaves rising up toward the first stem node. Above, we can continue up through more leaf systems, arriving at the crest panels, which unify the upper register, blossoming elegantly at the apex of each column. This object was singled out for recognition in 1912 when Sadakichi Hartmann referred to "the beautiful four-leaf screen that attracted so much attention at the National Art Club exhibition, New York, where the repetition produces a fascinating tapestry effect."[20] The design is not so much the stylization of an actual flowering plant—after all, what known species could offer such interpretable variety in leaf, stem, and bud—as Rohlfs's union of elements from varied plants and flowers. This design motif, certainly drawn in advance of the *Folding Screen*'s execution, is the stylization of a fantastic flowering plant from the designer's imagination. Free to explore nature and composition at the same time—this is Rohlfs at his best.

THE NATIONAL ARTS CLUB

Charles Rohlfs finished 1900 on a high note, participating in the first "Arts and Crafts" exhibition of the National Arts Club in New York, held between 28 November and 19 December. This exhibition, also a "House Warming for the Clubhouse Extension," included "Artistic Furniture, carved and stained," by Charles Rohlfs.[21] The Rohlfs objects, listed on the official entries, were:

1. Clock Case
2. "Smokers" Chair
3. Wood Box
4. High-back Chair
5. Two Frames of Photographs [meaning "with photographs"]
6. Strong-box of carved wood, Natural Color

We can identify several objects from two period photographs showing the galleries of the National Arts Club, Arts and Crafts Exhibition (fig. 7.35).[22] The Clock Case is the fantastical form that Rohlfs exhibited at the Pan American Exposition a few months later and ultimately donated, in an altered form, to the Automobile Club's Country Clubhouse in Clarence, New York (see fig. 8.12). The "Smokers" Chair, which would later be featured in some of Rohlfs's commissioned interiors, is a peculiar model with a large post leg at the front of a shaped seat, which the sitter is meant to straddle, complete with hidden ashtrays below the crest. Based on the photograph, the wood box was his coal hod form (see fig. 5.10), and the high-back chair was his *Hall Chair* form (see fig. 4.9). The three small objects can be identified sitting on a table by Joseph McHugh.[23] These six objects marked Rohlfs's entry into a world of art and furniture that set the course for his triumphant participation in the Pan American Exposition of 1901 in his hometown of Buffalo.

7.35 Arts and Crafts Exhibition, National Arts Club, New York, November–December 1900. National Art Club records, 1898–1960, Archives of American Art, Smithsonian Institution.

CHAPTER 8

THE CITY OF LIGHT

By 1901, Charles Rohlfs had come remarkably far in the four years since he took up the design and production of decorative arts as a profession. Conversant in a number of international styles—with tendencies toward prototypical versions of American Arts and Crafts approaches, as well as the fashionable *L'Art Nouveau*—Rohlfs adhered above all to his personal vision, even when it cost him immediate recognition from critics. His radical creativity and extraordinary imagination were robustly expressed in his signature designs from the high period of his furniture production between 1901 and 1904. During these years, Rohlfs was concerned both with unique creations and with the production of small lines of exemplar furniture, but never in numbers like his 1898–1900 production of the *Rotating Desk* and *Hall Chair* known as the "Graceful Writing Set."

A destructive fire in late 1900 led Rohlfs to set up a new, larger operation at 198–200 Terrace by January 1901, installing Horace Taber, from nearby East Aurora, as the head of a small staff working the machinery in the shop, joining cabinets and finishing pieces.[1] That month the trade journal *Art Education* featured Rohlfs's work in an article entitled "Furniture: Designed and Made by Charles Rohlfs." This volume of the "magazine devoted to art as an essential element of education, industry and general culture" likely featured Rohlfs in conjunction with its coverage of the Art Students' League of Buffalo. The article, though short and unsigned, includes many illustrations of Rohlfs's ingenious 1899 and 1900 designs. The author opened by reducing Rohlfs's essential concerns to their foundations: "Strength through good material and good workmanship is the first impression I received from the furniture of Charles Rohlfs, of Buffalo, N.Y." Echoing the clear preference among period critics for simpler, more refined forms that made Gustav Stickley, the Roycrofters, and Frank Lloyd Wright successful, the author continued, "So strong was this impression, gained no doubt from the simpler pieces, that I went hunting through the others for the same quality, and found it always, no matter how intricate, apparently delicate or whimsical the article appeared."

Signature among these bold, austere designs is the *Cube Chair* (fig. 8.1). Composed on a framework of massive, almost brutish, octagonal legs and post arm supports, with pierced inset screens, the *Cube Chair* represents a heavier reinterpretation of the fretwork models examined in chapter 7. Although the *Cube Chair*'s post-and-lintel framework structure recalls the *Cube Chair with Medallions* and *Corner Chair* models, its bold members and overall mass relate more closely to the *Rocking Chair*. Its faceted octagonal legs recall the *Ladder Back Chair*, though the apron of the *Cube Chair* is considerably simpler than on that model. The more

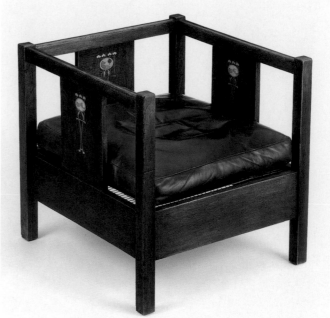

8.1

8.2

restrained treatment of the skirting under its seat increases the overall density of the *Cube Chair* through its integration with the simple cubic geometry. Carefully beveled armrests and beautifully rounded cap finals and pillow-hanging posts, along with the elegantly stylized mushrooms that ascend the fretwork screens at the sides, foil the overall rectilinearity of the chair. Ultimately a study in restrained geometric patterning, the *Cube Chair*, a compact object of utter solidity, is a frame for the subtle interplay of positive and negative spaces created by the decorative mushroom motif and the elongated teardrops outlined by it.

In 1903, Stickley introduced a sophisticated line of inlaid furniture, including four different seating forms that were each composed of an open post-and-lintel framework set with slats inlaid with copper, pewter, and fruitwoods. As shown by David Cathers, one of the settles was derived directly from a Mackay Hugh Baillie Scott inlaid settle. Rohlfs's *Cube Chair* may have inspired Stickley and his designers to adapt the inlaid settle to a chair form, which is the most elegant and modern of their inlaid seating forms (fig. 8.2).

The article cogently analyzed the work: "Mr. Rohlfs's furniture may be studied from two standpoints; or, it may be divided into two classes: one, dependent for beauty upon structural design almost solely; the other, upon ornamental fully as much as upon structural design." This central insight regarding two distinct strains of Rohlfs's work is critical to discussions of his decorative art. As I have suggested, in pieces that depend for interest largely on their formal qualities or structural design, "there is always excellent material, the finest workmanship and beautiful proportions." With words likely provided by Rohlfs, the author suggested that Rohlfs's sensitivity to proportion yields the sophisticated silhouettes and carefully proportioned negative spaces that give these objects such unusual character.

Likely referring to the *Table with Scroll Decoration* discussed in chapter 2, and echoing both Clemens and Rohlfs, the author notes how the overall design for the shape of the table and its undersupports provides "the whole ornamentation." The unity of decoration and structure in

8.1 *Cube Chair*, in *Art Education*, January 1901.
8.2 Gustav Stickley's United Crafts, Inlaid Cube Chair, 1903–1904. Oak, fruitwoods, pewter, and copper, with replaced leather and upholstery. Private collection.

these cases demonstrates the power of Rohlfs's design vision. At his best, Rohlfs is able, in the second category of decoration, to unite "ornamental design" with "structure," yielding objects that are "more elaborate, often ornate, sometimes whimsical, but always beautiful."

Rohlfs again sought to downplay his role as a craftsman in favor of focusing the journalist's attention on his role as a designer. Acknowledged as a master craftsman in both wood and metal, Rohlfs the designer is privileged over and above Rohlfs the artisan in this article. Though Rohlfs was, as we have read, openly committed to the dignity of his labors and the honor inherent to great craft, here he placed emphasis on design, perhaps as a direct result of his lack of formal training. Rohlfs may also have wanted to shift the emphasis of his role from craft to design because he had hired employees whose work seems to have been limited to craft, with Rohlfs always leading the team as designer.[2]

A shameless self-promoter, Rohlfs was notably harsh on those who did not immediately grasp the importance of his work. Speaking through the unnamed author in *Art Education*, he claimed, "It is [design] originality that the American public—her public of millions—appreciates so little in work and especially in work like this. For this reason they cannot put the true value on it." Clearly, although some forward-looking furniture buyers of Buffalo and other cities were embracing Rohlfs's creations, his furniture was not everyone's cup of tea. A number of objects that appear in early period photography but which seem not to have survived, can be located in later period photographs of Rohlfs's home. This suggests that these pieces were made as prototypes, and when they failed to sell, Rohlfs simply brought them home.

Not content with secondary recognition for his works, Rohlfs and his reviewer liken him to the artist who "paints a picture that is beautiful and entirely in his own way—color harmony, line arrangement, form—his own composition." This artistic expression, they claim, is the kind to which Rohlfs aspires, in the way that his furniture is not a mere "next chair" or "next table" along the history of design but a new move, a new personal expression: "a price is placed upon [a certain painting] that is never placed upon a picture, no matter how beautiful, painted in another person's way." Note the emphasis on price, likely a central issue in Rohlfs's challenges to sell his work. His furniture was often much more expensive than mass-produced objects, including Stickley's highest-quality Craftsman furniture.[3] As a result, his works seem to have sold unevenly, especially from 1897 to 1900, when he was relatively obscure.

The article makes an astute comparison, repeated in Leslie Bowman's later discussion of Rohlfs's work in *Virtue in Design*: "As to structural design in this furniture: there is nothing very extreme. The wild whirls of *l'art nouveau* have not entrapped Mr. Rohlfs." The critic Sadakichi Hartmann made a related point in 1912: "His work at times reminds of the *art nouveau*; but he has little in common with that willful style, as he is dependent not so much on suggestions from natural as on architecturic forms."[4] This important insight regarding the overall simplicity of many of Rohlfs's case pieces, chairs, tables, and other forms is often lost on those who lump Rohlfs into the Art Nouveau style or movement. By and large, his structures are plain, using simple geometric shapes to create the overall silhouettes, even when elaborate flourishes of carving are used. The *Art Education* article suggested that limiting himself to contained decoration in the form of panels, medallions, and the like gave Rohlfs more freedom of expression than applying ornament more generally to the overall structures of pieces.

Rohlfs's use of metal is also mentioned in the article. His ability to fuse metal and wood seamlessly set him apart both then and now. Handcrafted "clasps, locks, hinges and handles" seem to have impressed his reviewer as much as the metal bases of his chafing dishes, which were to win him much popularity. Integration of materials is a trademark of Rohlfs's design vision and execution of objects: "The design of the wood plays about with the metal and holds its own, always, with it."

8.3

Despite hiring employees and receiving increasing recognition for his work, Rohlfs was slow to develop new forms and to produce inventory for the few pieces he made in multiple throughout 1901. As the noted European design critic Clara Ruge reported in 1902, he usually employed fewer than five workers, and production on these pieces was slow and meticulous.[5] Many workers came and went, often training under Rohlfs and Taber and then taking on new work in various other artistic enterprises.[6] Sketching ideas as they came to him "from a chance word here, a thought there, a necessity, perhaps," Rohlfs would sift through design possibilities, eventually arriving at a detailed delineation of each piece.[7]

Thus, it is not surprising that relatively few new pieces of Rohlfs furniture are shown in the *Art Education* article. There are images of some of his favorite pieces, including the *Hall Chair* from the "Graceful Writing Set," the *Cube Chair with Medallions*, the *Cube Chair*, the *Log Holder*, all featured in earlier articles, and the *Linen Chest* examined earlier. One novel object was the "Revolving and Folding Music Stand and Holder," whose name betrays a level of convolution that was unfortunately characteristic of Rohlfs's less successful early works.

Two important pieces introduced in this article are the *Folding Screen* and a dramatic canopied *Bed*, which is related to the *Desk Chair*, the design of which we earlier attributed to Anna Katharine Green. An original period picture of this *Bed* (fig. 8.3) descended through the Rohlfs family and exhibits nearly identical markings to the period photograph of the *Desk Chair*. The *Bed* was significantly altered soon after it was shown at the Pan American Exposition and is not known to exist today.[8] The markings on the reverse of the photograph include the model number "32," the price "$350" (the highest documented price for a Rohlfs object), and the words "Anna K Rohlfs." The price indicates that the *Bed* was meant for production and that it was not a "one-off" design meant for Anna Katharine but rather one designed with her input. Its panels of carved wildflowers can be compared to the sinuous tall-stemmed variety shown on Anna Katharine's book *Lost Man's Lane*, published in 1898 (fig. 8.4). This cover, which Charles, Anna Katharine, or the two together likely designed, reinforces our understanding of their collaborations on graphic and decorative art motifs.

This *Bed* is the only clearly identifiable Rohlfs object shown in period photography of the Pan American Exposition.[9] It would make perfect sense that with the burdens of furniture production, moving his workshop, and managing employees, Rohlfs may have sought the design assistance of his longtime partner. Near the bed can be seen a sliver of what is likely to have been a low chest of drawers with mirror, featuring some of Rohlfs's most innovative and virtuosic carving (see fig. 10.32). This *Dresser with Mirror* was known in the Rohlfs home through the 1930s, though its whereabouts are currently unknown. Having taken both high-priced objects to the well-trafficked Pan American Exposition, Rohlfs was unable to sell either.[10]

THE PAN AMERICAN EXPOSITION

The Pan American Exposition was a national phenomenon. Now best remembered for the assassination of President William McKinley, the exposition was Rohlfs's first real triumph on the national and international stages. As was noted in *Art and Decoration* in 1901, in addition to showing a number of his works in his own booth, "the noted designer" Rohlfs was "engaged by a number of leading firms to design their booths at the exposition."[11] As later critical assessments of Rohlfs's work would note, Rohlfs apparently had considerable interest in architecture and the creation of architectural facades.

Though we have few details of Rohlfs's architectural contributions to the Pan American, we do know of related projects undertaken by the designer. Around 1902, Rohlfs created an "outdoor showcase" for the studio of the famous portrait photographer Elias

8.4

8.3 Charles Rohlfs and Anna Katharine Green, *Bed* with canopy, ca. 1900, exhibited at the Pan American Exposition. The Winterthur Library.
8.4 Charles Rohlfs, Anna Katharine Green, or both, Cover for *Lost Man's Lane*, ca. 1898. The Huntington Library, Art Collections, and Botanical Gardens, San Marino, Calif.

8.5

Goldensky at 1227 Walnut Street in Philadelphia (fig. 8.5). The structure features overall northern European detailing, including a faux shingled roof, triangular dormer, and massive strap hardware. The attached sign, not made by Rohlfs, exhibits typical German Art Nouveau styling and is hung from a wooden beam that features Rohlfs's signature carved terminal. In a later studio, Goldensky had a room called the Hall of Bohemians, where his friends would congregate for the "Five O'Clock Club" and "linger in the Rohlfs comfortable furniture and while away an hour or two in animated conversation."[12]

Although the only Rohlfs object shown in period photographs of the Pan American Exposition is the *Bed*, four objects shown in the brief mention of Rohlfs in *Art and Decoration* lead to a more general discussion of Rohlfs's participation at this important exhibition. A "Bracket, Designed and Made by Charles Rohlfs," is a lovely and useful object meant to descend from a picture rail (as repeatedly shown later in Rohlfs's home) to a shaped-panel backing, supporting a vase on its shelf.[13] This charming domestic object is the kind of simple decoration Rohlfs used extensively throughout his home. These brackets may have been made in large numbers and offered at the Pan American Exposition as relatively inexpensive souvenirs of the Rohlfs aesthetic.

Similarly utilitarian was the line of "Chafing Dishes" he developed around 1900 and continued to make throughout his career in various versions, two of which were first shown in *Art and Decoration*.[14] These six or so models featured metal and wooden bases with Belgian-made casseroles (fig. 8.6). In 1904, Rohlfs patented a model with a swinging lid, naming it "the Rohlfing dish," following the lead of critic Deshler Welch, who referred to it as such in 1902.[15] These claims of authorship and originality notwithstanding, the source of Rohlfs's inspiration

This valuable time-piece, designed and made by Mr. Rohlfs, was originally constructed as a feature of the Rohlfs exhibit at the Pan-American Exposition. It attracted wide attention and was instrumental in securing for Mr. Rohlfs an invitation from Dr. Roversi to exhibit in the Decorative Arts Exposition in Turin, Italy, in 1902.[17]

In addition to the works Rohlfs brought to show in his own booth (including the *Bed*), he was hired to create interiors for a number of other exhibitors.[18] Foremost among these efforts for other manufacturers showing at the exposition was his creation of a "Dutch Kitchen" environment for "a big milling firm in Cincinnati that wants a Dutch kitchen in which to display its flour and baked stuffs."[19] Rohlfs's Dutch Kitchen was apparently an enormous hit, according to the *Buffalo Morning Express*. A "busy man," "making numerous pieces of artistic furniture with which several manufacturers will display their exhibits at the Pan American," Rohlfs seems to have outfitted this elaborate booth completely, including designing a tile roof and floor and a Dutch-style fireplace "that will be the envy of every person who sees it." The overall blue-and-white color scheme was dramatized by the "dark red" fireplace and dark oak panels. Completing the domestic environment were brass and pewter candlesticks, cups, mugs, and platters, and "in one corner . . . an old-fashioned Dutch oven in which bread and rolls will be baked everyday by young women wearing Dutch costumes."[20] Rohlfs's theatrical design paired a dramatic palette with domestic hominess, kitschy antiques with high design. Although the details of the actual furniture used were sketchy, the article did mention "a high-backed oak seat made in true Dutch Style," a related table, and a "big candlestick, as large around as a barrel hoop and with sockets for a half a dozen candles that will hang in the center of the room."[21] A seat like this has been identified in the literature on Rohlfs, but it is not known whether this is the settle cited in the *Buffalo Morning Express*.[22] Also in the booth were Rohlfs's bellows, wielded by "young women in picturesque Dutch attire." The *Buffalo Morning Express* article also mentioned a visit to Rohlfs's studio, likely solicited by the self-promoting designer.

Although the exposition dominated Rohlfs's time and energy during 1901, he had some time for other designs. Notable is the excellent melding of use and beauty he achieved in his *Partners' Desk* (fig. 8.13). Featuring massive broad members and confident exposed tenon-and-key construction, this desk unites the practicalities of its use as office furniture with some of Rohlfs's most inventive structural and ornamental designs. This desk is restrained, yet exuberant, with a surface adorned by elegant, weblike carved ornament that articulates its form against its black finish. With its seemingly molten cascading carvings, the *Partners' Desk* stands among the most forward-looking of Rohlfs's compositions, evoking Victor Horta's seemingly melting Art Nouveau metal and plasterwork. The only known example of its form, the *Partners' Desk* was likely a commissioned piece.[23]

As with the earlier *Bench* and *Linen Chests*, the *Partners' Desk* exhibits one of Rohlfs's favorite decorative schemes—the adornment of side slats with intricate carved surfaces viewable only from the sides. The direct view of the desk from either of the two "front" perspectives is related to the massive yet simple forms of Gustav Stickley, whom the *Partners' Desk* may have influenced. In contrast, the sides showcase Rohlfs's ability to integrate elaborate decoration with the overall structure of the desk as well as its structural details, including the keyhole frets at the feet and the massive tenon-and-key joints featured twice on each slat side. Elegant side moldings just below the tabletop, a carved cross-stretcher, and Rohlfs's rare carving of the interior of the side slats set off the design with swirling systems of banded and arced carving that belie its simple structure (fig. 8.14).

8.12

8.11 *Chiffonier,* 1901, from the Rohlfs home. Oak and copper, 65 ⅜ × 31 ½ × 15 ¹⁵⁄₁₆ in. (166 × 80 × 40.5 cm). Princeton University Art Museum. Gift of Roland Rohlfs.

8.12 *Carved Clock,* 1900, exhibited at National Arts Club and Pan American Exposition. Oak with glass and clockworks, 102 × 30 × 15 in. (259.1 × 76.2 × 38.1 cm). Town of Clarence, N.Y.

8.13

One of Rohlfs's most inventive works of 1901 was his three-legged side table, which appeared in the press in 1902 in an article in *Woman's Home Companion*, modestly called a "Stand."[24] The overall structure of the *Stand* puns creatively on American and French Pier Table traditions, while its unusual carved motifs unite the kinds of decorative schemes on his best carved furniture with ornamental patterns that will play a significant role in the years 1902–1904 (fig. 8.15). The *Stand*, of which at least three examples are extant, was apparently useful and salable as a side table, appropriate as a pedestal for ceramic or metal objects, or for the type of wooden box Rohlfs showed on the table in period photographs.

Arising from a lobed foot, the *Stand*'s front leg is a solid, heavily carved board that tapers elegantly toward the joint at which the cross-stretcher pierces its center and swells again below this juncture to form the curved foot. The complex, yet elegantly integrated joint attaches the bowed stretcher, which pierces the front leg and notches around its edge. All these elements are locked structurally and visually into place by the large vertical pin, placed into the tenon-and-key formation at the center (fig. 8.16). The beautifully carved and inventively shaped stretcher and double-notched rear brace both feature scrolling carved ornament, including rarely seen interior surface carving, as on the *Partners' Desk*. The rear legs are intricately fretted and carved, though the stylized foliate pattern is backward-looking, almost Victorian, and seems out of place on an object so fresh in its design. Rohlfs's carving of the braces under the *Stand* and moldings on its sides integrate motifs similar to those on the *Library Table* of 1899, while in certain areas forecasting notable developments in Rohlfs's style. These soaring arcs and orgiastic bands of concentric and parallel-line striations give the *Stand* a disconcerting sense of motion and create the latent energy between opposing angles and wood faces that characterizes some of Rohlfs's best creations.

8.14

As one moves around to view the *Stand* head on, the tensions created at the sides are nicely resolved, coming to equilibrium in the stunning medallion at the front. This scrolling, notched composition relates to many of the highly symmetric, vertebral formations we have examined already. Of note is the integration of a Federal- or Colonial-style carved scrolling pattern, which arcs downward from the tabletop and then curves inward to form scrolled coils at the medallion's bottom. Though the central vertebral design and these scrolls dominate the ornament, the spadelike bulb descends down onto the front leg, grounding the medallion's decoration while also providing a downward focus, anchoring the *Stand* to its foot of similar shape. The tabletop itself is a complex shape, with flat-cut surface at its back for placement against a wall and arcing front lobes with carved articulation that tightens the overall structure, unifying the design.

As shown in 1902 with the title "Carved Box and Stand," the *Stand* was clearly conceived as part of a set. Only recently has an example of the carved box form intended to complete the set been located. The *Carved Box* shown here (fig. 8.18), though not identical to the one shown in *Woman's Home Companion*, is very similar and, given its dated mark, "1901," was likely made as a companion to an example of the *Stand* form we have just examined. Of simple overall composition, the variant model of the *Carved Box* shown in the period photo in 1902 and the extant 1901 model are both rather peculiar in shape and proportion. They are larger than standard jewelry caskets or humidors, and their intended function is unclear.

Both models are rectangular in shape, with trapezoidal beveled feet and a beautifully hand-mitered frame and inset carved panel in the lid. Elaborately carved panels form the sides, front, and back. On the model in the period photograph, the lid is fairly flat with elaborate carving, but in the extant model shown here, the lid features an elegantly raised, almost domelike lid with carved quatrefoil motifs (fig. 8.17) that relate to the carving on the *Coal Hod* discussed earlier (see fig. 5.12). Though the *Woman's Home Companion* model seems to privilege

8.13 *Partners' Desk*, 1901. Ebonized oak, 30 ½ × 60 × 36 ¼ in. (77.5 × 152.4 × 92.1 cm). The Huntington Library, Art Collections, and Botanical Gardens, San Marino, Calif. Purchased with funds from the Virginia Steele Scott Foundation.
8.14 *Partners' Desk*, detail.

CH. ROHLFS · SPEISENSCHRANK

SIDE BOARD Nº 901
HEIGHT 56." TOP 23"x 50"
BACK 40" IN HIGH

8.21 *Sideboard*, ca. 1901, in *Dekorative
Kunst*, 1901.
8.22 Gustav Stickley, **Side Board No.
901,** in Stickley, *Chips from the Workshops
of the United Crafts*, 1901.
8.23 *Carved Octagonal Table*, ca.
1900–1901, period photograph. The
Winterthur Library.

Turning then to the influence this *Sideboard* probably had on Stickley's development, in 1901 and 1902, of a line of sideboards and serving tables, we can identify at least two Stickley models that likely take their designs, or details of them, from this Rohlfs object. Nearly identical in overall form is Stickley's Model Number 901 Sideboard, first shown in "Chips from the Workshop" in 1901 (fig. 8.22). This model features similar feet, identical placement of two lower doors and two upper drawers, back- and side-splash gallery at the top, and virtually identical use of tenon-and-key revealed joinery. It is hard to imagine that Stickley was not thinking directly of Rohlfs's *Sideboard* when creating the Model Number 901. Similarly related is Stickley's Model Number 967 Sideboard, introduced in his 1902 Retail Plates.[27] In both cases, the influence of Rohlfs's design on Stickley's development of his earliest lines of furniture is manifest.

KUNST UND KUNSTHANDWERK

Charles Rohlfs again received recognition when Clara Ruge published her highly influential article "Das Kunstgewerbe Amerikas" in *Kunst und Kunsthandwerk* in March 1902. This extensive survey of the American designs at the Pan American Exposition included coverage of a variety of makers, including Tiffany and Company, Gorham Manufacturing, and three furniture makers, all from New York, Joseph McHugh, Gustav Stickley's "Eastwood Guild of Craftsmen," and Charles Rohlfs. Though Ruge complains that Rohlfs's presentation at the exposition was disappointing, she got a better sense of his creations when she visited his shop and "the cottage on Norwood Avenue in Buffalo," where she found "the man was revealed to me."[28]

"Plate stands" hung from moldings are shown at the edge of the one extant picture of the Pan American Exposition that shows a sliver of Rohlfs's booth. Ruge described them as "strips, which generally are affixed in dwellings in order to hang pictures from them with wire, thus avoiding having to pound nails into the walls."[29] Though she says nothing more about Rohlfs's work, the article is a treasure trove of pictures of objects that in many cases are not extant. These include a fairly simple side chair and bellows, which might have been part of the Dutch Kitchen installation, as well as the *Pan American Chiffonier*. Two other pieces possibly shown by Rohlfs in his display include an inventive and useful chest-over-drawer trunk with beautifully integrated carving on its front, sides, and top and an octagonal table with elaborately carved sides that is one of the most beautiful objects Rohlfs ever created, though not known to exist today.

The *Carved Octagonal Table* has a structure similar to Rohlfs's other octagonal tables (fig. 8.23). The octagonal tabletop is supported near each corner by a shaped leg that is angled to bisect the corner. As in his designs for other octagonal tables, slat side panels extend between the legs almost to the floor, with two of the contiguous side panels forming a door that opens to reveal interior shelves.

The *Carved Octagonal Table* is adorned with sublime carving, an organic motif of "Wild Honey Suckle" ascending each of the carefully shaped sides of the octagonal structure. Beautifully stylized root systems, encompassing the keyhole notches at the bottom center of each slat side, rise to a central stem, which in turn splits into three verticals. The two side stalks ascend through various lily pad–like leaf junctures and terminate in stylized buds that arc inward, while the central stem culminates with a stunning blossom at its apex.

Like the best of Rohlfs's 1901 objects, the *Carved Octagonal Table* was likely created for the City of Light's celebration, a Buffalo triumph, which in many ways brought out the best of his genius and set the stage for the masterpieces of his high period, 1902–1904.

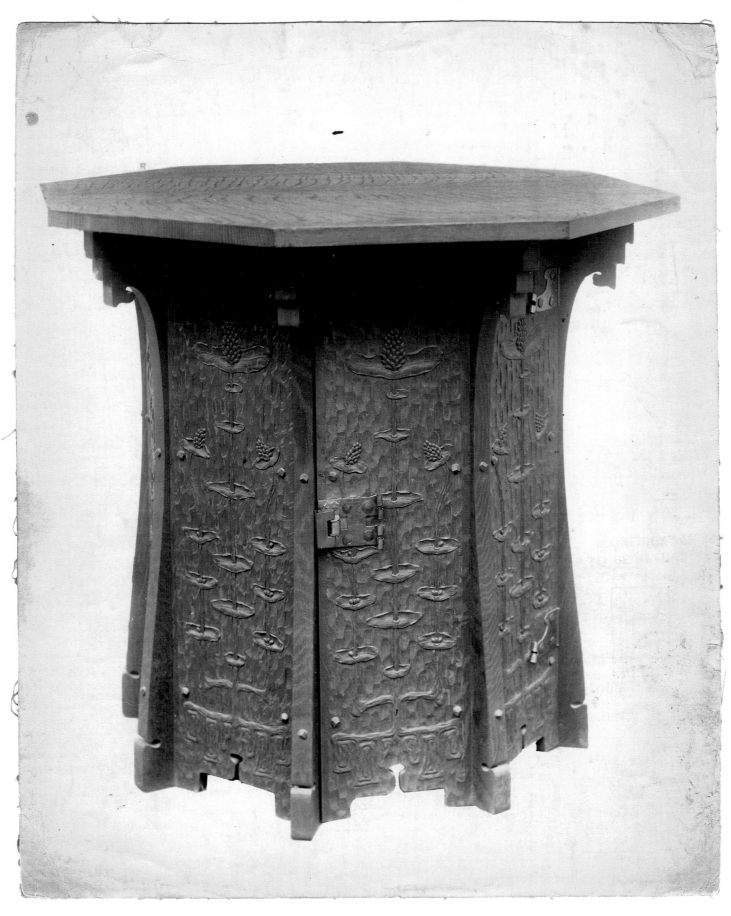

8.23

AN ARTIST WHO WORKS IN WOOD

Charles Rohlfs was at the top of his game by 1902. The range of fretted and carved masterworks he created during the high period of his furniture production, 1902 to 1904, stand among the most significant contributions to early twentieth-century decorative art by any designer or maker. Whether focusing on ostensibly utilitarian forms such as desks, tables, hanging shelves, or candle stands or on entirely aesthetic expressions that function largely as sculpture, Rohlfs created some of the most extraordinary objects of decorative art ever produced. He also enjoyed acclaim on the American design scene as well as growing recognition in Europe, especially through his participation in the International Exposition of Modern Decorative Art in Turin, Italy, in 1902.

A *Standing Desk*, made in 1902 and modified in 1904, is one of Rohlfs's most ambitious works of decorative art (fig. 9.1). This masterpiece of the Rohlfs style, with exquisite carving and perfectly integrated fretwork, exhibits brilliant design and subtle detailing.

The shape of the case may well owe a debt to Charles Rennie Mackintosh's development, in 1900 and 1901, of a series of cabinets of related form, which have become among the most celebrated works by the Scottish designer. The first of these, designed for the drawing room at 120 Mains Street, Glasgow, is a handsomely rectilinear model with wide overhanging top and rectangular inset panels below the upper cabinet (fig. 9.2). Decorative ornamentation includes silvered copper panels, designed and beaten by Margaret Macdonald, showing stylized figures representing old and new styles of writing. This form may, in turn, stem from the similar upright piano designs by Mackay Hugh Baillie-Scott, circa 1897, which feature similarly composed, fully skirted cases, with large winglike arms that open to reveal the keyboard area.

Mackintosh's careful attention to overall design is outshone only by the complexity of this desk's layout, which includes spacious side cupboards, copious internal compartments for desktop items, and even inward-facing cabinet storage below the desk. A close connection can be established between Rohlfs's *Standing Desk* and the Mackintosh desk based on the similar treatment of exterior structures, including the large doors in the upper cabinets, which in both cases open outward to form a winglike formation, and the detailing of the interior compartments. Given the similarities in overall design and details, it is almost inconceivable that Rohlfs did not see pictures of the Scottish designer's desk when it was shown in *Studio Special Number* in 1901 or *Dekorative Kunst* in 1902.[1]

Charles Rennie Mackintosh's Writing Desk (1901) for Michael Diack, in similar dark-stained oak, may also have had significant influence on Rohlfs's design for his *Standing Desk*

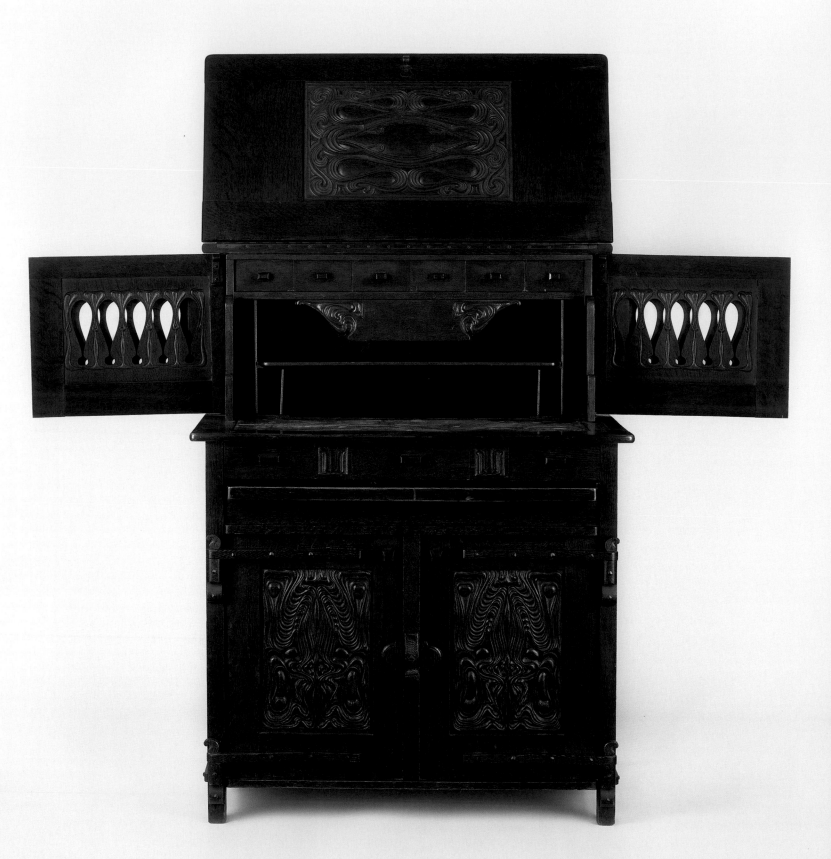

9.1

9.2 9.3

of the next year. Though this form lacks the comparable arm-door format, using a more conventional drop-front styling, it is notably similar in its decoration, which employs stylized organic motifs with a level of geometric abstraction and central placement similar to that of Rohlfs's ornament. Possibly, Rohlfs knew of Mackintosh's Bookcase for Windyhill, Kilmacolm, shown in *Dekorative Kunst* in 1902, featuring similar overall design with highly emphasized wing-spread structure.[2]

Though it is tempting to wonder about the possible reverse direction of influence, namely, that Rohlfs's 1902 *Standing Desk* may have in turn affected Mackintosh's designs for the extremely similar 1902 Cabinet, with inlaid glass panels inside the doors, for 14 Kingsborough Gardens, Glasgow (fig. 9.3), and the 1904 Writing Cabinet for Walter W. Blackie, Hill House, Helensburgh, there is at present no evidence to support this influence. The *Standing Desk* may have been shown at Turin in 1902, and Mackintosh might have seen it or a picture of it there, though it is not known to appear in any contemporaneous literature and therefore cannot be thought to have influenced Mackintosh's designs.

Charles Rohlfs's *Standing Desk* is one of his most ambitious projects and glorious results. Unusually elaborate, it seems a perfect selection for an exhibition such as Turin. Oddly, it does not appear in any extant period photography, published or otherwise, from around 1902, raising the question: Was the *Standing Desk* unavailable for photography because it was being shown at the International Exposition of Modern Decorative Art in Turin?

Fortunately, the *Standing Desk* exists today in extraordinary condition. Its rich coloration of deeply stained oak, shimmering across flat-cut and carved surfaces, and the deep red of its inset mahogany cabinet stunningly set off its superlative design and craft. Set simply on four block feet, adorned with the decorative oak casing for the hinges above, the *Standing Desk* asserts absolute solidity, whether closed rather like a large box or with its upper cabinet wings outstretched. The lower half of the desk is opaque and dense, while the upper cabinet is free to open its gallery contents to the viewer or veil them in the fretwork of closed arms. The handmade hinges on the lower cabinet drawers consist of oak casings set with hidden threaded steel pins, topped with delicate wooden finals. Metalwork is kept to a minimum: wooden straps join the doors to the lower cabinet case,

9.1 *Standing Desk* (shown open), 1902/1904. Oak and mahogany with copper and original lock, 68 ¼ × 69 ½ × 26 ⅞ in. (139.7 × 176.5 × 68.3 cm). Private collection.
9.2 Charles Rennie Mackintosh, **Design for a Desk for 120 Mains Street,** detail, Glasgow, 1900. Graphite on paper, 10 ⅝ × 19 ½ in. (27 × 49.5 cm). Hunterian Museum, University of Glasgow.
9.3 Charles Rennie Mackintosh, **Cabinet for 14 Kingsborough Gardens,** Glasgow, 1902. Oak painted white; insides of doors painted silver and inlaid with colored glass, with white metal hinges and handles, 60 ⅝ × 39 × 15 ¾ in. (154 × 99.1 × 40 cm). Hunterian Museum, University of Glasgow.

9.4

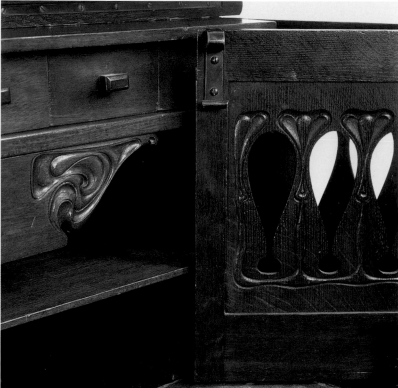

9.5

a simple wooden bar loosely holds the doors in place, and exquisitely beveled wood knobs serve as door pulls.

Above the lower portion of the cabinet, a secondary writing surface can be extended forward, revealing a leather writing area. The leather, now faded green, was likely originally stained bright green. It is taped off with its original tooled leather border, stained deep red, with a typical Greek key motif. The center and two flanking drawers, carefully proportioned in the ratio 10:7.75, complete the lower cabinet. Elegantly spaced across the desk's expanse, the drawers are interspersed with decorative panels ornamented with fluted scroll carving, and their interiors are the typical Rohlfs lacquered green. Inside the lower cabinet doors, on the right proper side, a fully detachable shelving unit, stained green, is set above a bucket drawer; on the left proper side, the door opens to reveal a solid block of three bucketlike drawers, set one above another, again all with green interior stain.

The inset upper gallery of the *Standing Desk* seems to have been added in 1904, when Rohlfs redated the side of the cabinet, originally marked with his "R in a bow saw" mark and the date 1902, each filled with red wax (fig. 9.4). In 1904, Rohlfs seems to have added the mahogany upper gallery compartments and simply slid their case into the existing dark-stained oak upper cabinet space (fig. 9.5). The six small drawers, set loosely in their enclosures, are all fully shaped at the rear, with elongated S-curves forming each of their rear sides. This

9.4 *Standing Desk,* detail, maker's mark and dates.
9.5 *Standing Desk,* detail.
9.6 *Standing Desk,* shown closed, with original Japanese lock.

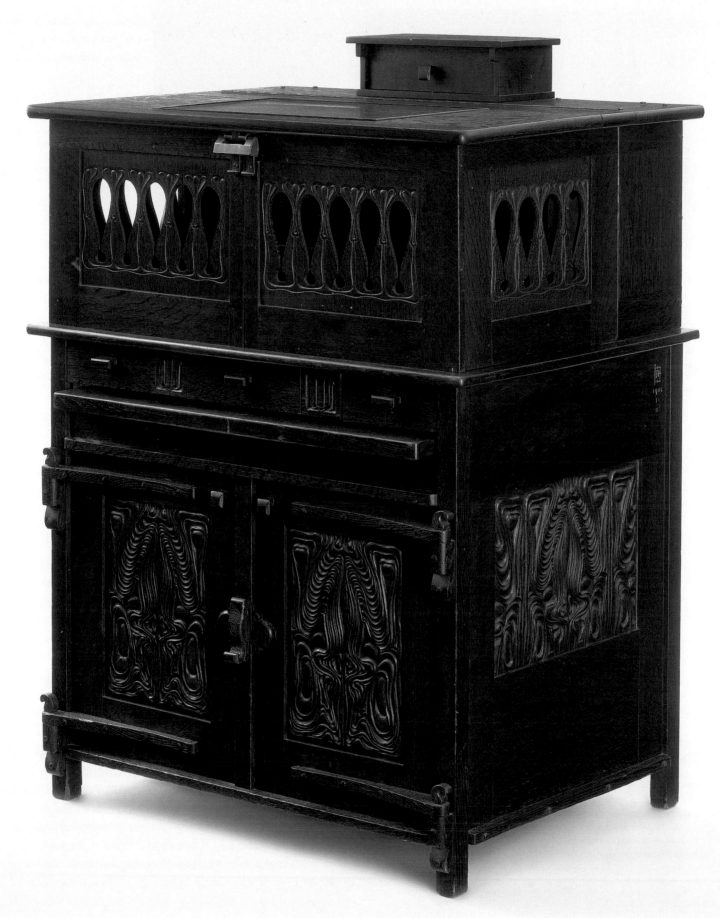

9.6

9.16

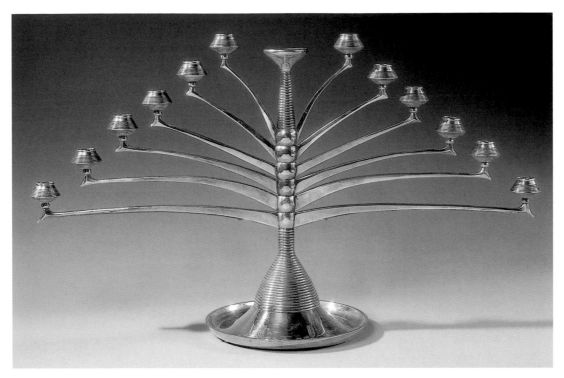

9.17

from the Rohlfs home, and the 1899 *Corner Chair* (see fig. 7.5). When placed on the wall, it addresses the human body directly—that is, the viewer's rib cage and spine are at a similar level to its backboard.

The shelf also functions nicely as a metaphor between the human form's dependency on a central spine and a tree's centeredness on a trunk, its outstretched stylized branches arcing upward in the shelf's central medallion. This interpretation in turn meshes with Rohlfs's desire to be the thing he is making, that is, as he makes a shelf in the form of vertebrae, he, the spine, is the tree, the wood. This naturalistic metaphor is also useful in describing the lower lobe of fretwork, which can be understood as the root system below the shelf or as a human pelvis. The *Hanging Shelf* is also one of Rohlfs's most successful meldings of an austere style with the stylized geometric patterning characteristic of the best of early twentieth-century modernism. The comparison with Bruno Paul's celebrated Candelabrum of 1901 is compelling (fig. 9.17).

Rohlfs's fretted brackets perpendicular to the main shelf body are great examples of his two-dimensional designs. The upper bracket, by which the *Hanging Shelf* was suspended over a picture rail, is lobed and notched with inventive mushroom and kidney bean shapes along with almost Art Nouveau curves that connect to the melting folds of oak oozing down the midsection. The lower bracket, which supports the shelf, foils the overall design with a hypermodernist, almost streamlined profile, with notches and lobes that integrate its details into the overall structure of the shelf.

9.16 *Hanging Shelf,* 1902, from the Rohlfs home. Oak, 51 ⅛ × 13 × 8 in. (130.2 × 33 × 20.3 cm). Private collection.
9.17 Bruno Paul, Candelabrum. Cast and wrought brass, 16 ½ × 27 × 9 in. (41.9 × 68.6 × 22.9 cm). Minneapolis Institute of Arts. The Modernism Collection, gift of Norwest Bank, Minnesota.

9.18

WOMEN'S HOME COMPANION

These and other pieces from 1902 brought Rohlfs considerable attention. The final sustained account of his work appeared in the *Woman's Home Companion* in June 1902. This charming survey of Rohlfs's 1901 and 1902 objects provides a final glimpse into his approach to design, as well as his ideas about his work and his particular psychology of achievement. Never was Rohlfs's ego so flattered as when the author of the article, Marsha Houk, suggested that though one might think Rohlfs was a "myth," he was actually "a reality." As previous reviewers had done, she echoed Rohlfs's focus on ideas when she called him "an artist in furniture, who makes his tables and chairs live and breathe with his thoughts."[6]

Rohlfs "inspires you to go and do noble things," claimed Houk. She likely relied on her subject when she suggested that his work has "struck a note so strong and vibrant it has gone echoing in ever-widening circles, until now Munich, that center of artistic appreciation, London and Paris are reaching out to do him honor."[7] Although a few objects of Rohlfs's decorative art have surfaced in Europe, a more thorough understanding of the exact quantities of pieces and the exact locations of clients has never been established. Given the rarity of Rohlfs objects in the United States, it was puffery when the article suggested that "America is beginning to realize that she has an artist [Rohlfs] wholly her own; a creator, not a follower; one who has unconsciously struck a new note in the world of art." Rohlfs's inventive style took a while to catch on, to the extent that it ever really did, and the question remains just exactly how deeply Americans really "got" his work in 1902.

"Meaning" and the "embodiment of an idea" take over the interpretive framework of Houk's analysis so that, as in other articles Rohlfs influenced, it is hard to believe that one is reading an essay on furniture, rather than, say, philosophy. Nevertheless, Houk was definitely getting at something when she described the directness and sincerity of Rohlfs's designs and, especially, when she pointed to the boldness and daring nature of his work. She also discerned completeness and resolution in Rohlfs's best designs, a harmony of aspects that, not easily reached, unites carved, fretted, and shaped elements with overall structural design, coloration, and finish. And all this fit "to the need that originated it."

One of Rohlfs's strangest ideas appears near the end of this article. In a section following extended quotations from Rohlfs, Houk asked, "Did you ever know that some lines lived and some never could?" With this question the article has gone far afield from traditional formal analysis of furniture and decorative art, and even past more unconventional interpretive schemes, to a land where, even metaphorically, lines have crossed into the realm of the living. Rohlfs himself may not have understood how some of his furniture shapes and carved wood designs achieve great beauty and sublime unity while others fail in design or execution. This grasping about for meaning and significance in the works of Rohlfs is likely to have been as much the maker's own attempts to understand design and ornament. Rohlfs's lack of training as a cabinetmaker or a designer certainly enabled him to experiment with his vision of beauty and harmony in design. At the same time, it left him searching throughout his career for a deeper understanding of his own works, a level of knowledge with which he was never fully satisfied.

Seeking an answer that would better describe the success of his decorative schemes, Rohlfs suggested that rather than meaningless or exaggerated curves created by mere caprice, his carvings have a "mission to perform" with straight lines of "masculine directness" and curves "with feminine grace." He even likened this physically manifest phenomenon to "an inanimate expression of the infinite idea, 'rest in action.'" Though the first part of this concept is abstruse, the idea of rest in action likely refers to the latent dramatic energy of Rohlfs's best designs.

This harmonized volatility functions in Rohlfs's best works as a framework against which dense, complex imagery is united across the surface of structural designs that are

consciously meant to bring ornament into order. Indeed, though we can try, at some level, to make sense of how these factors combine in Rohlfs's designs, in the end we are left in the predicament of "the artist himself," who admitted he is "scarcely conscious of what it is he has done."

"Do not ask me to define my work," he pleads. "I have no aims. Do not think I am a reformer; just put me down for a man who loves his work. Imagination? Yes, of course. We all have it. That is simply anticipation. What we see before it is, is just as real as the thing produced. Inspiration? Yes. But you must go to sources foreign to yourself. You must not stop to ask how some one else could have done his work. Get at the human heart by any and all means—and in this you can see the strength of his originality; you must open your own first and bid the beauty of life and light enter from the one and only Source. Wonderful eye-opener, that. Read Emerson, Shelley, Browning, and some of the world's great fiction, and above all read Shakespeare."[8]

INTERNATIONAL RECOGNITION

"Charles Rohlfs Delighted" is how the *Buffalo Morning Express* announced Rohlfs's successes in Turin on 21 June 1902. Likely at the suggestion of Rohlfs himself, the paper reported that he was "much pleased over the favorable attention his exhibit of furniture has received at the International Exposition of Decorative Modern Art, now in progress in Turin, Italy."[9] The article erroneously claims that Rohlfs was the "only American invited to enter his work," which was far from true. As official correspondence for the exhibit noted:

Three large shipments of American exhibits have already been made. There will be about 200 American exhibitors, nearly all of them from New York, and they include leading architects and interior decorators. There will be shown a collection of decorative panels from F.A. Bridgman, pottery from the Rookwood Pottery, Cincinnati; stained glass from J. & R. Lamb, Favrile glass, mosaics, enamels, and ornamental work from the Tiffany Studios; posters, sketches and book covers from the J. B. Lippincott Company. Carrere & Hastings send the plans of the new Public Library and the Triumphal Bridge at the Pan-American Exposition; Hunt & Hunt will show the new wing to the Metropolitan Museum of Art, while plans of a modern nineteen-storey New York skyscraper will be exhibited by another firm of architects.

Gas and electric-light fixtures, furniture and house furnishings, bronzes, bathrooms, and complete rooms will be shown by New York exhibitors.

Among other exhibitors are Tiffany & Co., the Gorham Manufacturing Company, and the School of Industrial Art for Women.

The exposition will be under the patronage of the King, and the Central Committee is presided over by the Duke of Aosta.[10]

Independent verification of Rohlfs's participation at Turin comes from a single mention in the accounting of expenses related to the American participation in the exhibition.[11] John Getz, agent for the Turin Exposition Commission, reported on 6 March 1902 on consolidation and shipping costs (including the rates for Rohlfs's entries at Turin) to organizers of the American participation in Turin, led by General Louis P. di Cesnola, director of the Metropolitan Museum of Art. Rohlfs may well have been the only American furniture-maker invited to participate.[12]

Press coverage of Rohlfs's works at Turin other than articles surely based on Rohlfs's own statements has not been discovered. The *Buffalo Morning Express* also reported that Rohlfs "received a letter from John Getz, architect of the exposition, dated Turin, June 4th, in which

the architect says that Mr. Rohlfs's exhibit is receiving much favorable attention."[13] Even the Italian royals apparently took special interest in Rohlfs's work, as reported by Getz: "The King and Queen again visited our section, and expressed their kind appreciation, as did the Duchess of Genoa and others." And those Americans who traveled to Turin were delighted by the Rohlfs works they saw at the fair: "Several Boston and Buffalo people were here a few days ago, among the latter a friend of yours who was pleased to see your exhibit."[14] Notably, after the prizes were awarded—none to Americans—"the American exhibitors at Turin [were] all greatly disappointed" and believed "that they were discriminated against and that they merited better awards."[15]

Charles Rohlfs did receive international recognition in the year after the Turin exposition when he became a member of Society of Arts (later Royal Society of Arts) in London, either by invitation or by nomination by existing members.[16] He remained proud of this honor throughout his life. Rohlfs claimed to have crafted furniture for Buckingham Palace, but it is unclear whether this commission was undertaken before or after he joined the Royal Society.[17]

Although Rohlfs spoke of his participation in another world's fair, the Louisiana Purchase Exposition in Saint Louis in 1904, his participation has not been verified.[18]

FANTASTICAL FRETWORK

If 1902 was the year of Rohlfs's triumphs of the intricately carved style, the years 1903 and 1904 were the heyday of his forms that emphasized fretwork. Rohlfs created numerous designs for his home and many unique forms for specific clients, as well as complex items that he intended to, and in some cases did, produce in small editionlike sets.

By 1903, Rohlfs was fading from the limelight in the design press, which despite feigned modesty, he avidly solicited. The last significant appearance of his works in an exhibition or in magazines or trade journals came in 1902, but in March 1903 Rohlfs was profiled as "A Celebrated Artist in Furniture, of International Fame," in *Successful American*. Though largely a fluff piece, this short essay on Rohlfs did recount some of the high points in his life, including special mention of "the Cooper Union night classes," where Rohlfs "became the best draughtsman of the school, and was also proficient in chemistry and physics."[19] The article also rehearsed his career steps, including his work as a "stove foundry designer" and his later determination to "trod the boards." It recounted one of Rohlfs's favorite canards: abandoning acting when "the lady's father objects to his daughter marrying an actor" caused him to "return to the drawing-board." At that point, "having made articles of furniture for his own home which had commanded admiration, he resolved to make a start in that line." The article admitted that his furniture was not well received at first, representing a decided departure from standard modes of design in late nineteenth-century America.

The article also mentioned the phrase about which Rohlfs was so ambivalent— namely, that he was the originator in America of the Arts and Crafts style. The "dramatic" quality of his work was analyzed and tied to his burgeoning popularity in the United States as well as on the Continent, where "Mr. Rohlfs' recent exhibit at Turin was a center of attraction to European artists." This was certainly a busy time for Rohlfs, whom the article mentioned as working ten hours daily, likely a pace he reached in 1900 while preparing for the Pan American Exposition and sustained for Turin and as a result of orders that likely stemmed from both exhibitions. Rohlfs's false modesty again took center stage when the article concluded that he "rarely refers to his own work," and enigmatically quoted Rohlfs: "If I only knew what I know that I don't know, you'd see something done"—a showman indeed!

Rohlfs's fretted masterpieces of 1903 were a return to pure design for Rohlfs, not unlike George Ohr's focus on bisque ware, which late in his career forced viewers to look at the formal qualities of his ceramics rather than focusing on their surface glazes. In this year, Rohlfs

9.19 *Plant Stand,* 1903. Oak, copper, and brass, 50 ⅞ × 19 ⅜ in. (129.2 × 49.2 cm). Private collection.

created two of his most important pieces of his career—the strange yet iconic plant stand (fig. 9.19), and his magnum opus of tabletop objects, a three-light candelabrum. The *Plant Stand* defies formal or stylistic categorization, whereas the *Candelabrum* stays closer to tradition, punning enigmatically on international design styles through the ages. Though uncarved, these objects represent Rohlfs at his most inventive and sublime. The *Plant Stand* seems to have been made far outside of Rohlfs's standard production, and the *Candelabrum* appeared only in his 1907 portfolio of illustrations. He seems never to have duplicated either model.

Arising from hooflike feet, the *Plant Stand* strikes one immediately as odd, even bizarre. The *Plant Stand* presents itself both as sculpture and as another being, asking more to be looked at, inspected, and evaluated than to be used. Like masterpieces of American art pottery, the stand looks more handsome in its pure presentation, without holding a plant, than used for its ostensible purpose.

The base of the *Plant Stand* is composed of three identical, elaborately shaped oak boards, all vertical, that are set at 120-degree angles to one another and conjoined for part of their ascent. The three oddly squared hooves pronounce "toes" on their top surface, "heels" at their lower rear edge, and "spurs" at the upper rear "ankle" juncture of the leg and the foot. The ribbonlike "legs" arc upward, flaring at complex angles as they ascend toward their juncture point, an elaborately constructed "pelvis" with fretted quatrefoil cavities and jutting lobes of wave, bean, and ovoid shapes. The three vertical boards are joined in the delicately shaped "spine," which ascends to a lobed neck that supports an elaborate set of interlocking horizontal slats. Above, elegantly shaped "horn" finials rise to suspend the metal bucket, forming the creature's "head." The oak members are joined below the metal bucket by an intricate set of tongues in grooves that lock into one another in a tripartite joint—an unusual feature on furniture from any period or culture. The metal bucket that hangs from the three finials was probably hammered by hand in Rohlfs's workshop and is beautifully seamed and set with contrasting decorative metals. Although the overall design owes much to Japanese and Chinese precedents, especially their traditions of similarly composed plant stands and related small presentation stands, in Rohlfs's hands the world's design traditions are transformed into a modernist eclecticism that few designers would be able to exploit to such effect.

The same subtle detailing is featured in Rohlfs's 1903 masterpiece *Candelabrum*, composed of gold-rubbed ebonized oak, copper, and kappa shells (fig. 9.20). About these shells, Rohlfs wrote in his 1907 portfolio of illustrations: "The Shell Shades are extra. The shells, Placenta Orbiscularis-Retz are found in the China Sea. They are a direct importation, unique in themselves and the use to which they are put, and difficult to secure. I have about 350 on hand now and may not be able to get more."[20]

Seamlessly integrating metal and ebonized wood elements, Rohlfs achieved a unity in the *Candelabrum* that defies the viewer to parse its Chinese, Islamic, Japanese, Moorish, Scandinavian, European, and even American design elements. Leaving no terminal (metal or wood) unembellished, Rohlfs controls and manipulates space, light, shadow, and form on this object of astonishing beauty and sophistication.

The *Candelabrum*'s two carved platform bases are surmounted by a perpendicular central crossbar that supports the overall structure, elegantly notching down over the edges of those bases. This interlocking construction, which may appear incidental, stabilizes the base of the *Candelabrum* and confers on its members an overall visual unity. The central upright posts and arched moldings introduce central curvilinear bowing at the midpoint (fig. 9.21). This set of posts, placed perpendicular to the fretwork panels, supports the upper structure and, when the *Candelabrum* is viewed from the side, creates a rhythmic pulsation of carefully shaped oak moldings that recalls similar buttressed compositions on Viking ships.

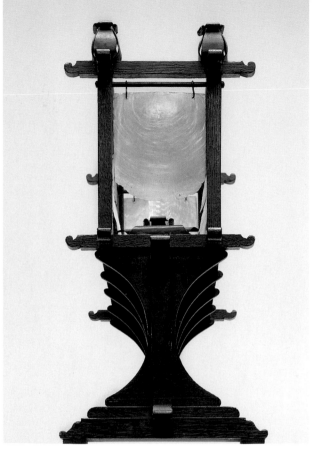

9.20 9.21

The fretwork midsection, with stylized imagery, that can be interpreted against a variety of design traditions, is framed at its top and bottom by carefully carved rafterlike extensions. These projections of the upper and lower bar frames holding the inset pierced panels emphasize the horizontality that is reiterated above in the framework of the upper light box construction. This parallel echo unifies the object while creating a challenging perspective at the juncture between the small rafterlike moldings extending at right angles from the lower corners of the light box and the extensions they immediately surmount. This collision of rafters, complicated by the arched moldings enmeshed therein, represents one of the most complex visual juncture points on any of Rohlfs's furniture or decorative art. In moving around the object, one experiences the brilliance of Rohlfs's manipulation of line, angle, and perspective. Rohlfs's complex integration of horizontal and vertical members harmonizes these disparate elements, no matter what the angle of orientation or elevation of view.

The *Candelabrum*'s upper register functions as a Japanese-style light box, such as those Frank Lloyd Wright and George Mann Niedecken were famous for employing in their interiors (fig. 9.22). It can also be interpreted as a little stage, curtained with kappa shells

9.20 *Candelabrum,* 1903. Ebonized and gold-rubbed oak, kappa shell, and copper, 17 × 16 ¾ × 7 in. (43.2 × 42.5 × 17.8 cm). Private collection.
9.21 *Candelabrum,* detail.

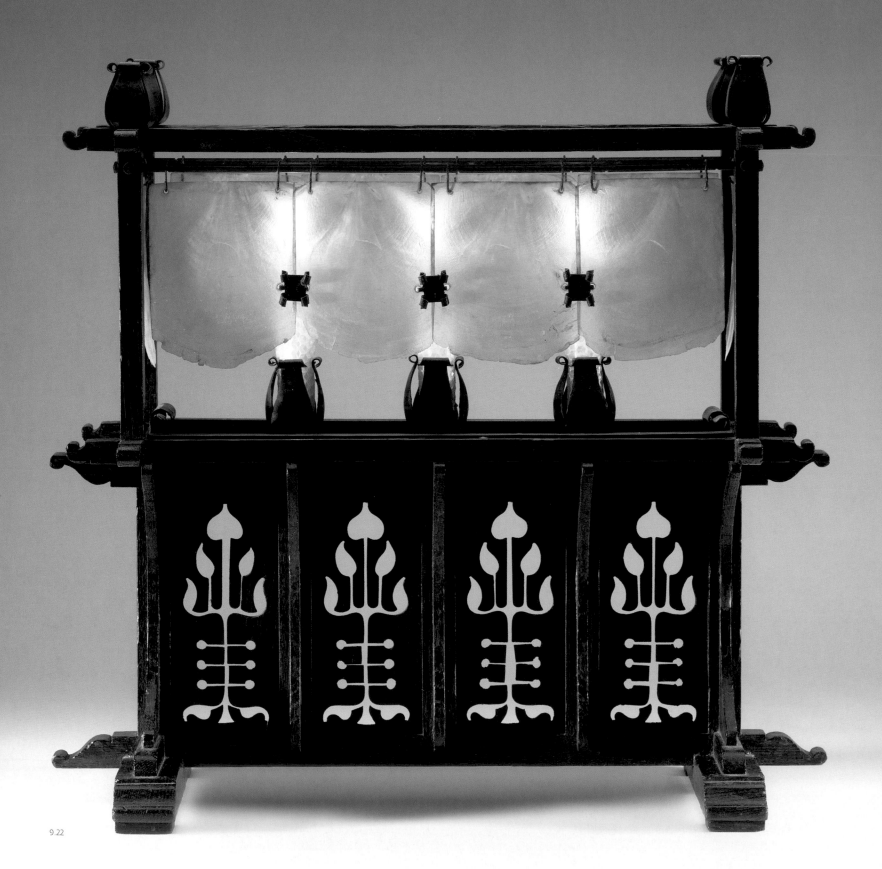

9.22

instead of a velvet curtain. Its open framework foils the density of the fretwork below. Tiny copper hooks suspend the kappa shells from almost imperceptible metal bars. These bars are integrated with the overall structure by little wooden plugs, which give the illusion of rafter extensions put to such good use below. The decorative copper tray and bobeches within the light box are matched to the delicate copper brackets that join each of the four kappa shells to the next, as well as to the similarly shaped bobeches (for small taper candles) set like finials atop the light box.

One detail about the history of the extant model of the *Candelabrum* is worth clarifying. In an extant period photograph, the *Candelabrum* was fitted with what appears to be a manufactured tray with four bobeches, not the configuration in which we find it today. This raises the question whether other examples of the form were made. On the reverse of the extant period photograph of the *Candelabrum*, however, Rohlfs wrote, "copper now made simpler," indicating that he reworked the interior of the *Candelabrum*.[21] Based on this information, the *Candelabrum* shown in the period photograph is probably the one extant example. Rohlfs's seamless use of a range of materials in this perfectly integrated object makes it one of the most inventive and fully resolved examples of his radical eclecticism.

OTHER WORKS FROM THE ROHLFS HOME

Between 1902 and 1904, Rohlfs developed the design for a *Tall Case Clock*, which was either made for the Rohlfs home on Norwood Avenue or, failing to attract a buyer, simply ended up there (fig. 9.23). Donated by Roland Rohlfs to The Metropolitan Museum of Art in New York, this clock showcases Rohlfs's ability to work with inventive shapes, in this case with modernist restraint. Though marked with the usual Rohlfs "R in bow saw" mark, the *Tall Case Clock* is undated, perhaps because of the tight spaces where such a mark might have been carved. The date of 1902–1904 depends on two salient facts: the number of works made in this period that stayed with the Rohlfs family, and the relation of the design to a series of tall case clocks developed by German designer Richard Riemerschmid between 1902 and 1909.

Rohlfs's *Tall Case Clock* rises from a platform-cabinet base, through a dramatically shaped midsection, on which sits a square cabinet with a strikingly modernist circle as its face, perched atop the clock like a human head. Delicate metalwork hinges and decorative nodules adorn the base and midsection, while the bold and dramatic severity of the clock face commands attention above. The Sullivanesque fretwork in the central casework places the clock firmly in the nineteenth century, though the light-hearted minimalism of its face suggests comparison with the postwar inventions of, for example, George Nelson.

Though certainly used to novel ends by Rohlfs, the raw materials of the *Tall Case Clock* design owe a debt to the genius designer Riemerschmid, whose development of similar designs in the first decade of the twentieth century included a "Standuhr" model installed in his studio.[22] Shown repeatedly between 1902 and 1909, these models greatly influenced clock design both on the Continent and, in this case, in the United States. *Deutsche Kunst und Dekoration*, for example, showed one of Riemerschmid's models in its October 1903–May 1904 issue at the right proper foot of a small stairway in an entrance hallway. Some years later Rohlfs would situate his *Tall Case Clock* model in an almost identical position in his Park Street home, putting it on the stair landing in the entranceway (just up from where Riemerschmid had placed his clock).

Riemerschmid and other German designers developed similar tall case clocks in varying woods, including a 1903 model by the designer now in the collection of the Museum für Kunsthandwerk in Dresden and another in the Museum für Kunst und Gewerbe in Hamburg. Though overall similarities tie Rohlfs's model to the much-published German precedent, his principal innovation was his removal of the four-corner post structure that diminishes

9.22 *Candelabrum,* candles lit.

9.23

9.24

the power of the swooping central case.[23] The force and drama of his modernist clock face without numerals set this work apart as a bold and intriguing attempt to demonstrate his awareness of innovative Continental design while creating his own vision of this important modernist form.

Three other works from 1904 that appeared in Rohlfs's home deserve mention. An "Octagon Table," described in his 1907 portfolio of illustrations, has a door at the front with "copper hinge" that provides "access to two shelves inside" (fig. 9.24). The *Octagon Table* features an octagonal tabletop with eight skirted sides that extend almost to the floor. Its design derives from the earlier *Carved Octagonal Table* with "Honeysuckle" motif. The elegantly skirted form is given a concavely arced shape by the eight legs that define its overall geometry. In this instance, Rohlfs uses a design motif not seen since around 1900, when he seems to have largely taken out of production the popular carved *Hall Chair*. In 1904, Rohlfs made the only known extant model of the *Octagon Table*, in chestnut, and, notably, only the second known post-1900 example of the *Hall Chair*.[24] This 1904-dated *Hall Chair* model features the

9.23 Tall Case Clock, ca. 1900–1904, from the Rohlfs home. Oak with copper and green enamel paint, 81 × 19 ⅛ × 9 in. (205.7 × 48.6 × 22.9 cm). The Metropolitan Museum of Art, New York. Gift of Roland Rohlfs.
9.24 Octagon Table, 1904, from the Rohlfs home. Chestnut and copper, 30 ⅛ × 32 in. (76.5 × 81.3 cm). Private collection.

most extravagant carving of any extant example as well as other slight differences from the earlier production model. Reviving the design from the lower half of the pierced and carved backrest of the *Hall Chair*, Rohlfs employs on the *Octagon Table* an identical fecund bulb form terminating in fingerlike, outwardly curling leaves (see fig. 4.11).

We know from a period photograph that, at about this time, Rohlfs made a "Pedestal," which never made it into his 1907 portfolio, and which unfortunately is not extant (fig. 9.25). This vintage shot shows the *Pedestal* surmounted by a lamp that is known to appear in a period photograph of Rohlfs's home by around 1905, thus dating it, along with the *Pedestal*, to around the same time when the *Octagon Table* and late-model version of the *Hall Chair* were created. Although the *Octagon Table* features just the lower portion of the original panel from the backrest of the *Hall Chair*, the *Pedestal*, because of its vertical structure, features the bulb-to-leaf section of its motif, as well as the complex latticework fretting above, albeit in what appears to be in a fully uncarved state. The extant *Octagon Table*, the only known example of its form, was from the designer's home. Therefore, not only was this *Pedestal* probably made for Rohlfs's home, but the *Hall Chair* was likely to have been made for this purpose as well. It is also not unreasonable to surmise that in putting these three works with similar motif systems into the same environment, Rohlfs may well have been endeavoring to integrate tenets of his contemporary George Washington Maher's rhythm-motif theory or Frank Lloyd Wright's notion of *Gesamkunstwerk* into his design scheme for his Norwood Street home.

Returning to the vintage picture, which provides the only information we have on the *Pedestal*, let us consider the *Lamp*, which has survived, descending through three generations of the Rohlfs family (fig. 9.26). First priced, on the reverse side of the period photo, at the whopping sum of $60.00 around 1904 or 1905, when it was created, but later repriced even higher, at $75.00 and given the model number #101, the piece was eventually marked "Not for Sale." Created, like the bucket on the 1903 *Plant Stand*, from sheets of hammered copper and decorated with peculiar coils of tubular metal, scrolling feet, and large ring handles, the *Lamp* has a decidedly Asian sensibility, perhaps inspired by the Asian decorative art Charles and Anna Katharine so admired in the collection of the Rijksmuseum in Amsterdam. Its canister base originally contained a traditional oil-can lighting system. Rohlfs electrified the *Lamp* himself, likely between 1910 and 1920. The shade is inventively supported on four copper arms that fit neatly down into pierced rectangles in the top of the canister, permitting easy removal of the shade.

Having likely first used kappa shells in his 1903 *Candelabrum*, Rohlfs here exploited the possibilities of this semitranslucent material to create a glowing ring of light that obscures the brightness of the bulb, originally a flickering flame, behind a sheet of white that seems to float in space above the decorative metal below. A triumph of inventive imagery and complex design, the *Lamp* represents one of Rohlfs's rare forays into lighting.

Closely related are two chandelier forms Rohlfs made for his home. One of these models, shown in a period photograph of the Norwood House, circa 1904 or 1905, consists of a cruciform juncture of two fretted bars suspended from a central post (see fig. 10.17). The other, also made for the Norwood Street house, features four bulbs simply ensconced in boxes made of kappa shells (see fig. 11.9). Each of the four encased bulbs is suspended from the metal and oak ceiling plate only by its own wiring. These inventive chandelier forms demonstrate Rohlfs's fairly simplistic approach to lighting design, which, though not a central feature of his output, did present an opportunity for creative and theatrical expression. Using unusual materials, unconventionally united into compelling designs, Rohlfs created a small body of lighting forms that seem remarkably fresh to this day.

9.25

9.25 *Lamp and Pedestal,* ca. 1904, period photograph. American Decorative Art 1900 Foundation.
9.26 *Lamp,* ca. 1904, from the Rohlfs home. Copper, brass, and kappa shell, with replaced glass, 23 ¼ × 15 ⅞ in. (59.1 × 40.3 cm). Private collection.

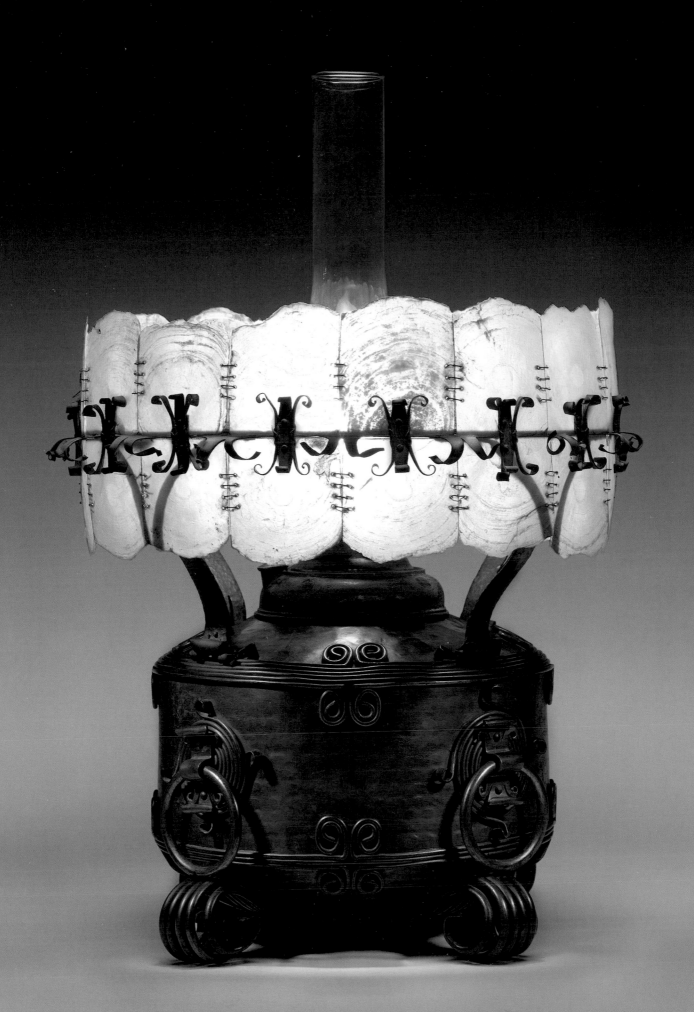

9.26

CHAPTER 10

TWENTIETH-CENTURY PROGRESSIVE
YET STRICTLY AMERICAN

As 1904 wound down, Charles Rohlfs, now fifty-one, may have been getting a little bored, or frustrated, with yet another career—in this case the one that had become his defining achievement. In less than a decade, he had gone from obscurity to a position of significant rank among innovative furniture-makers at the turn of the century. He had created some of the most important decorative art of the early modern period in the United States and had gained international recognition for his artistic accomplishments. Still, between 1904 and 1907, Rohlfs was committed to a new goal. Rather than producing radical art furniture, Rohlfs focused on creating a successful business. He pursued this goal with two divergent strategies: special commissions and mass marketing.

On 14 June 1904, Rohlfs received a patent for a chafing dish with a contraption that allowed the user to swing the chafing disk lid to the side rather than having to remove it. In pursuit of a market for his wares, he published a leaflet offering a line of casseroles or chafing dishes (see Appendix, pages 242–243).[1] The leaflet included an endorsement of the patented model from Rohlfs's friend the critic Deshler Welch. "Besides being 'something different,' clever, ornamental and unique, your chafing dish is distinctly practical. It is really a new table idea. . . . Let us change the name 'chafing' and call this a Rohlfing dish! It's a success."[2]

The leaflet continues:

For eight years Charles Rohlfs has been making Casserole Chafing Dishes—being the originator in limited quantities. Owing to their superiority Mr. Deshler Welch the highest authority on chafing dish cookery suggested that an effort be made to make enough of them to enable people who cared to own the genuinely made article to obtain the same without difficulty or delay.

His suggestion has been followed.

The high standard and unique quality of the work produced in Mr. Rohlfs' shop will be upheld, the only difference being that more artisans will be employed.

The swing-lid "Rohlfing Dish" is the latest style of Mr. Rohlfs' make. Its convenience will be noted at once. It has been patented for obvious reasons. Like all the previously made styles it is made of hand hammered copper.

The casserole is made expressly for Mr. Rohlfs, in Belgium, of the best obtainable material. It has the added merit of being thoroughly tempered, and is consequently durable. It is also light and quick in operation.

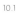
10.1

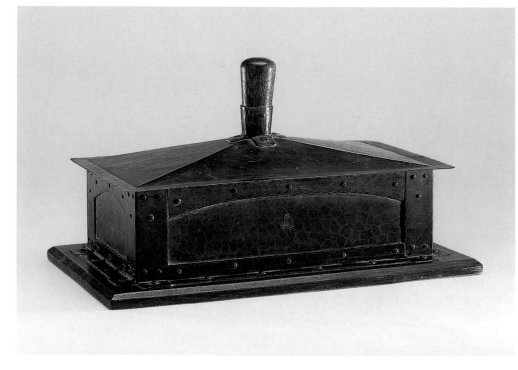

10.1 "Medieval" Chafing Dish, ca. 1900–1906. Oak, copper, and replaced ceramic casserole, 22 × 14 ½ in. (45.7 × 36.8 cm). Private collection, New York.

10.2 Gustav Stickley, Humidor, ca. 1905. Oak and copper, 6 ¾ × 12 ¼ × 8 ¼ in. (17.1 × 31.1 × 21 cm). Private collection.

10.3 Desk with Suspended Gallery (stage 1, lower cabinets). Oak and copper, each cabinet 29 ¼ × 19 × 33 ¼ in. (74.3 × 48.3 × 84.5 cm).

10.4 Desk with Suspended Gallery (stage 2, without suspended gallery).

10.5 Desk with Suspended Gallery (stage 3, complete), 1904. Oak and copper, 71 ½ × 70 ¹⁵⁄₁₆ × 36 ⅜ in. (181.6 × 180.2 × 92.4 cm). Private collection.

10.2

No effort is made to hide the evidences of hand-made work. It is offered for sale as nearly
as possible to the condition in which it leaves the anvil.
A truly artistic adjunct to the home from the hands of artists.[3]

Rohlfs offered a range of models. The florid Rohlfing Dish was contrasted with the "Bachelor" model, a considerably simpler, more utilitarian stand. As described in chapter 8, Rohlfs likely took the idea of producing chafing dishes from a catalogue published by Gorham Manufacturing in 1890. The "Gothic" and "Medieval" (fig. 10.1) periods were invoked in the design and naming of those two chafing dish models, while the "Gipsy" was sophisticated, almost streamlined, with a charming riveted base and modernist profile. Last, the "Safety" model featured a full enclosure for the flame meant to heat the casserole above, emphasizing its metal tubular construction and evoking Rohlfs's history as a stove and oven designer.

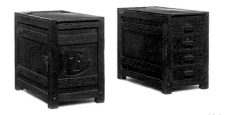

Though chafing dishes were said to be popular in the period, Rohlfs's copy of the leaflet tellingly shows reduced prices over time for four of the six models. Prices that had ranged from $20 to $35 later ranged from $12 to $25.[4]

Still, there was clearly a market for handwrought metalwork. Around 1905, Gustav Stickley introduced a line of rustic and charming metalwork objects, some of which likely owe a debt to Rohlfs's designs. Stickley's 1905 catalogue of handwrought metal included a Chafing Dish No. 352 with "hammered copper, on wood base, terracotta casserole" with wooden handle. This form is remarkably similar to chafing dishes made by Rohlfs, including the "Medieval" and, particularly, "Gothic" models, as well as two models depicted in *Art and Decoration* in May 1901.[5] Another close comparison may be seen in a rare uncatalogued Stickley humidor that features the dowel-in-a-shaft oak handle that was part of many of Rohlfs's chafing dish lids (fig. 10.2). Stickley sublimely integrated the dramatic oak handle with the humidor's beautiful faceted copper lid, just as Rohlfs's chafing dish lids unite their handles with beautifully domed lids

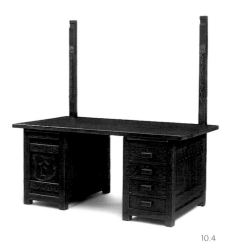

From the start of his profession as a furniture-maker, Rohlfs designed and made furniture on request. This approach was well suited to his desire to create objects that were appropriate for their owner and purpose. Most of his significant work was too idiosyncratic—as Rohlfs would have described it, too artistic—for general consumption. His lack of success at Marshall Field is early evidence of this problem. Still, there were individuals with a taste for the Rohlfs style.

In 1904, a patron likely came to Rohlfs asking for a desk of the same form as the *Desk with Overhead Gallery*, which Rohlfs had attempted around 1899. The earlier desk was structurally unsound and ultimately needed to be restructured to provide adequate support for its massive overhead gallery. For his second attempt, Rohlfs reengineered the desk from feet to finials, creating an extraordinary early example of modular furniture. The two fundamental failures of the *Desk with Overhead Gallery* were the unified construction of the overall desk, which made it virtually immovable, and the prohibitively massive upper cabinet, complete with heavy oak drawers inside.

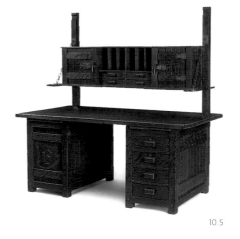

In the 1904 commissioned model, Rohlfs solved both structural issues, successfully creating a *Desk with Suspended Gallery*. The two cases forming the base of this desk are free-standing (fig. 10.3). From the front view, the right proper case is adorned with the initial "F," and the right proper side of the desk has a single door that opens onto an open framework interior with shelves. The left proper case has four drawers with beautifully shaped handles. The tabletop simply sits unjoined atop the two lower cases, and large posts slide on dowels down into the rear post legs of the lower cabinets through holes in the tabletop (fig. 10.4).

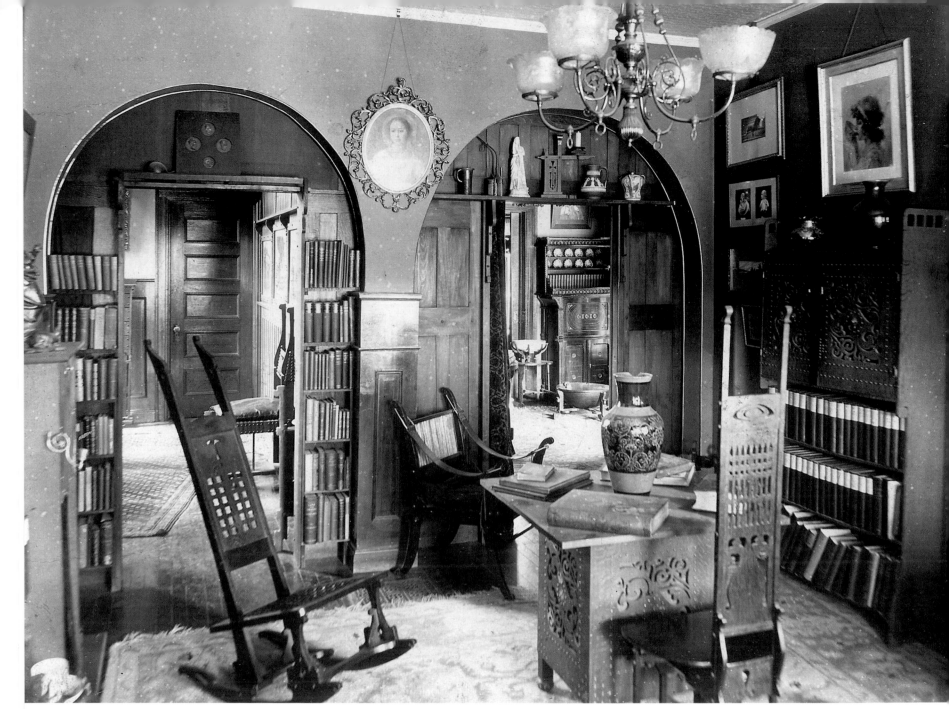

10.15

by his art, and who might be considered, in some ways, the William Morris of this country." His workshop is privileged as the producer of "odd pieces of furniture," which Welch mentions are "signed by the maker with the pride of a master man."

The greatest insight about the Rohlfs furniture in this article comes from that all-important picture of Anna Katharine's study, "where most of her books have been written" (see fig. 4.3). Here we glimpse the Victorian-styled excess in which the Rohlfs family lived. A product of their taste for a rich, enveloping interior and the natural repository for many of Rohlfs's unsold works, the Norwood Avenue house was unrelentingly overdecorated and in many ways diametrically opposed to the restrained spaces being promoted by Stickley's *Craftsman*. For all the clutter, the picture is invaluable as a guide to some of the furniture with which the Rohlfs family lived. We locate in the photograph Anna Katharine's *Writing Desk* and two flanking

magazine bins or wastebaskets. Also identifiable are the 1888 *Settee*, depicted in Charles's drawing for the *Decorator and the Furnisher*, a rocking chair closely related to the 1901 *Tall-Back Rocking Chair*, and a modest version of the *Plant Stand*. In a final domestic flourish, the article pictures "An Inherited Chafing-Dish," on which we are told Rohlfs based his models, "that has been in the family of Anna Katharine Green for one hundred and four years." Given that the "'Rohlfing' Dish" had been patented mere months earlier, the photo was likely placed in the article by Rohlfs to promote his line of chafing dishes and further his canard that they were based on the inspiration of this family heirloom rather than the Gorham chafing dish catalogue.

Even earlier photography, circa 1904, is included in another article from the same period, whose title announces Anna Katharine to be "Buffalo's Most Noted Novelist."[17] The article was written when Anna Katharine's *Millionaire Baby* was "in the publisher's hands," placing it in late 1904, just before the publication of this novel in January 1905. As a lavishly illustrated, first documentation of the Rohlfs's home on Norwood Avenue, this article is invaluable for understanding the environments the couple created for themselves. The unassuming three-story house, shown first in an "Exterior View of the home of Anna Katharine Green," is of modest Victorian design: a typical home in a charming Buffalo neighborhood (see fig. 4.2).

"Her home," the article announces, "is a delightful abode, and the rooms express more than anything else the sense of rest." Certainly to the modern eye the clutter in the pictures might not convey the same sensibility, but the journalist found in the rooms "everything artistic, but nothing lavish to detract from the reposeful atmosphere of the place." Perhaps in comparison to an Aesthetic Movement or Victorian interior, these claims might be warranted, but the sheer volume of objects in each room calls this statement into question. The fusion of Charles and Anna Katharine's artistic pursuits is a focus of the article: "It is seldom one finds a couple so equally gifted. While Mrs. Rohlfs has been called 'an artist of words,' Mr. Rohlfs has won a name for himself in the designing of furniture, to which he applies the principles of beauty and utility."[18] The article meanders off its topic, Anna Katharine Green, to suggest something about the importance of her husband's furniture. "He has developed his artistic faculties until the results are such that his work is nearly as well known abroad as in this country. He is looked upon as the originator of the art movement in furniture in America and received special mention from the King and Queen of Italy for the beauty of his exhibit at the Turin Exposition, he being the only American invited to exhibit."[19]

The copious pictures offer the most insight into the works by Rohlfs with which the family lived. A large photograph documents the sitting room and parts of two other rooms visible through a pair of arched doorways (fig. 10.15). Objects identifiable in the picture include, in the foreground left, a version of the *Tall-Back Rocking Chair*, likely the one identified in the *Book News Monthly* photograph of Anna Katharine's study. In the rear ground is a side chair modified from its original state as the *Chair with Leather Seat and Back*, pictured in *House Beautiful* in January 1900. The original form seems to have had a number of structural flaws, including the elaborate cross-stretcher, which by this point had been removed and replaced by braces for the legs at the floor. The object is extant today, but the leather straps on its seat and back have been replaced with simple wood boards.

Near the center of the picture we can identify an example of Rohlfs's "Man's Chair," based on a Greek chair design, in oak with slung leather straps for armrests and an upholstered seat cushion. The chair's backrest is vertically set in an odd fashion with leather or upholstery strips in a style Rohlfs used only occasionally. There is one extant example of this *Man's Chair with Slung Leather Arms* with intact leather arm straps and a nicely fretted and carved backrest.[20]

To the right and forward in the picture an example of the *Hall Chair*, its back to the camera, sits at a wonderful (unfortunately unknown) rectilinear table with elaborate fretwork

screens below and an overhanging platform tabletop. The fancy fretted panels that make up the sides of the table echo the designs in the Rohlfs bookcase at the right edge of the picture, as well as the fretting on the *Writing Desk* in Anna Katharine's study, all three significantly influenced by Victorian design. At the right rear ground, an example of the "Cresset" candlestick sits on a ledge above the doorway. In the next room, an example of the coal hod form is visible, as well as the *Trefoil Table*, set with a small oak pedestal holding a glass or ceramic bowl.

In the next photograph in the article (unfortunately not reproducible) the viewer has moved through the right doorway in the previous picture and is now standing just past that doorway in yet another parlor or sitting room. Overhead is a chandelier that recalls the "big candlestick, as large around as a barrel hoop and with sockets for a half a dozen candles," shown in Rohlfs's Dutch Kitchen installation at the Pan American Exposition. Rohlfs also designed the overmantel, whose branching vertebral structure evokes the work of German, Belgian, and French Art Nouveau designers (see fig. 10.16). The complex interlocking structure crosses candelabra imagery with vegetal motifs, terminating at the top with diamond-shaped latticework, all of which call to mind the designs of Victor Horta, Richard Riemerschmid, and Henry van der Velde.

In the next room, to the rear, the pierced and carved "Chime Call" is attached at the right side of the door jamb (see page 261). Below it sits an example of Rohlfs's "Curate's Delight" stand (see fig. 10.33), covered in what appear to be cups and saucers from a coffee or tea service. The cruciform hanging candelabrum with fretwork can also be seen in the next room, along with his dining chairs. Noteworthy, too, is the elaborate *Lamp* with kappa shell shade, which likely dates from around the time the photo was taken in late 1904 (see fig. 9.26). In later period photography, this room included Rohlfs's *Folding Screen* (see fig. 7.34).

The last picture in the article (also not reproducible) provides another perspective on the beautiful hanging candelabrum and, in the distance, the *Lamp*. The large dining table with elaborate carved feet is surrounded by six chairs (fig. 10.17). In the center is a lovely, small oak pedestal holding a ceramic or glass bowl. The most notable piece of furniture is the large hanging *China Cabinet* with an elegant corner server set underneath it. As depicted here, the *China Cabinet* has a different overall sensibility from when it was shown in *House Beautiful* in January 1900 (see fig. 5.8). By 1904, the *China Cabinet* was installed with a large lobed gallery above rather than the spiked finial shown earlier. The simpler effect focuses attention on the cabinet, especially its glazed doors with exquisite fretwork. I must mention, however, the decorative excess with which the rooms are organized. This room is complete with gaudy Victorian wallpaper, typical of the period but at odds with the more austere Arts and Crafts design sensibility.

Notably missing from any of these pictures is one other object from the Rohlfs home, which may have been created around this time: the charming *Wastebasket*, which descended in the Rohlfs family (fig. 10.18). This fascinating undated object defies categorization in terms of either Rohlfs's overall output or American design more generally. Composed of an open framework of carved posts, the *Wastebasket*, which later sat next to Anna Katharine's desk in the Park Street house, suspends a sack from four rings in a formation reminiscent of the structure of the early *Crib* and the 1903 *Plant Stand*. Elegantly proportioned arches in the base, ovoid piercings above, and carved finials that relate back to Rohlfs's design for the finials on his celebrated *Hall Chair* complete the design for this unusual *Wastebasket*. The open sensibility and sophisticated geometry relate the *Wastebasket* to an equally sophisticated *Rocking Stool*, likely made around the same time and donated by Roland Rohlfs to the Princeton University Art Museum (fig. 10.19).

10.16 Interior of the Rohlfs home on Norwood Avenue, ca. 1905. The Winterthur Library. Gift of American Decorative Art 1900 Foundation.
10.17 Dining room of the Rohlfs home on Norwood Avenue, ca. 1908. The Winterthur Library. Gift of American Decorative Art 1900 Foundation.

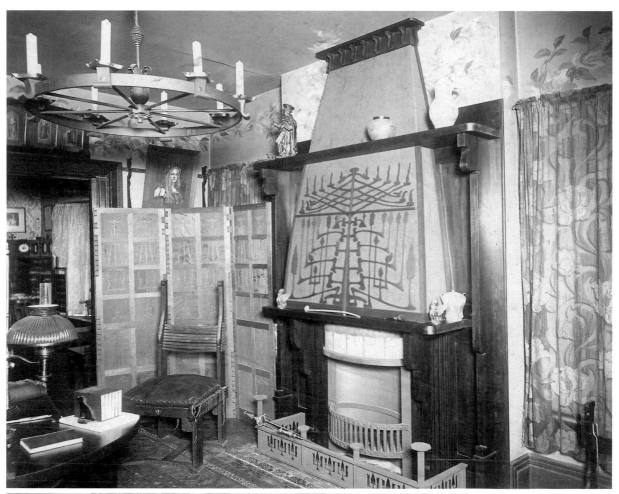

10.16

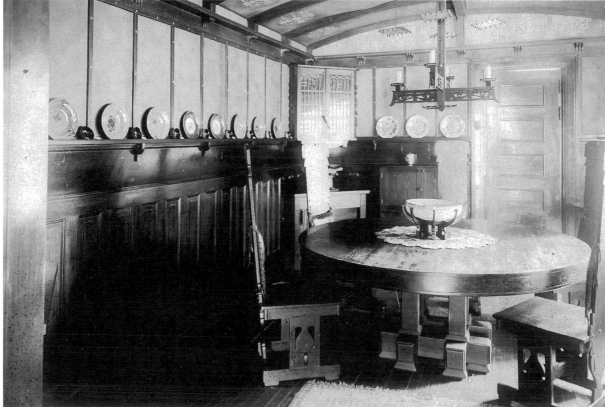

10.17

CHAPTER 11

GROWING OLD GRACEFULLY

As Charles Rohlfs settled into a new phase of his life, with furniture-making playing a less central role, Anna Katharine suffered troubled years between 1907 and 1909.[1] Plagued by fatigue, depression, and nervous strain, she alternated periods of extreme productivity with bouts of illness and hospitalization. The family reunited for a common goal along the lines of their interest in literature and theater when the Twentieth Century Club presented *The Physician in Spite of Himself* with Charles playing the leading role as he had so often before, and with daughter Rosamond playing the nurse.[2]

Decorative art continued to captivate the designer. In 1907, Rohlfs made a stunning ebonized oak stand featuring beautiful and complex bowed fretwork reminiscent in shape to a swan's neck (fig. 11.2).[3] This stand was made specifically and ingeniously to hold a very large Bohemian glass vase with metal overlay, marked on its base with the name of a Venetian glass retailer. How the couple acquired the piece is not known. They may have purchased the vase when they visited Venice or another European city in 1890 or received it later as a gift.[4]

Rohlfs continued to serve on the advisory and decorations committees for the Buffalo Industrial Exhibition, held at the Convention Hall under the direction of the Manufacturers' Club. By 1905, Rohlfs was director of the Manufacturers' Club, which was subsumed by the Buffalo Chamber of Commerce in 1910. He used his skills as an orator, diplomat, and manager to protect and promote members' interests and furthered the club's political involvement in local governance. On 16 December 1908, the *Buffalo Evening News* reported:

> As to the decorations there is only one opinion and that is the general statement that Convention Hall never before looked so beautiful as it looks every day and night this week as the result of the work of Chairman Charles Rohlfs and his coworkers. There is some dispute among visitors as to the more appropriate characterization of the yellow which is the most dominant tone in the color scheme. Mr. Rohlfs calls it "summer sunshine" but another member of the committee insists that "Autumnal Hale-o" would be a more fitting name. By strange coincidence the dissenting committeeman is W. H. Hale who executed Mr. Rohlfs' plans.
>
> Mr. Rohlfs finds one fly in his ointment and that is a huge shirt that stands with sleeves outstretched like a heroic scarecrow in a Missouri cornfield above the exhibit of the Buffalo Shirt Company. Mr. Rohlfs would like to see something—or anything—happen to that shirt.

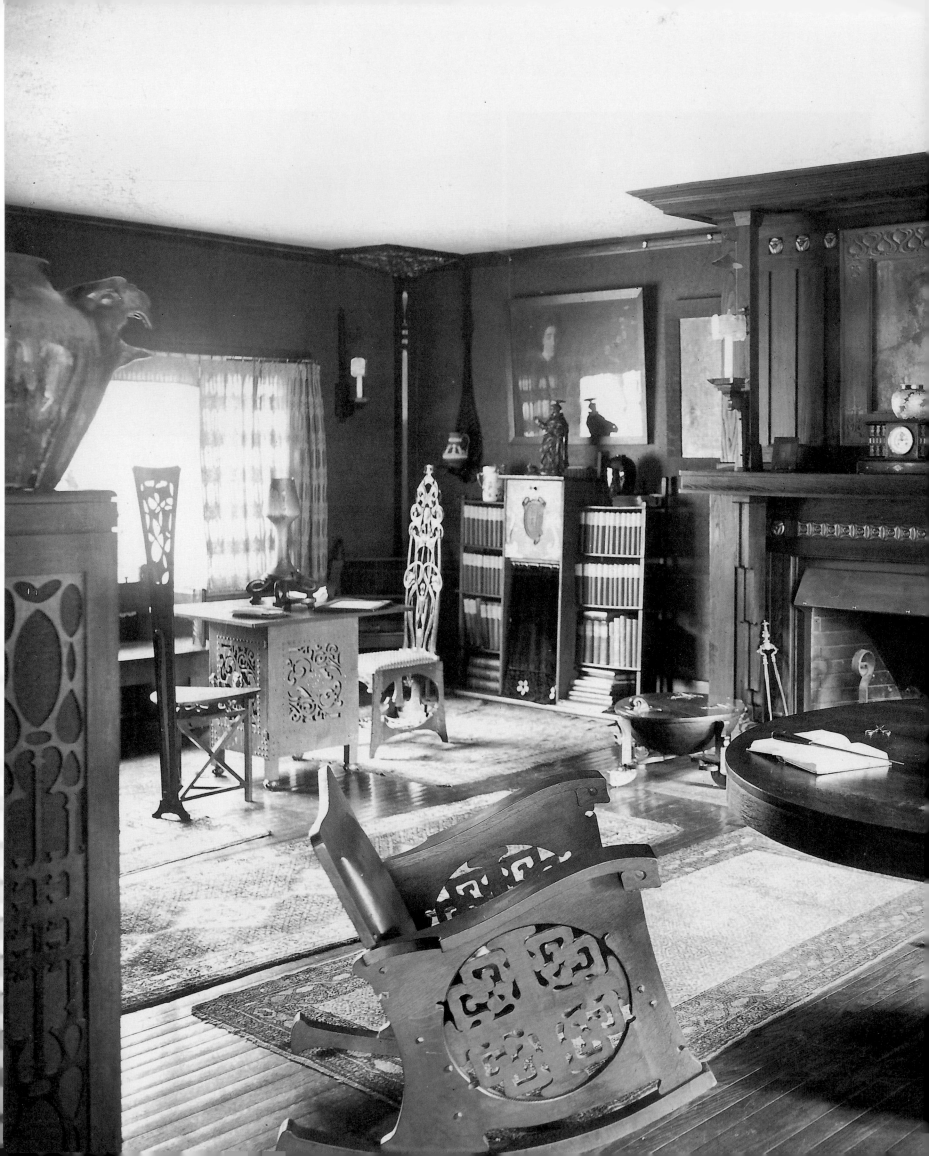

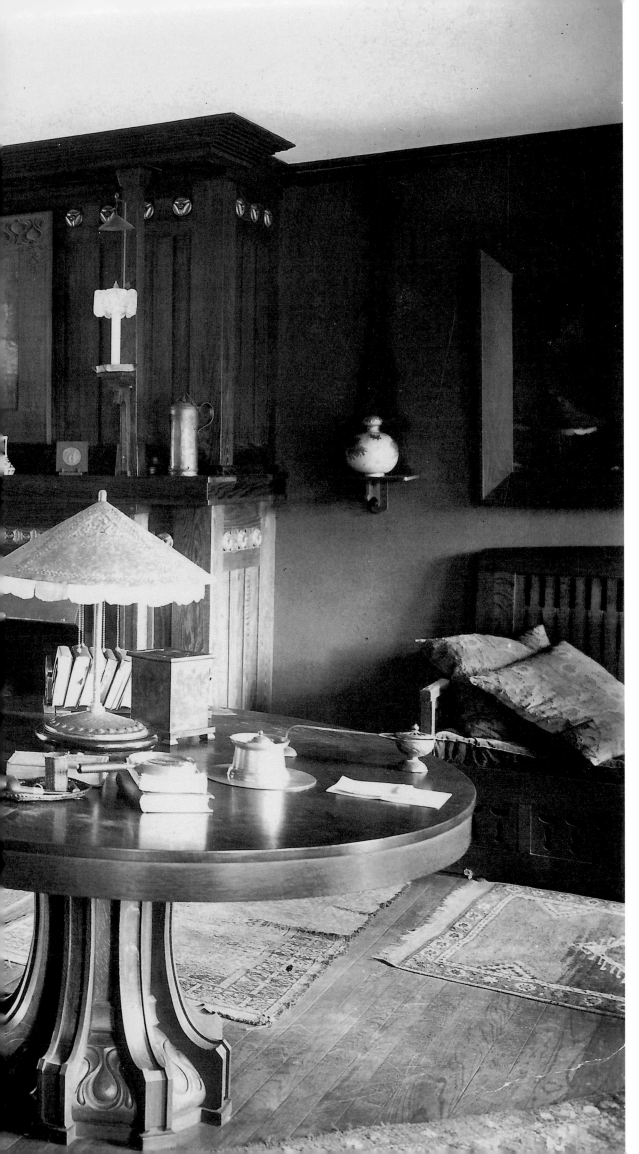

11.5 Living room of the Rohlfs
home on Park Street, ca. 1920.
The Winterthur Library.

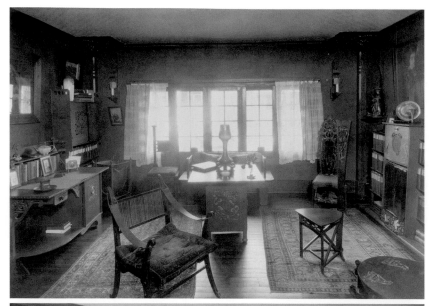

11.6

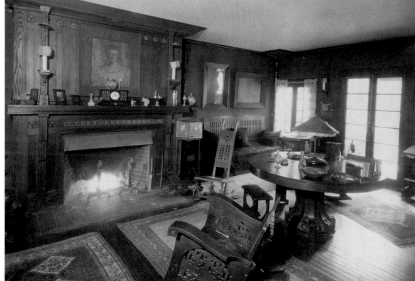

11.7

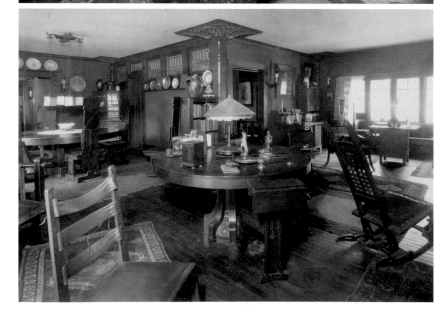

11.8

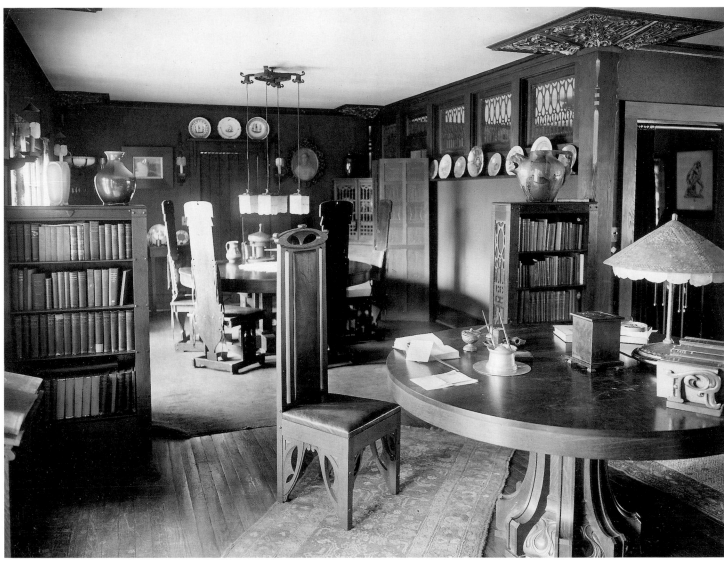

11.9

The Park Street bedroom is furnished with the 1904 *Octagon Table* (fig. 11.11) and the early *Kneeler* (fig. 11.10). The *Dresser with Mirror* (like the one shown at the Pan American Exposition) that was shown in the 1907 portfolio is now outfitted with electrified versions of the *Carved Candle Stands*. Also present are a small rocker, andirons, and a triangular hanging cabinet. One object not seen in prior photographs is a floral folding screen, which unfortunately is not known to exist today.

Although the interiors Rohlfs designed for patrons demonstrate his interest and skill in creating beautiful and harmonious environments, the Rohlfs home must be viewed as a collection of extraordinary objects, perhaps too packed into a relatively small space to be appreciated as they can be when seen in a purer setting. The greatest collection ever assembled of Charles Rohlfs's decorative art objects was his own. Their assemblage may not have created a sublimely beautiful environment, but the works must have given enormous pleasure to Anna Katharine and Charles.

11.6 Living room of the Rohlfs home on Park Street, ca. 1920. The Winterthur Library.
11.7 Living room of the Rohlfs home on Park Street, ca. 1920. The Winterthur Library.
11.8 Living room and dining room of the Rohlfs home on Park Street, ca. 1920. The Winterthur Library.
11.9 Living room and dining room of the Rohlfs home on Park Street, ca. 1920. The Winterthur Library. Gift of American Decorative Art 1900 Foundation.

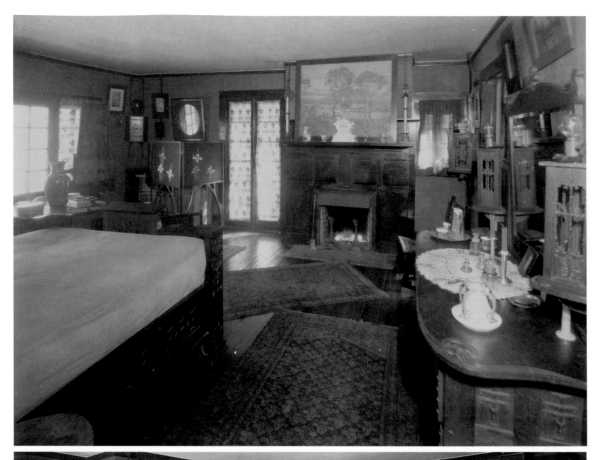

11.10

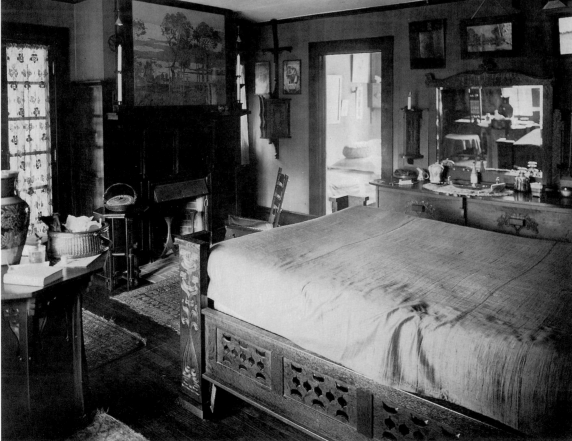

11.11

CIVIC PURSUITS

A year after Charles and Anna Katharine built their new home on Park Street, the family celebrated Rosamond's marriage to Robert Twitty Palmer on 10 May 1913. The "new artistic home" was the site of the reception that followed the wedding at Buffalo's First Presbyterian Church.[12] Around this time the Rohlfses' second-born, Sterling, now in his mid-twenties, was settling in Colorado. With two children out of the home, Charles and Anna Katharine were free to pursue a variety of interests. This seems to have been easier for him than for her, as Anna Katharine continued to suffer from illness, often requiring "time away."[13] Charles, in contrast, embraced the decline of his furniture business by doing what came naturally to the one-time oven designer, one-time actor, and one-time furniture-maker: he found new pursuits.

Rohlfs's decision in 1911 to donate the *Clock* he had made in 1901 for the Pan American Exposition to the Automobile Club's Country Clubhouse in Clarence, New York, of which he was a member, may be understood as a formal end to his career as a furniture-maker.[14] As the *Buffalo Motorist* reported in March 1911, "The accompanying picture gives but faint conception of the beauty and richness of the clock recently presented to our club by our member, Charles Rohlfs." A place of honor had been picked out for the clock: "This magnificent timepiece is to grace the head of the grand stairway in our new Country home at Clarence." The club was well aware of the importance of the clock, calling it "a work of skillful art and is readily distinguished as a most estimable combination of usefulness and ornamentation." All this attention must have pleased Charles greatly.

By 1913, Rohlfs had transitioned into his new career as political adviser and city leader in the Buffalo Chamber of Commerce. Having become chairman of the house committee by 1913, he supervised the decoration of the interiors for the chamber's new offices and club facilities. A leader in industrial reform, Rohlfs traveled to Chicago and to Madison, Wisconsin, to gather information on the movement toward regulations for factory work conditions and on the grassroots organizations in the central United States that were leading the push toward establishing government commissions on industry.

As chairman of the Committee on Educational Interests, Rohlfs was a leader in improving education in greater Buffalo. He urged the community to improve school facilities and equipment and advocated the teaching of hygiene and training in vocations, neither of which was standard at the time. Remembering his education at the Cooper Union, Rohlfs led the Chamber of Commerce's efforts to establish an Industrial Education and Vocational Guidance Committee, as well as a bureau of the same name to oversee the implementation of the committee's initiatives.

By 1915, Charles Rohlfs received recognition for his contributions to yet another field. Visiting schools of industrial education around the country, Rohlfs surveyed educational initiatives and met with leaders in Illinois, Indiana, Ohio, Wisconsin, and Washington, D.C. He received national attention when William Hawley Smith covered his role in Buffalo industrial education in the *Industrial-Arts Magazine* in April 1915.[15]

The Central Council of Business Men's Organizations eventually elected Rohlfs, then the director of the Chamber of Commerce, president of its umbrella organization for Buffalo's sundry local associations. The *Buffalo Live Wire* suggested of Rohlfs's qualifications, "The new president will bring to his duties that balance of mind and poise of judgment, that sense of humor, that patience with mankind, that has proved his excellent equipment for public service, and no doubt during the ensuing term his leadership of the Central Council will be of value. He is a worker who will make the council felt in its sum total, as well as in its affiliation memberships."[16] Serving three terms, Rohlfs was occasionally criticized by members for his tendency to comment publicly on politically charged issues. Many of these subjects, including

11.12

11.13

11.10 Bedroom of the Rohlfs home on Park Street, ca. 1920. The Winterthur Library.

11.11 Bedroom of the Rohlfs home on Park Street, ca. 1920. The Winterthur Library. Gift of American Decorative Art 1900 Foundation.

11.12 Rosamond Rohlfs, ca. 1913. Rohlfs Family Archive.

11.13 Anna Katharine Green in the backyard at 156 Park Street, ca. 1915. The Winterthur Library.

ILLUSTRATIONS OF WORKS BY CHARLES ROHLFS
IN THE METROPOLITAN MUSEUM OF ART

In 1985, Professor Robert Judson Clark of the Department of Art and Archaeology at Princeton University donated to The Metropolitan Museum of Art a set of printed advertising cards and pamphlets published by Charles Rohlfs to promote his work. These include a single advertising card showing a flower holder, consisting of a carved mahogany stand and test tube; a leaflet (circa 1904) showing six models of casserole chafing dishes offered by Rohlfs; and a set of seventy unbound leaves, published on 1 November 1907, illustrating objects made by Rohlfs. These are some of the most important contemporary visual records of Rohlfs's work. Aside from several early Marshall Field and Company advertisements and a few solicitations in, for example, *Good Housekeeping*, they are the only records we have of Rohlfs's attempts to market his works. In a number of instances, the illustrations provide the only known documentation of designs for forms that are no longer extant. I am grateful for the crucial assistance from the Departments of Prints and Drawings and American Decorative Arts at The Metropolitan Museum of Art and for their willingness to make this important research material available to the public.

Pages 242–263. Printed Advertising Cards and Pamphlets, ca. 1904 and 1907. The Metropolitan Museum of Art, Gift of Robert Judson Clark, 1985 (1985.1119.1–.75).

"Bachelor"

HEIGHT, 15 INCHES, PRICE, $15.00

All Genuine Pieces are Branded
t h u s

with the date

Charles Rohlfs

200 The Terrace

Buffalo,
N. Y.
U. S. A.

Member Society of Artists
London.

PRICES F. O. B. BUFFALO

———

ALL CASSEROLES 9 INCHES
IN DIAMETER

The "Rohlfing" Dish

PATENTED JUNE 14, 1904

HEIGHT, 18 INCHES, PRICE, $25.00

22—

PASTOR'S—Continuous Performance.
THIRD AVENUE—A Child of the Slums.

NEW YORK SUNDAY JUL. 31, 1904.

*This paper has the largest circulation in
the United States.*

TWO OF KAISER'S SONS
VISIT SWITZERLAND

Princes August Wilhelm and Oscar
Among the Throng at
Interlaken.

[SPECIAL CABLE TO THE HERALD.]
INTERLAKEN, Saturday.—The social event
of this week here was Mr. Deshler
Welch's outdoor Welsh rabbit party, on
the terrace of the Villa Oehrli Haus. The
paraphernalia of the American chafing
dish were the objects of curious interest
to the guests.
Among the great number of visitors
here are the Princes Wilhelm August and
Oscar, two sons of the German Emperor.
The golf putting match contested this
week was won by Mrs. Graham.

SUB-PREFECT ACCUSED

From the Author of

"THE BACHELOR AND
THE CHAFING DISH."

THE CRITIC IN THE
KITCHEN, ETC., ETC.

Dear Rohlfs:
 Besides being "something dif-
ferent," clever, ornamental and
unique, your chafing dish is dis-
tinctly practical. It is really a new
table idea.
Good Things en Casserole.
 Let us change the name "chaf-
ing" and call this a Rohlfing dish!
It's a success.
 Yours always,
 DESHLER WELCH.

For eight years Charles Rohlfs has been
making Casserole Chafing Dishes—being the
originator—in limited quantities. Owing to
their superiority Mr. Deshler Welch—the
highest authority on chafing dish cookery—
suggested that an effort be made to make
enough of them to enable people who cared
to own the genuinely made article to obtain
the same without difficulty or delay.

His suggestion has been followed.

The high standard and unique quality of
the work produced in Mr. Rohlfs' shop will
be upheld, the only difference being that more
artizans will be employed.

The swing-lid "*Rohlfing Dish*" is the
latest style of Mr. Rohlfs' make. Its conve-
nience will be noted at once. It has been pat-
ented for obvious reasons. Like all the pre-
viously made styles it is made of hand ham-
mered copper.

The casserole is made expressly for Mr.
Rohlfs, in Belgium, of the best obtainable
material. It has the added merit of being
thoroughly tempered, and is consequently dur-
able. It is also light and quick in operation.

No effort is made to hide the evidences of
hand-made work. It is offered for sale as
nearly as possible to the condition in which
it leaves the anvil.

A truly artistic adjunct to the home from
the hands of artists.

CHARLES ROHLFS MAKES TO ORDER INTERIORS

FURNITURE TO SUIT ANY PLACE FROM SPECIAL DESIGNS. METAL WORK. WRITING SETS.
CHAFING DISHES, AU CASSEROLE. CANDLE STICKS, IN MANY STYLES. ANNIVERSARY GIFTS OF A UNIQUE CHARACTER.

1985.1119 (73)

"Gothic"

HEIGHT, 21 INCHES
PRICE, . . $20.00

"Medieval"

HEIGHT, 18 INCHES
PRICE, . . $35.00

"Gipsy"

HEIGHT, 12 INCHES
PRICE, . . $20.00

"Safety"

HEIGHT, 17 INCHES
PRICE, . . $30.00

243

520-522 ELLICOTT STREET
NEAR TUPPER STREET
BUFFALO, N. Y., U. S. A.

November 1, 1907.

"His work is strangely suggestive of the days when the world was young, but in spite of that, distinctive of this progressive twentieth century, and strictly American. It has the spirit of to-day blended with the poetry of the medieval ages."

The illustrations are offered to help make selections for gifts at a time of the year when people are usually at their wits end to know what to get for appreciative friends. Any piece shown will please the lover of a good thing well made. Their usefulness makes the remembrance lasting.

I cannot guarantee the delivery of any of the pieces illustrated herewith unless orders are placed before December 1st or earlier. The pieces are not made in quantities — only as ordered — and not at all for "the trade."

Pardon me for adding that my work is considered to be artistic to a degree by competent critics.

NOTE. The illustrations show but a few of the hundreds of pieces made in my shop during the past twelve years.

The larger pieces are shown to call your attention to the fact that I make anything that is used in-doors: Preferably in my own style (not "Mission") from strictly original designs, also in any period or style from special designs to suit the requirements of the user.

CHARLES ROHLFS.

PLEASE NOTE

Anything bearing the brand will be found exactly as described or better, and the workmanship beyond question.

Unless otherwise stated the wood used is thoroughly seasoned Oak or Ash.

The finish is an agreeable brown in matt.

Metal used is either solid brass or copper. The latter is given a Japanese bronze finish.

Heights given include length of candle. Extra candles may be purchased anywhere or can be supplied on request.

The Shell Shades are extra. The shells, **Placenta Orbiscularis**—Retz are found in the China Sea. They are a direct importation, unique in themselves and the use to which they are put, and difficult to secure. I have about 350 on hand now and may not be able to get more.

The shades are adaptable to nearly all the candle holders shown.

All prices given are F. O. B. Buffalo.

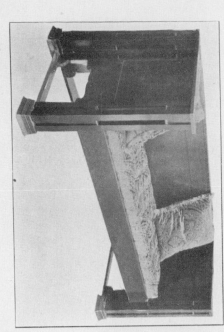

Settle

In mahogany

Cost depends upon upholstering

In oak, fine leather cushions on seat, $100

 Rohlfs, Buffalo

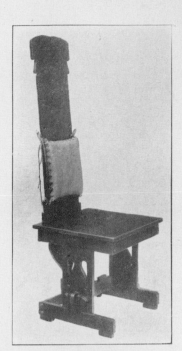

Dining Chair

One-half dozen, $75

oak

Single, (15)

with cushion

 Rohlfs, Buffalo

Man's Chair

You rest one elbow on one strap, throw your
leg over the other and dream dreams The
cigars are on me if this is not comfort

Oak, leather cushions and straps

Plain, $30

Carved, 40

 Rohlfs, Buffalo

Man's Chair

Lady will probably use it when she can

Cost depends upon upholstery

 Rohlfs, Buffalo

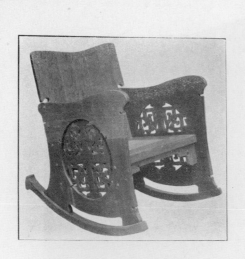

Easy Sitting Rocker

Unusual balance

Cost depends upon upholstery

 Rohlfs, Buffalo

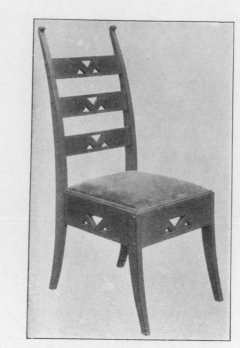

Very easy sitting chair

Cost depending on kind of seat used

 Rohlfs, Buffalo

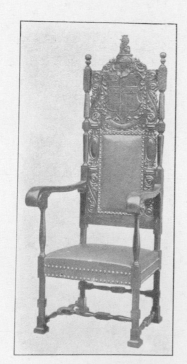

Hall Chair

To order only on account of device

 Rohlfs, Buffalo

Library Table

Top five feet by thirty-three inches
Oak or ash to order

 Rohlfs, Buffalo

Dining Table

Diameter six feet

Quartered oak

Color as required $75

Wild Honey-Suckle
Octagonal Table

Top, thirty-two inches across Two shelves
inside Copper hinge and lock-plates
with Chinese lock $100

 Rohlfs, Buffalo

Octagon Table

Two panels make door for access to two
shelves inside.

Copper hinge and lock plates
Top, thirty-two inches

Oak $27
Ash 25

 Rohlfs, Buffalo

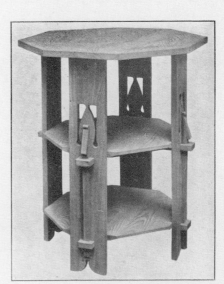

Smoker Table

Top twenty-four inches across

Q. Oak $17
Ash 15

 Rohlfs, Buffalo

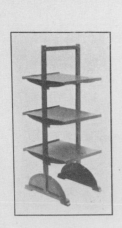

Curate's Delight

Height, thirty-five inches

Quartered Oak, $10

For many different uses Color as required

 Rohlfs, Buffalo

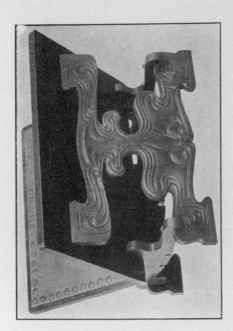

Carved Wood-Holder

Sides, twenty-one inches long Polished copper
insides and wrought nails

Oak, $25

 Rohlfs, Buffalo

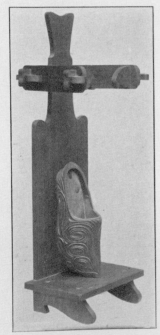

Umbrella Stand

Height, three feet
Holds six umbrellas Safe against having
holes poked through your umbrella
Shoe carved and copper lined $15

 Rohlfs, Buffalo

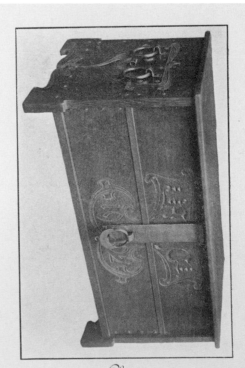

Chest

Top four feet by two feet Oak Mountings
of heavy hammered copper Lower drawer
Trays inside To order only to suit requirements

 Rohlfs, Buffalo

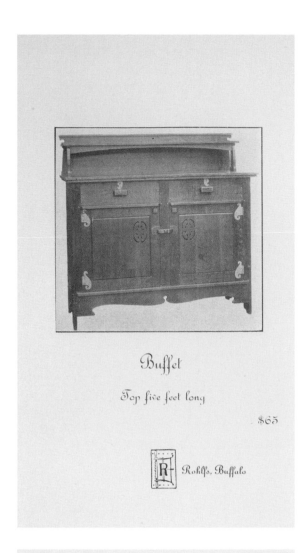

Buffet

Top five feet long

$65

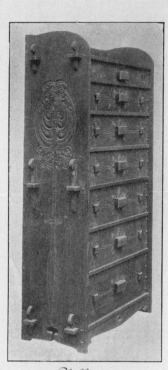

Chiffonier

Height, six feet and six inches

Width three feet Oak, carved, $85

One key unlocks all drawers by use of peculiar steel bolt

Rohlfs, Buffalo

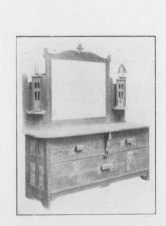

Carved Dresser

Top, six feet long

Larger illustration can be furnished

Color as required $175

Rohlfs, Buffalo

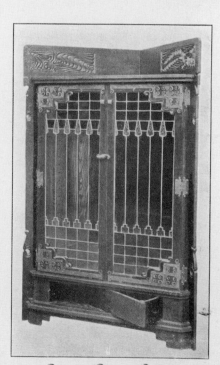

Corner China Cabinet

Height, five feet and eight inches

Oak, metal glazing coppered $125

Rohlfs, Buffalo

Carved Desk

Three feet and eight inches wide

All requirements met inside

Color as required $100

 Rohlfs, Buffalo

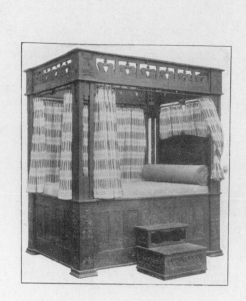

Bed, with Step

Oak, carved $300

 Rohlfs, Buffalo

K.D.

Trinket Box
or for Man's Desk

Double lid Revolves on base Variety of
divisions inside

With initial, $15

Upheld in cut to show carving

 Rohlfs, Buffalo

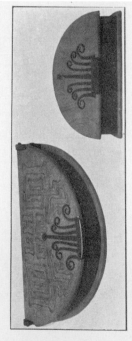

Trinket Boxes

Six inch one, with scrolled copper hinge $3

Twelve inch one, with scrolled lock plate
and initials $15

Both dull grey finish Pocket divisions

 Rohlfs, Buffalo

Statesmen Frame

Sight, eight by ten and one-half inches,
with picture $7

 Rohlfs, Buffalo

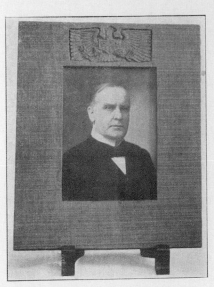

Carved Frame

Oak, sight seven and seven eighths by five and
five eighths $4

 Rohlfs, Buffalo

Panel used on wainscoating in New York
City residence

 Rohlfs, Buffalo

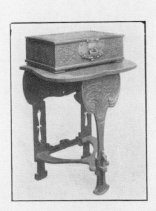

Carved Box

Twenty-two inches long, $40

Mountings copper

Carved Table, $30 Quartered oak

Color as required

 Rohlfs, Buffalo

No. 1 Eddystone

Height, twenty-one inches

$2

 Rohlfs, Buffalo

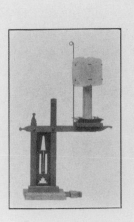

No. 2 Cresset

Height, fifteen inches

$2.50

 Rohlfs, Buffalo

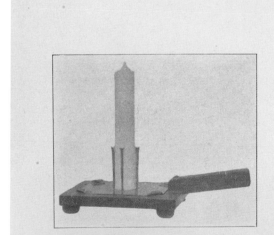

No. 3 Plumber

Height, nine inches

Polished copper and oak

$1.25

 Rohlfs, Buffalo

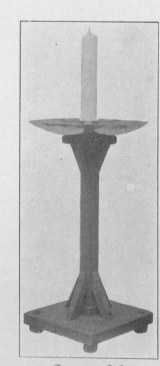

No. 4 Beacon Hill

Height, twenty-two inches
Oak, polished copper $2.50

 Rohlfs, Buffalo

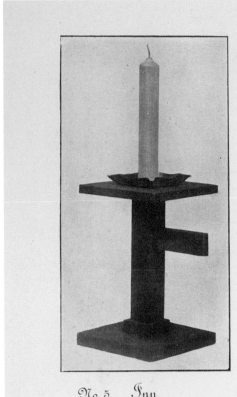

No. 5 Inn

Sixteen inches high, oak $1.75

200

 Rohlfs, Buffalo

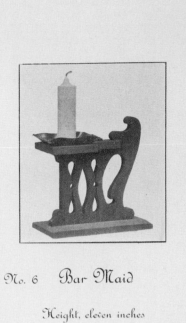

No. 6 Bar Maid

Height, eleven inches

$1.25

 Rohlfs, Buffalo

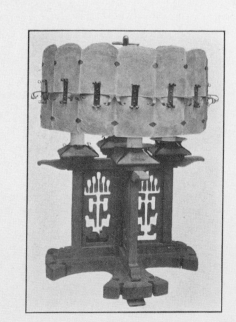

No. 9 Banquet

Height, eighteen inches
Oak with shell shade

$40

 Rohlfs, Buffalo

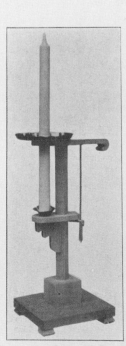

No. 10 Rush Light

Height, twenty-four inches
Oak and copper $2.25

 Rohlfs, Buffalo

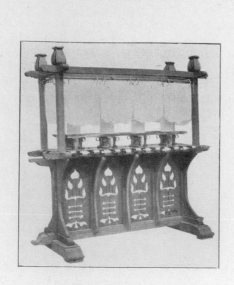

No. 12 Banquet

Oak, polished copper and shell shades
Height, sixteen inches

$15

 Rohlfs, Buffalo

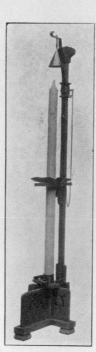

No. 17 Chinese
Height, thirty-six inches
Candle dark red, oak, dull copper $3.50

 Rohlfs, Buffalo

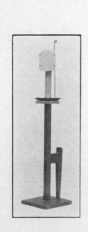

No. 20 Heidelberg

Height, twenty-seven inches

$1.50

 Rohlfs, Buffalo

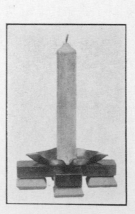

No. 21 Zuiderzee

Height, ten inches

$1

 Rohlfs, Buffalo

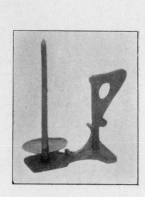

No. 24 My Lady

Height, five and one-half inches

Excellent as favors for pretty affairs, luncheons, etc.

One-half dozen, with two dozen candles

$1.50

 Rohlfs, Buffalo

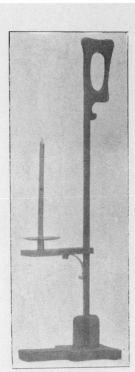

No. 25 The Sylph

For party favors Height, fifteen inches
Half dozen with two dozen candles $3

 Rohlfs, Buffalo

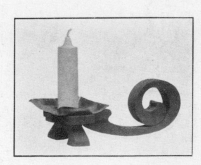

No. 29 Andiron

Height, six and one-half inches

$1

 Rohlfs, Buffalo

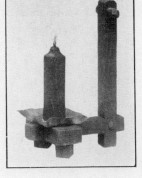

No. 30 Andiron

Height, ten inches

$.50

 Rohlfs, Buffalo

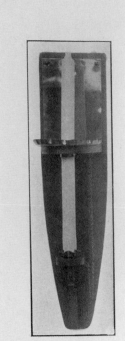

No. 31 Seonce
Cranmer
Height, eighteen inches
Ash back $2
Candle rich red

No. 19 Seonce
Cathedral
Height, thirty-nine inches
Oak $6
Candle rich red

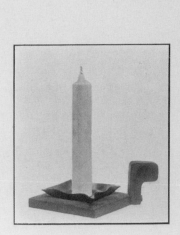

No. 33 Oom Paul

Height, five inches

$.75

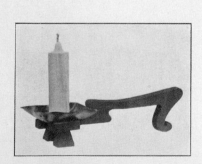

No. 34 Andiron

Height, six inches

$1

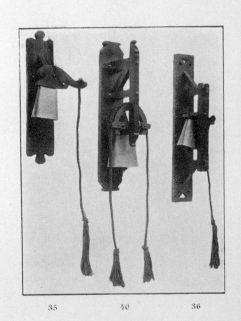

35 40 36

Tintinabulators

No. 35	Eighteen inches high	$1.75
No. 40	Twenty-two "	2.75
No. 36	Twenty-four "	2.25

No. 37 Call Bell
Height, three feet
Bell and clapper hanger polished brass
Carved back $9

 Rohlfs, Buffalo

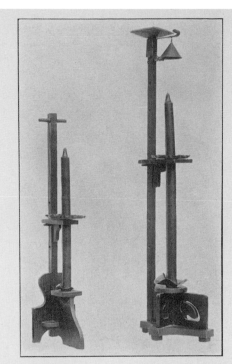

No. 38 Chinese No. 39 Chinese
Height, twenty inches Height, twenty-eight inches
Candle rich red Candle rich red
Ash $1.50 Ash $2.25

 Rohlfs, Buffalo

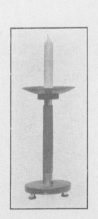

No. 41 The Duchess

Height, twenty-two inches

Solid mahogany and polished brass

$3.50

 Rohlfs, Buffalo

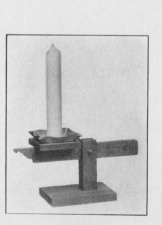

No. 43 Pathfinder

Height, ten inches

$1

 Rohlfs, Buffalo

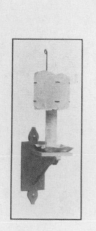

No. 44 John Jay

Height, fourteen inches

$1

 Rohlfs, Buffalo

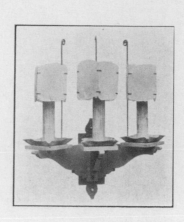

No. 45 Alexander Hamilton

Three branch bracket

Height, fourteen inches $5.50

 Rohlfs, Buffalo

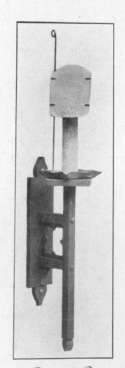

No. 46 Daniel Boone
Height, twenty-one inches $1.50

 Rohlfs, Buffalo

No. 47 Puritan

Height, twenty-three inches

$4

 Rohlfs, Buffalo

No. 48 Patrick Henry

Height, twenty-one inches

$3.50

 Rohlfs, Buffalo

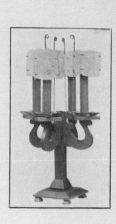

No. 49 The President

Height twenty-one inches

Solid mahogany Rubbed finish

Polished Brass $6

 Rohlfs, Buffalo

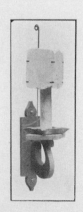

No. 50 Patriot

Height, fourteen inches

$1

 Rohlfs, Buffalo

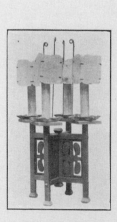

No. 51 Ben Franklin

Height, twenty inches

$4

 Rohlfs, Buffalo

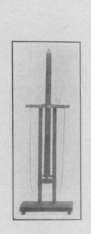

No. 32 Patrician

Height, thirty inches

Candle twenty-four inches long, rich red

$3.50

 Rohlfs, Buffalo

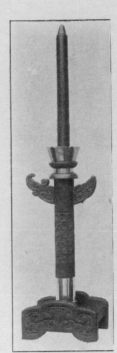

No. 53 Imperial Chinese

Height, three feet and three inches

Solid mahogany and polished brass Carved
surfaces dull, others polished $20

 Rohlfs, Buffalo

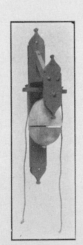

No. 54 Tokio

Double bell

Height, eighteen inches

To hang outside of room door

$3

 Rohlfs, Buffalo

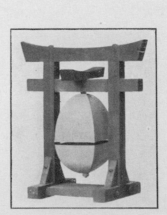

No. 55 Shinto Torri

Double bell

Height, ten inches

$3

 Rohlfs, Buffalo

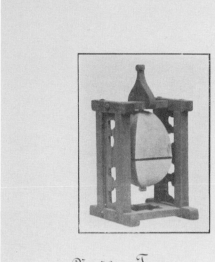

No. 56　Togo

Double Bell

Height, ten inches

Call or table bell

$3

 Rohlfs, Buffalo

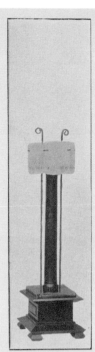

No. 57　Martha Washington

Height, twenty-five inches with octagonal shell
shade　Polished brass trim

Solid mahogany base　　　　Rubbed finish

Candle rich red

 Rohlfs, Buffalo

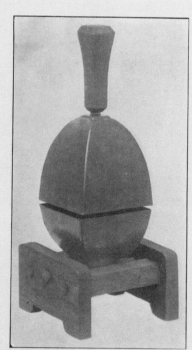

Nogi

A decided departure in bells; not hung;
it oscillates　Sleigh-bell effect　$2
Japanese bronze finish

 Rohlfs, Buffalo

Chime Call

Height, seven feet and six inches
Swings back against wall　Bracket carved both
sides　Coppered tubes, polished, oak　$20

 Rohlfs, Buffalo

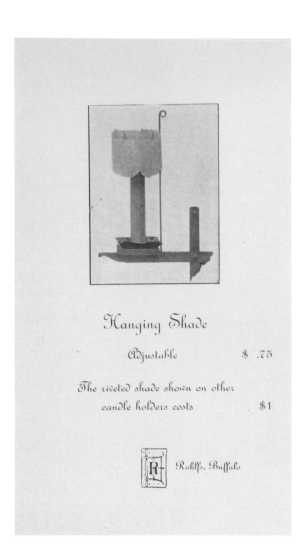

Hanging Shade

Adjustable $.75

The riveted shade shown on other
candle holders costs $1

Shell Shade

Adjustable $.50

A Flower Holder

Frame is made of Solid Mahogany
supporting a glass tube (test tube)
eight inches deep

Designed and Made by

Charles Rohlfs

200 The Terrace, Buffalo, N. Y.

NOTES

INTRODUCTION

Author's note: Heartfelt thanks to Bruce Barnes and Joseph Cunningham, who generously welcomed me into their long-term research project and supported my contribution to this book from day one. Likewise to Liza Ortman for her hospitality and talents as a family historian. For invaluable guidance and editing help, thanks to Jonathan Prown. For other important conversations and research suggestions, thanks to Glenn Adamson, David Cathers, Edward S. Cooke, Jr., Bert Denker, Ellen Denker, Barbara and Henry Fuldner, Michael James, Ethan Lasser, Arlette Klaric, Cheryl Robertson, Timothy James Scarlett, and Steven A. Walton. For research and illustration assistance, thanks to Patricia Virgil at the Buffalo and Erie County Historical Society Library, Amy Pickard at Buffalo and Erie County Public Library, and Carol Salomon at the Cooper Union Library.

1. Clemens, "New Art and New Artist," 586.
2. Houk, "Artist Who Works in Wood."
3. Stark, "Back Stairs."
4. The suggestion that Peter Rohlfs was a "successful cabinet-maker" appears in Hartford, "Charles Rohlfs," 194. The suggestion that Peter Rohlfs was a "manufacturer of pianos" appears in Jarvis, "Men You Ought to Know."
5. Hartford, "Charles Rohlfs," 194. Records at the Cooper Union indicate that Rohlfs enrolled in both the School of Science and the School of Art, an unusual course of study at that time. I am grateful to Carol Salomon at the Cooper Union Library for this insight.
6. Brooklyn City Directories for the years 1871 through 1882 were accessed on microfilm at The Winterthur Library: Joseph Downs Collections of Manuscripts and Printed Ephemera, Winterthur, Del.
7. The best source on the design and creation of stoves in this era is Tammis Kane Groft, *Cast with Style: Nineteenth Century Cast-Iron Stoves from the Albany Area*, rev. ed. (Albany, N.Y.: Albany Institute of History and Art, 1984).
8. Groft, *Cast with Style*, 24–25.
9. Many handbooks for pattern makers were published in Rohlfs's time and shortly afterward that offer considerable insight into the skills and knowledge that he would have had: see Joshua Rose, *The Pattern Maker's Assistant* (New York: D. Van Nostrand, 1878); Isaac McKim Chase, *The Art of Pattern-Making: A Comprehensive Treatise* (New York: John Wiley and Sons, 1903); and Edmund C. Hanley, *Wood Pattern Making* (Milwaukee: Bruce Publishing, 1922–1924).
10. Rose, *Pattern Maker's Assistant*, 15–19.
11. Rose, *Pattern Maker's Assistant*, 244–247.
12. Zetterholm, Rohlfs family history.
13. Stark, "Back Stairs."
14. The most comprehensive source on the Aesthetic Movement in America is Doreen Bolger Burke et al., *In Pursuit of Beauty: Americans and the Aesthetic Movement* (New York: The Metropolitan Museum of Art and Rizzoli, 1986).

15. Clifford Edward Clark, Jr., *The American Family Home, 1800–1960* (Chapel Hill: University of North Carolina Press, 1986), 103.
16. Mary Warner Blanchard, *Oscar Wilde's America: Counterculture in the Gilded Age* (New Haven and London: Yale University Press, 1998), 87–89.
17. "A Roman Studio," *Decorator and Furnisher*, December 1884, 86–87, as cited in David Park Curry, *James McNeill Whistler: Uneasy Pieces* (Richmond: Virginia Museum of Fine Arts, Richmond, in association with Quantuck Lane Press, New York, 2004), 121.
18. Handwritten notes, n.d., Rohlfs Family Archive.
19. "Drawing Room," *Art Interchange*, 19 January 1882, 14, as cited in Blanchard, *Oscar Wilde's America*, XII.
20. For more on Oscar Wilde, the Aesthetic Movement, and his trip to the United States, see Blanchard, *Oscar Wilde's America*; also Diane Chalmers Johnson, *American Art Nouveau* (New York: Harry N. Abrams, 1979), 17–22.
21. Oscar Wilde, "The English Renaissance," in Robert Ross, ed., *The First Collected Edition of the Works of Oscar Wilde, 1908–1922*, vol. 14 (London: Dawsons of Pall Mall, 1969), 251.
22. Oscar Wilde, "House Decoration," in Ross, *Works of Oscar Wilde*, 287.
23. Rohlfs, "True and False in Furniture."
24. Rohlfs, "True and False in Furniture."
25. Roger B. Stein, "Artifact as Ideology: The Aesthetic Movement in Its American Cultural Context," in Burke et al., *In Pursuit of Beauty*, 39.
26. Rohlfs, "Address to Arts and Crafts Conference."
27. Wilde, "House Decoration," 282.
28. U.S. Design Patent No. 17,000. For more on Japonisme in the United States, see William N. Hosley, *The Japan Idea: Art and Life in Victorian America* (Hartford, Conn.: Wadsworth Athenaeum, 1990).
29. U.S. Patent No. 360,784.
30. Rohlfs and Green, Diaries for Rosamond and Sterling, 1 August 1886.
31. Comparative statistics for stove companies were published annually. In 1874, Jewett and Root (as the company was called before Josiah Jewett bought out his father's partner, F. A. Root) produced "5000 tons stoves" a year, whereas the companies in New York City produced less than 1,000 tons each. Other large companies in New York State thrived in Albany and Troy, but none produced more than 3,000 tons. *Wiley's American Iron Trade Manual of the Leading Iron Industries of the United States*, Thomas Dunlap, comp. and ed. (New York: John Wiley and Son, 1874), 334–348.
32. Groft, *Cast with Style*, 21.
33. Sherman S. Jewett and Co., *Semi-Centennial* (Buffalo, N.Y.: Matthews, Northrup, 1886), 51.
34. The Jewett company records have been lost, so there is no way to know whether Rohlfs was fired or quit. As one source indicates, Jewett may have hired him as a manager, in which case Rohlfs may have felt too removed from the design process and left to find a new artistic outlet. Given a probable inheritance from Anna Katharine's father and ongoing illnesses, their

departure may very well have been personal. See Jarvis, "Men You Ought to Know."
35. Stark, "Back Stairs."
36. Rohlfs and Green, Diaries, 20 March 1887.
37. Clark, *American Family Home*, 121.
38. Steven M. Gelber, *Hobbies: Leisure and the Culture of Work in America* (New York: Columbia University Press, 1999), 155–192.
39. Gelber, *Hobbies*, 188–192.
40. Peg Woffington, *Chicago Times-Herald*, 28 December 1895.
41. "Romance Which Caused Chas. Rohlfs to Leave the Stage and Find Fame and Fortune in a Peculiar Occupation," *St. Louis Globe-Democrat*, as cited in *Clippings*, "A Bit of Romance," sheet 12. All Buffalo City Directories cited hereafter were accessed on microfilm at the Historical Society Stacks at the University of Wisconsin–Madison for the years 1887 through 1913. All were published by Courier Company in Buffalo. The directories for 1887–1901 are on rolls P76-6883 through P76-6847. The directories for 1902–1913 are on rolls P92-9603 through P92-9608.
42. Diffin, "Artistic Designing of House Furniture," 5.
43. Welch, "Charles Rohlfs, Laborer." 69.
44. For more on the idea of handwork in Arts and Crafts furniture, see Edward S. Cooke, Jr., "Arts and Crafts Furniture: Process or Product?" in Kardon, *Ideal Home*, 64–76.
45. For further descriptions of Rohlfs's construction methods, see Cooke, "Arts and Crafts Furniture: Process or Product?" in Kardon, *Ideal Home*, 64; Elizabeth Cumming and Wendy Kaplan, *The Arts and Crafts Movement* (London: Thames and Hudson, 1991), 164; Robert Edwards, "The Art of Work," in Kaplan, *Art That Is Life*, 230; and Catherine Zusy, "Bench," in Kaplan, *Art That Is Life*, 237–240.
46. Clemens, "New Art and New Artist," 588.
47. "Furniture: Designed and Made by Charles Rohlfs."
48. Gustav Stickley's Craftsman Workshops, for instance, hired out its metalwork and then staffed its own metal shop. Cathers, *Gustav Stickley*, 142–143.
49. "Furniture: Designed and Made by Charles Rohlfs," 225.
50. Although Rohlfs left no records that relate directly to metalworking for his furniture, the family archives do include a letter he wrote dated 24 April 1926 to his son Sterling suggesting a different mixture of metals for casting a bridle bit. An apparent pattern for the bit made of aluminum alloy also survives.
51. "Personality Tells."
52. A number of pieces of Rohlfs furniture demonstrate construction techniques very similar to commercially produced furniture of the early twentieth century. These details probably came to the shop with Rohlfs's hired cabinetmakers. For instance, the large *Library Table* (ca. 1899) features a heavy top, made from boards laminated together to prevent cracking, that is affixed to the frame below with a series of small screwed blocks.

53. Rohlfs, "My Adventures in Wood Carving," 22.

54. It is tempting to think that Rohlfs may have called on his former employee in 1912 when he and Anna Katharine built their Park Street house, which has elaborate plaster cornices and ceiling panels of molded plaster. The architectural records for the house do not mention individual contractors hired by the architect. Colson-Hudson, Architects, "Mason and Carpenter Specification for Mr. Chas. Rohlfs, 156 Park Street," collection of the Buffalo and Erie County Historical Society Library and Archives.

CHAPTER 1.
MEMORIES, PLEASURES, AND PROMISES

1. Rohlfs and Green, Diaries for Rosamond and Sterling (hereafter cited as Diaries), entries dated May–August 1887; Zetterholm, Rohlfs family history, 10.

2. Unattributed newspaper clipping, Rohlfs family scrapbook, n.d., Rohlfs Family Archive.

3. Diaries, entries dated 1886 and 1887; Zetterholm, Rohlfs family history, 10.

4. Diaries, entries dated 1885–August 1887; Zetterholm, Rohlfs family history.

5. Diaries, 2 October 1887.

6. Diaries, August 1887.

7. Stark, "Back Stairs."

8. Rohlfs quoted in Buffalo Times, 8 January 1909.

9. As reported in Hartford, "Charles Rohlfs," 194.

10. Diaries, 20 March 1887.

11. Zetterholm, Rohlfs family history, 2; photocopies of associated material related to birth are included in the Rohlfs Family Archive, including an article on Anna Katharine Green by Mary R. P. Hatch, Book News Monthly, September 1893.

12. Zetterholm, Rohlfs family history, 3; Zetterholm, handwritten notes.

13. Zetterholm, Rohlfs family history, 3–4; Zetterholm, handwritten notes; documentation in Rohlfs Family Archive, including copies of school administrative and catalogue records confirming the administration and community reactions to the lecture.

14. The Rohlfs Family Archive includes photocopies of school catalogue showing the alteration described.

15. Quoted in Zetterholm, Rohlfs family history, 4.

16. Second Annual Catalogue of Pupils, April 1866, Poultney Historical Society, Vt.

17. School records in the Poultney Historical Society indicate that her three classmates were Phoebe Cown, Jerusha Kingsley, and Emma Hopper.

18. Green, Songs from the Poets, title page. Later inscriptions related to successive gifts within the Rohlfs family read: "To Roland with love from Mother / May 20–1930 / And now to Rosamond II with love / from Roland."

19. At least one transcription of a letter to her from Ralph Waldo Emerson is in the Rohlfs Family Archive.

20. Copy of "Ode to Grant," leaflet, n.d., inscribed "respectfully inscribed to Mrs. Gen. Grant by Miss Anna C. Green / New York / 1869," in Rohlfs Family Archive, along with a copy of a letter from Green to publisher E. C. Stedman, 4 March 1869, sent with submission of a manuscript of "Ode to Grant."

21. City of New York, municipal records, 1869 City Registry, Microforms Room, New York Public Library.

22. For example, Green wrote alongside Mary R. P. Hatch in Haverstraw-on-the-Hudson, around this time, as later described in the Writer, 1888.

23. Though there has been confusion about this point, I believe that Charles Rohlfs's great-grand-daughter has settled the issue, stating the point of view given here. Peter Rohlfs was likely born in Denmark because his family relocated there rather than as a result of the frequent nine-teenth-century shifts of Danish-German border.

24. F. E. Russell, cashier, note on Stuckle, Becker and Co. letterhead, 5 November 1868, Rohlfs Family Archive; note written on Stuckle, Becker and Co. letterhead, 31 March 1869, Rohlfs Family Archive.

25. Rohlfs's personal records, including, e.g., his 1868–1869 Class "E" student card for "Free Night School of Science," and other papers in Rohlfs Family Archive document his admission in 1867–1868 and 1868–1869. Although he was perhaps not a student in 1870, the Cooper Union archives indicate that he was again in attendance in 1871.

26. Rohlfs, "The Rohlfs of Buffalo." This undated handwritten history of the Rohlfs family was submitted to Cornell University publication division but never published. Though this manuscript was not in the past recorded in the Cornell University Library System, a copy has now been deposited with the library's Manuscripts Division as corollary documentation of research for this book.

27. Charles Rohlfs seems to have assumed the stage name "Charles Rohlfe," perhaps sometime in the 1870s, and is listed repeatedly in theater programs under this pseudonym. Numerous playbills and other documentary evidence of Rohlfs's participation in theatrical pursuits during this period are contained in the Rohlfs Family Archive and The Winterthur Library.

28. National Cyclopaedia of American Biography, 257. This is perhaps the best published source of information on Rohlfs's career in the theater, but it surely relied, at least in part, on Rohlfs as a source. Rohlfs later mentioned that after these performances, "a few days later, I had a couple of paragraphs to myself in the Philadelphia Public Ledger." Rohlfs, "My Adventures in Wood Carving," 22. One Hundred Wives, by Colonel Pierce and J. B. Runnion, was a melodrama dealing with Mormonism, which, in reviewing the play on 15 February 1881, the New York Times described as "the flagrant evil which is allowed to thrive, weed-like, in our free land." It is not clear whether Rohlfs appeared in the New York performances.

29. Note on this interchange in Green's hand in Rohlfs Family Archive. Also recounted in Zetterholm, Rohlfs family history, 6.

30. Green, fragment of a letter to Mary R. P. Hatch, December 1879, Rohlfs Family Archive.

31. Original programs, The Winterthur Library.

32. Stark, "Buffalo Writer and Husband Growing Old Gracefully."

33. Documentation of this performance, including a photograph of Rohlfs in costume for this role, is in a scrapbook in the Rohlfs Family Archive.

34. Original programs, The Winterthur Library.

35. Rohlfs, "My Adventures in Wood Carving," 22. Anna Katharine Green, a member of the Daughters of the American Revolution, did come from an old New England family. She was the great-great-granddaughter of Senior Captain James Green, who served in the Revolutionary War.

36. Green, copy of letter to Hatch, 22 August 1880, Rohlfs Family Archive.

37. U.S. Patent Office, Specifications of Patents, 14 December 1880, 400.

38. Original programs, The Winterthur Library.

39. Green, fragment of a copy of a letter to Hatch, May 1881, Rohlfs Family Archive.

40. Zetterholm, Rohlfs family history, 7–8.

41. Letters from this year in the Rohlfs Family Archive repeatedly refer to her work on various writing projects and to her exhaustion. This is also recounted in Zetterholm, Rohlfs family history, 8.

42. Green, fragment of copy of letter to Hatch, 1883, Rohlfs Family Archive.

43. Green, fragment of copy of letter, 12 April 1881, Rohlfs Family Archive.

44. Green, letter to Mrs. Harwood, September 1884, original in the collection of the Maryland Historical Society, copy in Rohlfs Family Archive.

45. Diaries, entry dated 31 August 1885.

46. Diaries, entries dated September 1885–March 1886.

47. Diaries, entries dated April–September 1886. At this time the family kept in its employ Katie Solomon as a maid and cook and later hired Minnie Cook in the same capacities.

48. Green, letter to E. C. Stedman, 14 December 1886, copy in Rohlfs Family Archive. Stedman was quite a literary tastemaker. He compiled a large Library of American Literature (with Ellen M. Hutchinson, 11 vols., 1888–1890), a Victorian Anthology (1895), and an American Anthology, 1787–1899 (1900). The last two named volumes were ancillary to a detailed and comprehensive critical study in prose of the whole body of English poetry from 1837 and of American poetry of the nineteenth century. Mrs. Elliott Coues had been Mary Emily Bates, originally of Philadelphia, before marrying in 1887 Dr. Coues, a leading Washington physician, ornithologist, and theosophist. She was not only his wife but his scientific assistant, working with him on numerous pioneering publications.

49. U.S. Patent Office, Official Gazette 37 (23 November 1886): 788 (Jewett); 38 (15 March 1887): 1134 (Griffing); 39 (5 April 1887): 103 (Jewett).

CHAPTER 2.
A CORNER IN THE STUDY OF
ANNA KATHARINE GREEN

1. Rohlfs and Green, Diaries for Rosamond and Sterling (hereafter cited as Diaries), 29 January 1888, 23 October 1887.
2. *Decorator and Furnisher,* June 1888, 78.
3. *Decorator and Furnisher,* June 1888, 78.
4. Unfortunately, the original drawing is unknown.
5. Green, fragment of unidentified handwritten notes, 1 May 1888, Rohlfs Family Archive. Also recounted in Zetterholm, Rohlfs family history, 11.
6. *Henley's Twentieth Century Formulas, Recipes and Processes* (1907), which documents late nineteenth-century and early twentieth-century techniques for finishing metals and woods, suggests a number of formulas, including varnish-based and shellac-based wood polishes, but nowhere mentions abrasive techniques for furniture polishing. See, e.g., *Henley's Formulas for Home and Workshop* (reprint, New York: Crown, 1979), 592, 593.
7. A 1912 article on Rohlfs showed a model even more similar to the Rietveld chair—namely, an open structure post and lintel construction that relates closely in its overall shapes and orientation of members, especially its use of a canted seat and backrest. Hartmann, "Charles Rohlfs: A Worker in Wood," 68.
8. In particular, a similar pinched teardrop with frame and internal shape is featured on a rotating fall-front desk, executed by Rohlfs or one of his employees or another period maker, now in the collection of the Virginia Museum of Fine Arts, Richmond.
9. Cathers, *Furniture of the American Arts and Crafts Movement,* 32–34; Cathers, *Gustav Stickley,* 31.
10. See, e.g., *Craftsman Arts and Crafts Auction,* Lambertville, N.J.: Craftsman Auctions, 11 March 2006 (lot 64). During my research, another similarly oversized unsigned example turned up in 2007, indicating that these were likely made during the period by an admirer of Rohlfs's models.
11. "The New Things in Design."
12. For all flower table models not shown in the text, see Stickley, *New Furniture.* At least one example of the Sunflower Tea-Table is in a private collection.
13. It is worth noting a few of the divergences between the actual *Settee* and Rohlfs's reinterpretation of it in the interior sketch. In the sketch, at the posts that top the *Settee,* Rohlfs morphed the single feathered crook-shape into what looks like a related but mirrored, more tightly coiled double version of the ornament. Rohlfs also invented new imagery at the exterior posts and replaced the large feathered flourishes on the interior of those posts with the same new ornament. Below the seat, Rohlfs omitted the center decoration and altered the ornaments on the edges of the seat apron, introducing a pair of shaped moldings at those edges that were not included on the *Settee.*

CHAPTER 3.
GRANDEUR NEVER BEFORE
EXPERIENCED

1. Rohlfs and Green, Diaries for Rosamond and Sterling (hereafter cited as Diaries), 17 July 1888.
2. Her correspondence with W. Gladstone about his support of the international copyright is recounted in Zetterholm, Rohlfs family history, 11. It is also mentioned in partial copies of notes and papers, ca. 1890, Rohlfs Family Archive.
3. Diaries, undated entry.
4. Obituary of James Wilson Green, *New York Times,* 14 January 1890.
5. Green, fragment of note relaying news of her father's death, Rohlfs Family Archive. Also in Zetterholm, Rohlfs family history, 11, and Zetterholm, handwritten notes. Anna Katharine's ailments might have been purely physical or a result of her grief during this time. Still, we must entertain the question of whether these and her frequent periods of illness, exhaustion, and need for secluded convalescence throughout her life might betray questions about her sexuality. Her decision to marry relatively late in life and her close relationships with women (many of whom she visited frequently and rather privately), coupled with periodic sustained depression throughout her life, raises the possibility that Anna Katharine was a closeted or repressed lesbian.
6. Green, fragment of note of reply to offer to meet her in New York, April 1890, Rohlfs Family Archive. Also in Zetterholm, Rohlfs family history, 11.
7. Green, fragments of some of the letters, Rohlfs Family Archive. Also in Zetterholm, Rohlfs family history, 12, and Zetterholm, handwritten notes.
8. Diaries, 28 March 1890.
9. Rohlfs and Green, Journal of family trip to Europe (hereafter cited as Journal), 22, 23 April 1890. All unreferenced details of the Rohlfs family's tour of Europe in 1890 are taken from their travel journal.
10. Journal, 25 April 1890.
11. Journal, 5 May 1890.
12. Journal, 10 May 1890.
13. Journal, 12, 13 May 1890.
14. Journal, 13 May 1890, and similar text included in letters from the same date.
15. Journal, 17 May 1890.
16. Journal, 12 July 1890.
17. Journal, 13 July 1890.
18. Journal, 1 August 1890.
19. Journal, 13 July 1890.
20. Journal, 4 August 1890.
21. Journal, 11 August 1890.
22. Journal, 12 August 1890.
23. Journal, 14 August 1890.
24. Journal, 16 August 1890.
25. Journal, 22 August 1890.
26. Journal, 20 September 1890
27. Journal, 23 September 1890.
28. Journal, 27 September 1890.
29. Journal, 30 September 1890.

30. Journal, 8 October 1890.
31. Journal, 12 October 1890.
32. Journal, 18, 19 October 1890.
33. Original flyers and other documentation in Rohlfs Family Archive.
34. Program from *The Leavenworth Case,* written by Anna Katharine Green and starring Charles Rohlfs as James Trueman Harwell, Private Secretary. Grand Opera House, New Bedford, Mass., Opening Night, 27 February 1893. The Winterthur Library.
35. Rohlfs and Green, Journal for Roland Rohlfs (hereafter cited as Journal for Roland), 12 February 1892.
36. Both James, *Drama in Design,* 27, and Zetterholm, Rohlfs family history, 14, report the birth as having taken place in Brooklyn, which does not seem to be correct, as per the entries cited above in the Journal for Roland.
37. Journal for Roland, 10 February 1892.
38. Journal for Roland, 24 April 1892.
39. Journal for Roland, 3 July 1892.
40. *Brooklyn Standard Union,* 27 March 1893; *Brooklyn Evening Sun,* 28 March 1893.
41. *Syracuse Courier,* April 1893; *London [Ontario] Advertiser,* April 1893.
42. Journal for Roland, 25 September 1893.
43. Journal for Roland, 25 September 1893.
44. Uncited clipping, August 1893, Rohlfs Family Archive.
45. *American Press Association* clipping, 5 April 1893, Rohlfs Family Archive.
46. *Cincinnati Time-Star,* 24 April 1893.
47. Edward Bok, *Book News,* September 1893. It appears that Anna Katharine never completed this play.
48. Information from various announcements of his dramatic recitals, 1894–1896, Rohlfs Family Archive.
49. "The Rohlfs Recital," *York Daily,* 8 February 1895.
50. Peg Woffington, *Chicago Times-Herald,* 28 December 1895.
51. "Plays and Players," *Chicago Dispatch,* 16 December 1895; "Amusements," *Saginaw Globe,* 3 January 1896; "Charles Rohlfs in Harwell," *Courier-Herald,* 3 January 1896.
52. Woffington, *Chicago Times-Herald,* 28 December 1895.
53. J. Wilson Green became editor of the *American Republican,* the party organ, in 1844, was active in the party in New York City for many years, was elected as a city councilman in 1865, and was later named its president. (Obituary of J. Wilson Green, *New York Times,* 14 January 1890, 5.)
54. On 21 July 1896, in a ratification meeting at the Republican Club of the Twenty-fourth Assembly District in Manhattan, Rohlfs pulled no punches: "Do not think that you are alone in suspecting Platt's loyalty. I have found the same feeling throughout the State. Tweed put his hand in the public treasury and was caught. Tweed ran this little island as he wanted to. Another man, Platt, now runs it, and you cannot touch him. . . . He has passed what laws he wants,

and he is the whole state government from the Governor down. We are like children and he is the master. What is the remedy? The primaries. Platt knows the importance of the primaries and takes control of them, as Crocker did. To get proper and honest representation for the passage of your laws you must regain control of the primaries, and drive out Platt and his brigands. An effort was made to send out notice of this very meeting, but access to the enrollment books was denied by Platt's henchmen. Are you going to stand this? You must awaken to your duty and attend the primaries." *New York Times*, 22 July 1896.

55. The speakers who addressed the meeting were labor leader T. V. Powderly, ex-Senator Warner Miller, Charles Rohlfs, Frank D. Pavey, and John Ford (*New York Times*, 10 September 1896).

56. "Bryan Men Seek a Row," *Chicago Daily*, 4 October 1896, 3; "Not Ready for a Debate," *Davenport Weekly*, 2 October 1896, 1.

57. *Chicago Daily*, 4 October 1896, 3.

58. *Chicago Daily*, 4 October 1896, 3. See also *Davenport Weekly*, 2 October 1896, 1.

59. "As [Rohlfs] closed his speech, which was greeted with extravagant demonstrations of approval, Pomeroy arose, evidently laboring under much excitement, and launched into a savage attack on him. 'You were not invited here to listen to vituperation, but argument,' he said to the audience. 'It was not expected that any speaker who was invited to address you would so far forget the amenities of the occasion as to descend to the coarse abuse of a man who is held in high enough esteem to be marked by signal honoring at the hands of the American people. I do not believe organized labor cares for this kind of thing, and we repudiate it. It is not pleasing to have to publicly rebuke a speaker, but it seems deserved. I offer you an apology, but I have none to offer to the man who has just spoken.'" *Chicago Daily*, 4 October 1896, 3.

CHAPTER 4.
FROM CASTING ABOUT TO A GRACEFUL WRITING SET

1. "Romance Which Caused Chas. Rohlfs to Leave the Stage and Find Fame and Fortune in a Peculiar Occupation," *St. Louis Globe-Democrat*, n.d. (ca. 1904), quoted as "A Bit of Romance" in "Clippings," Charles Rohlfs's compendium of press coverage of his decorative art, sheet 12.

2. Diffin, *Buffalo Courier*, 22 April 1900, 5.

3. All quotations from "A Bit of Romance."

4. "A Bit of Romance."

5. For reference, see photograph in *Book News Monthly*, September 1906, 29. Other undated period photos of the Rohlfs homes also show this desk.

6. Welch, *Book News Monthly*, September 1906, 29.

7. Quotations from Kevin Tucker, e-mail correspondence with author, 25 April 2006.

8. Sarah Fayen, e-mail correspondence with author, 25 April 2006. Amelia Peck and Anita Ellis each

independently suggested the same reading of the figure in later e-mails to the author on 25 April 2006.

9. Stark, "Buffalo Writer and Husband Growing Old Gracefully."

10. Moffitt, "Rohlfs Furniture," 81–82.

11. Moffitt, "Rohlfs Furniture," 82.

12. Moffitt, "Rohlfs Furniture," 82.

13. Diffin, "Artistic Designing of House Furniture," 5.

14. Welch, "Charles Rohlfs, Laborer." 5.

15. Welch, "Charles Rohlfs, Laborer." 5.

16. There is an unsigned, undated variant of the *Rotating Desk* (see discussion of this form later in this chapter) in the collection of the Virginia Museum of Fine Arts, Richmond, that has been attributed to Rohlfs. This example is suspect because of the absence of any maker's mark associating it with Rohlfs and especially because of its oddly variant carving style and technique. (For a photo of this desk, see Frederick R. Brandt, *Late Nineteenth and Early Twentieth Century Decorative Arts: The Sydney and Frances Lewis Collection in the Virginia Museum of Fine Arts* [Richmond: Virginia Museum of Fine Arts, 1985], 72, or Tod M. Volpe and Beth Cathers, *Treasures of the American Arts and Crafts Movement: 1880–1920* [New York: Harry N. Abrams, 1988], 40.) The desk exhibits a multitude of carefully arranged decorative brass head screws that, in this sort of complex configuration, are uncharacteristic of Rohlfs's work. Neither the fretted nor the carved elements show the styling or approach of Rohlfs's design or craft. This desk was more likely made by one of Rohlfs's employees, probably sometime after 1902, or by a nearby furniture-maker in western New York. Although it is regrettable if this piece has errantly entered the literature on Rohlfs, it does suggest the popularity of Rohlfs's designs around the turn of the century. Another similar example has recently emerged, this one bearing a possibly authentic Rohlfs signature, indicating that this version of the desk may have originated in the Rohlfs shop, but further conclusions about this example are not yet clear.

17. For example, from 1900 to 1902, virtually all such "R in bow saw" marks, along with associated date marks, were filled with a red pigmented wax.

18. Rohlfs pieces from before 1898 are profoundly rare, so reaching a definitive conclusion on early marks is difficult. Nevertheless, I am not aware of any unsigned examples of Rohlfs's work (other than the *Settee*) that I would confidently attribute to Rohlfs.

19. *Chicago Daily Tribune*, 18 December 1899, 8.

20. The carved rotating desk in the collection of the Museum of Fine Arts, Houston, is roughly carved with a mark resembling the "Sign of the Saw" and the date "1883," but on inspection it is clear that the carved mark and date were not made by Rohlfs. This carved rotating desk was likely made by one of Rohlfs's employees or another furniture maker during the same period.

21. I am unaware of extant objects dated after 1907, except for a lamp made by Rohlfs in 1928 for his son Sterling (see figs. 11.23 and 11.24).

22. *Chicago Daily Tribune*, 10 October 1899, 16.

23. *Chicago Daily Tribune*, 1 October 1900, 12.

24. *Chicago Daily Tribune*, 22 October 1900, 12

25. *Chicago Daily Tribune*, 5 November 1900, 12, and 10 December 1900, 12. Notably, the later of these full-page Marshall Field and Co. advertisements showed, near the section advertising Rohlfs's works, the Stickley "Twinflower" model and invited inspection of this line of "Fumed Oak Tabourettes."

26. *Chicago Daily Tribune*, 3 June 1901, 8.

27. Though the "Graceful Writing Set" is shown in an early period photo including a small wastebasket or magazine stand, the lack of any surviving examples, in contrast to the many examples of the desk and chair, suggests that this form was not included as a part of the "set."

28. See, e.g., Moffitt, "Rohlfs Furniture," 85; and "Furniture: Designed and Made by Charles Rohlfs," 226. The naming of Rohlfs objects in period articles often directly reflects Charles Rohlfs's own formal or informal names for such objects. Although we cannot know exactly which names might have come directly from Rohlfs and which may have been concocted by journalists, the influence that Rohlfs had on the press would lead to the conclusion that most of the names are his.

29. Pictures, "courtesy of Messrs. Marshall Field and Company for the illustrations of this article," appear, including both the "Swinging Writing Desk" and "Hall Chair" in Moffitt, "Rohlfs Furniture." There is also an example of the *Hall Chair* known to have descended in the family of Marshall Field. At least one period publication claimed that Marshall Field himself had rooms filled with Rohlfs furniture (*Buffalo Times*, 8 January 1909).

30. Though no catalogue, advertising, or other documentation for the "Graceful Writing Set" has ever been located, various model numbers have been associated with the *Hall Chair* and *Rotating Desk* form. The *Rotating Desk* acquired by the Dallas Museum of Art retains its original hang tag with "Model 500" handwritten by Rohlfs.

31. Kevin Tucker has noted in examining the Dallas Museum of Art's *Rotating Desk*: "The cabinetry really is rudimentary and unsophisticated. Screws holding the upper back panel penetrate at glue lines, and the rest of the joinery is equally basic. It would have, save the carving, been fairly easy to reproduce multiples of this form." Tucker, notes to the author, 27 August 2007.

32. This possible prototype has been offered by Associated Artists, LLC, Southport, Conn. There is extant at least one version of this chair form with similar spindles constituting the entire backrest.

33. Volpe and Cathers, *Treasures*, 39.

34. The finials are better interpreted as having a flame motif than as simply being "S-carved," as characterized in Volpe and Cathers, *Treasures*, 39.

35. The 1902 example is very finely carved but slightly less rigorous and complete in its crest pattern.

36. See note 34, above. Though Rohlfs's design was structurally innovative, the cabinetry remains almost amateurish.

37. Kevin Tucker has pointed out that, although fancier hinges were employed on some examples of the Rohlfs rotating desk, the Dallas Museum of Art's *Rotating Desk* exhibits simpler metal hinges.

38. Virtually all known examples of the *Rotating Desk* exhibit finials that have been broken and repaired. One notable example in the Minneapolis Institute of Arts retains its original finials, completely intact.

39. The three variant forms are a 1901 example in the collection of the Two Red Roses Foundation, the carved rotating desk in the collection of the Museum of Fine Arts, Houston (which bears a recently forged mark and date), and one that emerged in the market and was sold at Bonham's New York, 18 June 2007 (lot 2006).

CHAPTER 5.
THE ROHLFS FURNITURE

1. This and following quotations are from Moffitt, "Rohlfs Furniture," 81–85.

2. Moffit, "Rohlfs Furniture," 83.

3. Susan Soros, *The Secular Furniture of E. W. Godwin* (New Haven and London: Yale University Press, 1999), 143.

4. Sarah Lloyd, assistant curator, Applied Art, Bristol City Museum and Art Gallery, has suggested that "Godwin furniture was plagiarized frequently. Godwin was aware of this and noted in his 1877 catalogue that the copies of his designs did not do justice to his originals. One of the companies that copied the Godwin designs (particularly the furniture made by William Watt) was Cottier & Co. They were a London based firm who in 1873 opened a branch in New York. They caught the attention of Clarence Cook who wrote an illustrated article about their furniture for *Scribner's Monthly*. This article was later incorporated in a book entitled *The House Beautiful*. It is quite possible that Rohlfs saw these illustrations or indeed was influenced by either Cottier's imitations or images of the William Watt furniture itself." E-mail to author, 18 December 2006.

5. Soros, *Secular Furniture of E. W. Godwin*, 143, 154, 146 (ill.).

6. The name "Schonborn" at the bottom of the left proper page of the calendar shown in the picture likely refers to the northern Bavarian family whose name was lent to the mini-state of that region. I am grateful to Frya Barnes for this analysis.

7. Moffitt, "Rohlfs Furniture," 83.

8. Moffitt, "Rohlfs Furniture," 84.

9. Some might interpret this as showing Rohlfs's conscious or unconscious interest in the life-sustaining and nurturing role of female breasts.

10. The reverse of a period photograph of one of the examples of the form was labeled "Coal Hod."

11. Clemens, "New Art and New Artist," 585.

12. One of the two extant 1901 examples of the coal hod, a later copy of the original 1898–1899 model, is largely identical in form and decoration to the model shown in Moffit, "Rohlfs Furniture."

13. Rohlfs used colors in many interiors from 1897 to 1904, red and green being the most common.

14. For an example of the ca. 1912 Settle, see Donald C. Pierce, *Art and Enterprise: American Decorative Art, 1825–1917; The Virginia Carroll Crawford Collection* (Atlanta, Ga.: High Museum of Art, 1999), 326.

15. Mario Manieri Elia, *Louis Henry Sullivan* (Princeton, N.J.: Princeton Architectural Press, 1996), 116.

16. Rohlfs, Address to Arts and Crafts Conference. The Chicago architects seem likely to be Louis Sullivan and Frank Lloyd Wright. Given the date of the address, it is odd that Rohlfs does not refer also to Henry Hobson Richardson (1838–1886), who was the architect of three buildings in Buffalo: the Dorsheimer House (built 1869–1871) at 434–438 Delaware Avenue, the Buffalo State Hospital complex (built 1869–1880), and the Gratwick House (built in 1886) at 776 Delaware Avenue. Frank Lloyd Wright's Larkin Building and Darwin Martin House were not built in Buffalo until shortly after Rohlfs's addresses in 1902.

17. Although this picture could be of another example of the chair, this seems unlikely, given that a second example has never surfaced, despite this example's provenance from the Rohlfs home and its repeated exhibition around the world. Under magnification, the period picture and the extant *Tall Back Chair* seem to have matching grain.

18. A period photograph, ca. 1916, of the *Tall Back Chair* in its fully carved state has been deposited in The Winterthur Library.

19. Clark, *Arts and Crafts Movement in America*, 26.

20. Around 1909, Rohlfs made a variant version of the *Desk Chair*, in mahogany, with an additional ornament, possibly copied from another work by Rohlfs, carved immediately below the central panel. This chair was custom ordered, possibly as a wedding gift, for a couple that lived in Ohio. Because this later variant chair is made in mahogany, the carved motif, depicting the cellular structure of oak, loses much of its significance.

21. See "Elmslie's Sketch for 'Surprise Point' Chair, about 1913," in Jennifer Komar Olivarez, *Progressive Design in the Midwest* (Minneapolis: Minneapolis Institute of Art and University of Minnesota Press, 2000), 52.

22. See, e.g., Tall Back Chair from the Bolton-Bush House, ca. 1907, in Randell L. Mackinson, *Greene and Greene: Furniture and Related Designs* (Salt Lake City, Utah: Peregrine Smith Books, 1979), 47.

23. D'Ambrosio, *Distinction of Being Different*, 11, 19 (fig. 9).

CHAPTER 6.
THE TRUE AND FALSE IN FURNITURE

1. This and following quotations are from Rohlfs, "True and False in Furniture."

2. Exodus 25:9.

3. Rohlfs, "True and False in Furniture."

4. Rohlfs, "True and False in Furniture."

5. Quotations from Rohlfs, "Grain of Wood," 147–148.

6. Rohlfs, "Grain of Wood," 148.

7. "Poems in Wood"; "Personality Tells"; "Mr. Rohlfs and Handicraft."

8. "Poems in Wood."

9. "Poems in Wood."

10. "Poems in Wood."

11. "Personality Tells."

12. "Poems in Wood."

13. "Personality Tells."

14. "Mr. Rohlfs and Handicraft."

15. "Poems in Wood."

16. "Poems in Wood."

17. "Personality Tells."

18. "Personality Tells."

19. "Poems in Wood."

20. "Poems in Wood."

21. "Personality Tells."

22. *Rohlfs*, interview with Grace Adele Pierce.

23. This and all following quotations in this chapter are from Rohlfs, Address to the Arts and Crafts Conference, Chautauqua.

CHAPTER 7.
A NEW ART AND A NEW ARTIST

1. This and following quotations are from Diffin, "Artistic Designing of House Furniture."

2. Diffin, "Artistic Designing of House Furniture," 5.

3. Diffin, "Artistic Designing of House Furniture," 5.

4. For reference, see *Vienna, 1900–1930: Art in the Home* (New York: Historical Design, 1997), for an illustration of Josef Hoffmann, Armchair, ca. 1905, in the permanent collection of the Musée d'Orsay, Paris.

5. Presented generally and without analysis as an "oriental motif" in Volpe and Cathers, *Treasures of the American Arts and Crafts Movement: 1880–1920* (New York: Harry N. Abrams, 1988), 44, 48.

6. See, for reference, Karen Livingstone and Linda Parry, eds., *International Arts and Crafts* (London: V&A Publications, 2005), pt. 4, "Arts and Crafts in Japan," 294–338.

7. Wood Sorel Design Motifs, Japan, ca. 1900, in *Japanese Design Motifs*, 56.

8. Unfortunately, records of the Rohlfs family's library holdings are not available.

9. The *Library Table* and *Desk with Overhead Gallery* en suite with the *Carved Swivel Chair* were both sold at Sotheby Parke Bernet in New York on 14 July 1983 (lots 147 and 146, respectively) by the same "elderly gentleman" who had owned them for a long time. Lita Solis-Cohen, "Furniture of Charles Rohlfs," *Maine Antiques Digest*, September 1983.

10. The manuscript page is preserved in the Harry Ransom Humanities Research Center at the University of Texas at Austin. In earlier writing on Rohlfs, this drawing of two views of the same table was mistaken for two tables by both Joan Roberts and Michael James. To quote James, "Rohlfs' spontaneity is indicated by sketches of two tables on the back of one of Anna

Katharine's hand-written drafts. They resemble tables produced by him circa 1900, which was also the time of the book's publication." James, *Drama in Design*, 77, n. 7. This is in error. Rather, the drawings show the front and side views of the extant *Library Table*.

11. Another possible Rohlfs drawing appears on the reverse of a page of Green's manuscript for *The Hasty Arrow* in the Harry Ransom Humanities Research Center. This pencil rendering is extremely fragmentary and may relate to a later table by Rohlfs but may also be a drawing by Green of a partial interior or a piece of furniture related to her manuscript.

12. We cannot exclude the possibility that some of the current green coloration of the *Library Table* is the result of restoration or enhancement. The *Library Table* appears currently to have a brighter and greener hue than is shown in the photograph of the *Library Table* when it appeared on the market at Sotheby Parke Bernet in New York on 14 July 1983 (cover photo, lot 147).

13. It has been suggested that it was possible to raise and lower the suspended cabinet. There is no evidence whatsoever to support this speculation. Period photography clearly shows the cabinet to be suspended by a pair of chains, each of fixed length. Each chain hangs from a ring attached to a metal plate that is screwed into a vertical oak post. The bottom of each chain suspends a similar metal plate that is screwed into the top of the horizontal board on each side that supports the upper cabinet from beneath. It is possible that the speculation that the gallery could be raised and lowered resulted from mistaking the microscope on top of the gallery for a mechanism that might have adjusted the cabinet height.

14. Based on examination of the photograph in the auction catalogue when the *Desk with Overhead Gallery* first appeared in the market, at Sotheby Parke Bernet in New York on 14 July 1983 (lot 146), the overhead cabinet at that time actually hung from (replaced) hardware. Based on inspection of a photo of the desk when it was again offered for sale at Christie's New York in June 1993, it appears that the gallery at that time was no longer suspended from the chains. In any case, by the time it was again offered for sale in New York in 2006, the overhead gallery was no longer suspended by the chains.

15. In the 1983 photograph of the *Desk with Overhead Gallery*, the color of the side boards that supported the gallery appears to match the overall color of the desk and gallery. When the *Desk with Overhead Gallery* was offered for sale in 2006, the side boards, which no longer supported the gallery, appeared to be predominantly brown, in contrast to the predominantly green color of the rest of the desk and gallery. This suggests that these boards may have been replaced at some time since 1983. Nevertheless, since we know that some repairs had been made to the *Desk with Overhead Gallery* before 1983, it is not possible

to be certain when any of the modifications to the desk were made.

16. Aside from structural repair necessary to support the overhead cabinet, the center drawer and stretcher underneath were expertly reconstructed based on the original design at some time between 1983 and 1993.

17. After purchasing the *Desk with Overhead Gallery* at Sotheby's in 1983, the buyer commented, "What is wonderful is that traces of the original green finish remain and we have a contemporary picture of what it should look like." Solis-Cohen, "Furniture of Charles Rohlfs." For more on the green coloration, see note 12, above.

18. This and following quotations in this chapter are from Clemens, "New Art and New Artist."

19. See, e.g., the similar four-panel screen by Gustav Stickley in Cathers, *Gustav Stickley*, 43.

20. Hartmann, "Charles Rohlfs: A Worker in Wood," 75. It is unclear when the *Folding Screen* was exhibited at the National Arts Club. It does not appear in the list of objects shown in late 1900, but it may have been featured in one of the exhibitions of Arts and Crafts presented annually by the National Arts Club starting in 1907.

21. The National Arts Club, New York, Season 1900–1901, First Exhibition, reel 4262, frames 86, 90. National Arts Club Records, 1898–1960. Archives of American Art, Smithsonian Institution.

22. Photographs of "Galleries, National Arts Club, Arts and Crafts Exhibition," reel 4260, frames 250 and 280, Archives of American Art, Washington, D.C.

23. The exhibition presented the following works by McHugh: "Desk, stained oak and iron," "Armchair, broad arms," "Four Small Tables, Oak," "Armchair, weather stained ash," and "Settee." The National Arts Club, New York, Season 1900–1901, First Exhibition, reel 4262, frame 90, National Arts Club Records, 1898–1960, Archives of American Art, Smithsonian Institution.

CHAPTER 8.
THE CITY OF LIGHT

1. This and following quotations are from "Furniture: Designed and Made by Charles Rohlfs," 225–229.

2. This explanation has been suggested by Bruce Barnes.

3. Comparisons can be made for example between pricing of similar objects by Rohlfs and Stickley, ca. 1905: Settle: Rohlfs $100, Stickley $83.50; Fall-front Desk: Rohlfs $100, Stickley $30; Occasional Table: Rohlfs $17, Stickley $10.50; Round Dining Table: Rohlfs $90, Stickley $30–$50; Dresser with Mirror: Rohlfs $175, Stickley $50.

4. Hartmann, "Charles Rohlfs: A Worker in Wood," 75.

5. Ruge, "Das Kunstgewerbe Amerikas."

6. Employees identified during research for this book as working in Rohlfs's workshop include Joseph Balk, cabinetry and woodcarving; Fred Burks, supervisor; Christian Gerhardt, woodcarv-

ing; William C. Mahn, wood finishing; Charles Olson, machinery and repair; Charles Ortman, cabinetry; Charles Reif, cabinetry and woodcarving; Joseph Schlegel, cabinetry; Paul Schramm, cabinetry; William Schutrum, cabinetry; Charles Spencer, cabinetry, supervisor; Horace P. Taber, supervisor; and George Thiele, woodcarving.

7. Diffin, "Artistic Designing of House Furniture."

8. Robert Judson Clark, recounting his conversation with Roland Rohlfs in an interview with author, 15 March 2006.

9. A corner of Rohlfs's booth at the Pan American Exposition is visible in the rear-ground of a photograph of Gustav Stickley's United Crafts display. See Cathers, *Gustav Stickley*, 48.

10. This "Carved Dresser" was offered in Rohlfs's 1907 portfolio of illustrations for $175.

11. *Art and Decoration*, May 1901, 354.

12. Gary D. Saretzky, "Elias Goldensky: Wizard of Photography," *Pennsylvania History* 64 (April 1997): 236.

13. *Art and Decoration*, May 1901, 354.

14. *Art and Decoration*, May 1901, 355.

15. U.S. Patent Office, *Official Gazette*, vol. 110, 14 June 1904, 2002; Welch, "Chafing-Dish."

16. It is, of course, also possible that the published photograph of the *Carved Panel* is upside down.

17. "Historic Time-Piece for New Country Home," 16.

18. *Art and Decoration*, May 1901, 354.

19. "Rohlfs's Dutch Kitchen."

20. "Rohlfs's Dutch Kitchen."

21. "Rohlfs's Dutch Kitchen."

22. See James, *Drama in Design*, 65.

23. A later library table, dated 1907, is a variant form of the *Partners' Desk*, without drawers. See for reference *Decorative Arts 1900* (Detroit, Mich.: Detroit Institute of Arts, 1994), 33.

24. Though the *Stand* shown here is unsigned and undated, two other known examples, in private collections, are each signed and dated 1901. The *Stand* was discovered with two examples of the *Hall Chair* form, both of which are signed.

25. I thank Frya Barnes for her translation of both German articles discussed here.

26. This and following quotations are from "Ein Amerikanischer Möbel-Künstler," 74–76.

27. For an example, see Cathers, *Gustav Stickley*, 56.

28. Ruge, "Das Kunstgewerbe Amerikas," 129.

29. Ruge, "Das Kunstgewerbe Amerikas," 130.

CHAPTER 9.
AN ARTIST WHO WORKS IN WOOD

1. *Studio Special Number*, 1901, 113; *Decorative Kunst*, 1902, 217.

2. *Dekorative Kunst*, 1902, 200.

3. Jones, *Grammar of Ornament*, pl. 16.

4. Rohlfs, portfolio of illustrations.

5. Some of the grotesque elements of the carving and the unmistakable resemblance of the meandering carved motif at the base to intestines may suggest, to some, a more provocative defecatory interpretation of the overall carving.

6. This and following quotations are from Houk, "An Artist Who Works in Wood."

7. In this case, there was likely some hyperbole, either by Houk or Rohlfs.

8. Houk, "An Artist Who Works in Wood."

9. "Charles Rohlfs Delighted."

10. "The Turin Exposition Will Contain Many American Exhibitions of Decorative Art," *New York Times*, 30 March 1902, 24.

11. Archives of The Metropolitan Museum of Art. Folder registration: Turin—International Exhibition 1901–3, T8466 (30 pieces). From the office of General Louis P. di Cesnola, Director, Metropolitan Museum of Art, New York. Report to Officers, President L. di Cesnola, Vice-President W. E. Dodge, from agent for the Commission, John Getz, New York, 6 March 1902.

12. Though makers like Louis Comfort Tiffany, Gorham Manufacturing, and Grueby Pottery are mentioned in the records, the files at The Metropolitan Museum of Art do not indicate any other participant who was clearly a furniture-maker.

13. More accurately, John Getz and Luigi Roversi, secretary to Louis P. di Cesnola, director of The Metropolitan Museum of Art, were active in obtaining object contributions for the exhibition. *New York Times*, 14 February 1902, 6. General di Cesnola, who was from Turin, was the head of the American commission appointed by the Italian government to supervise American participation; Roversi was its secretary. *New York Times*, 30 March 1902, 24.

14. "Charles Rohlfs Delighted."

15. "American Exhibitors Disappointed," *New York Times*, 5 October 1902, 5.

16. According to Clare Batley, an archivist at the Royal Society of Arts, "Charles Rohlfs became a member of the Society of Arts in 1903 and remained a member until 1914. (N.B. we became the Royal Society of Arts in 1908.) To become a member the individual was either invited by the Society or was nominated by existing members. Nominations were brought before the Society's Council and those who were not rejected were 'elected' as members. According to *RSA Journal* Vol. 51 (1902–3), page 350, Mr. Rohlfs was elected as a member of the Society at a Council Meeting held on 11th March 1903. His address was given as: 198–200 The Terrace, Buffalo, New York, USA. However, the Minutes of the Society (1902–3) show that Mr. Rohlfs was actually proposed as a member on 11th March 1903 but the ballot and election actually took place on 25th March 1903. Unfortunately though, the Minutes do not indicate whether Mr. Rohlfs was invited, or proposed, for membership." E-mail to Bruce Barnes, 22 May 2007.

17. Notwithstanding extensive efforts, I have not been able to find any information about Rohlfs's commission for the royal family.

18. I have not been able to find any reference to Charles Rohlfs in the records of the Louisiana Purchase Exposition, notwithstanding extensive research in the archives related to the exposition of both the Saint Louis Art Museum and the Missouri Historical Society. There is also no mention of Charles Rohlfs in a lengthy report that was made on New York State's participation at the Louisiana Purchase Exposition. DeLancey M. Ellis, *New York at the Louisiana Purchase Exposition*, St. Louis, Report of the New York State Commission, 1904.

19. Hartford, "Charles Rohlfs: A Celebrated Artist in Furniture."

20. Rohlfs, portfolio of illustrations, page titled "Please Note."

21. Further documentation on the reverse of the period photograph of the *Candelabrum* reads "#12 / $15.00 / 20.00 with shade / Height 17" / #104" and bears the stamped mark "Bliss Bros. / Photographers / 265 Oak ST. & 348 Main St. / Buffalo, N.Y."

22. Notes on the Rohlfs *Tall Case Clock*, Katharine Hoover Voorsanger, Object Files, American Wing, The Metropolitan Museum of Art, New York.

23. For a long listing of European publications of this and similar models between 1902 and 1909, see *Richard Riemerschmid vom Jugendstil zum Wekbund: Werke und Dokumente* (Munich: Müncher Stadtmuseum, 1982), 157.

24. A related model had been made in 1902.

CHAPTER 10.
TWENTIETH-CENTURY PROGRESSIVE YET STRICTLY AMERICAN

1. The date of this chafing dish leaflet is unclear. It includes an excerpt from a newspaper published on 31 July 1904, and the statement (perhaps an exaggeration) that "for eight years Charles Rohlfs has been making Casserole Chafing Dishes—being the originator—in limited quantities."

2. Rohlfs, chafing dish leaflet, page titled "From the Author."

3. Rohlfs, chafing dish leaflet, untitled page.

4. The price changes were annotated in pencil on Rohlfs's copy of the portfolio of illustrations.

5. *Art and Decoration*, May 1901, 355.

6. *Buffalo Times*, 8 January 1909.

7. *New York Times*, 31 December 1921, 23. A photograph of the exterior of the main house is shown in Maitland C. DeSormo, *The Heydays of the Adirondacks* (Saranac Lake, N.Y.: Adirondack Yesteryears, 1974), 46.

8. "An Adirondack Camp," *International Studio*, July 1909, xxv. This article has two photographs of the lodge interior. Two other photos of the interior are deposited in the Adirondack Library, Saranac Lake, N.Y. (catalogue nos. 96.107 and 96.108).

9. "William Ziegler Dies; Arctic Search Goes On," *New York Times*, 25 May 1905, 9; "Ziegler's Adopted Son Gets Nearly $10,000,000," *New York Times*, 26 May 1905, 9.

10. The main house, which had become the Seven Keys Lodge, burned to the ground on 20 October 1972. "Fire Destroys Seven Keys Lodge; Built by Wealthy Man in 1890's," *Adirondack Daily*, 23 October 1972.

11. "An Adirondack Lodge for William A. Read," *American Architect and Building News*, 14 July 1906, 90.

12. In addition to the 1906 coverage in *American Architect and Building News*, the Read lodge was covered in "An Adirondack Lodge on Lake Wilbert, Franklin County, New York," *House and Garden*, December 1907, 202–207; Aymar Embury II, *One Hundred Country Houses: Modern American Examples* (New York: Century, 1909); and Herbert H. Saylor, *Bungalows* (New York: McBride, Winston, 1911), 13, 39, 94, 100, 111, 118, 148, 150, 152, 153. Rohlfs's furniture also appears in at least one bedroom.

13. Letter, 24 June 1903, Rohlfs Family Archive.

14. Photocopy of letter, 10 July 1903, Rohlfs Family Archive.

15. Photocopy of letter, 21 July 1903, Rohlfs Family Archive.

16. Records of these commissions preserved in the Rohlfs Family Archive.

17. "Buffalo's Most Noted Novelist."

18. "Buffalo's Most Noted Novelist."

19. "Buffalo's Most Noted Novelist." Of course, although Rohlfs may have been the only American furniture-maker, there were many other Americans represented.

20. Another extant example of this chair form has likely been seriously modified, insofar as it now has solid oak arms attached where surely there originally were leather straps.

21. Rohlfs, portfolio of illustrations.

22. Rohlfs, portfolio of illustrations, title page.

23. Rohlfs, portfolio of illustrations, title page.

24. The quantity of forms and the duration of his enterprise in Buffalo are likely overstated—"hundreds" seems an exaggeration, and ten years is likely more accurate.

25. Rohlfs, portfolio of illustrations, title page.

26. Rohlfs, portfolio of illustrations, page entitled "Please note."

27. One example is in the collection of the Carnegie Museum of Art, Pittsburgh, Pennsylvania, and another is in a private collection in New York.

28. Anne O'Donnell, e-mail to the author, 16 July 2007.

29. Bowman, *Virtue in Design*, 63. This exact reference seems unclear. Rohlfs had been using similar square rivets for years—including before 1900, at which point it is likely they had yet to be used in Vienna.

30. See Cathers, *Furniture of the American Arts and Crafts Movement*, 116.

31. David Cathers, e-mail to the author, 31 July 2006.

32. The price changes were annotated in pencil on Rohlfs's copy of the portfolio of illustrations.

33. At least two closely related models of the Buffet from this later period are known, one in a private collection in New York and one in a private collection in California.

34. This is the same form that was exhibited at the

Pan American Exposition and would later be photographed in the Rohlfs home at 156 Park Street.

35. Rohlfs, portfolio of illustrations, untitled page.

36. Rohlfs did pursue sales, no matter how small. On 10 January 1908, he sent a postcard to "Mrs. Clifford N. Thompson, 74 Haskell St., Westbrook, Me." The front of the postcard featured a large ecclesiastical bell case by Rohlfs, installed on the wall of what appears to have been a church or public space with wainscoting. Printed underneath the photo is "by Charles Rohlfs." In the lower right corner is an impressed sign-of-the-saw mark, which may have been added by Rohlfs. The postcard was #1043 in the postcard series printed by H. L. Woehler of Buffalo. Alongside the photograph on the front of the card, Rohlfs wrote: "The price of the flower holders is now 75 cts by mail. Should I send you one? Charles Rohlfs Jan 9/08." (The postage was one cent, and postmarks indicate that the postcard took less than twenty-six hours to travel from Buffalo to Westbrook, Maine.) I am grateful to Boyce Lydell for making this postcard available.

CHAPTER 11.
GROWING OLD GRACEFULLY

1. Various letters mentioning, for example, "nervous overwork" and "illness," Rohlfs Family Archive.

2. Program, 23 February 1909, Rohlfs Family Archive.

3. I thank Nina Gray for mentioning this comparison.

4. Jutta Page has suggested the following detailed analysis of the origin of the vase: "The company whose name is engraved under the base is the retailer Fratelli Bottacin (more precisely A. e G. Fratelli Bottacin), located at San Lio 5821, Venice, and in operation in the late 19th to early 20th C. The fact that the company name is given as A. e G. Bottacin Freres may indicate that it was intended for export to France. The company collaborated much with the glassworks Fratelli Toso on Murano for their products, but I do not believe that this impressive glass vase was made in Italy. It appears to me that it came either from the Novy Bor area in the Czech Republic (then Steinschonau in Bohemia) or from Austria, possibly the factory of Josef Riedel. I need to look into parallels a bit more closely and I am sure similar acid-etched and gilded objects can be found. It was common practice by Venetian retailers like Bottacin, Salviati, and Pauly & C. to purchase glass not only from Italian companies but also from Germany and especially from Bohemia for resale to satisfy the tourist market. Some also had retail representations in Paris and London. The retailer's mark was applied already at the factory, while the maker would remain anonymous." E-mail to the author, 17 July 2007.

5. *Buffalo Times*, 8 January 1909.

6. *Buffalo Courier*, 17 October 1909.

7. "Third Annual industrial Exposition," *Buffalo Live Wire*, November 1910, 18.

8. Beaver Manufacturing, advertisement.

9. *Buffalo Times*, 3 March 1923.

10. Stark, "Back Stairs."

11. This chair is on long-term loan to the Burchfield-Penney Art Center, Buffalo State College, from a private collection in Buffalo. Before its modifications, the chair was undated because it had been made before 1900.

12. Undated partial newspaper clipping, Rohlfs Family Archive.

13. Various letters between March and April 1913 suggest the strain she was under and her need for rest. Copies in Rohlfs Family Archive.

14. It is also possible that, as Bruce Barnes has suggested, the *Clock* would not fit into the Park Street house.

15. William Hawley Smith, "Overequipped and Undertaught," *Industrial-Arts Magazine* 3, no. 4 (April 1915): 145–148.

16. "Chamber Director Honored," *Buffalo Live Wire*, 315, undated copy in Rohlfs Family Archive.

17. This and following quotations are from "A Little-Known Husband."

18. "A Little-Known Husband."

19. Documents in Rohlfs Family Archives.

20. Original wedding announcement, Rohlfs Family Archive.

21. Notes written by Green or Rohlfs, 19 May 1917, Rohlfs Family Archive.

22. "Breaks Altitude Record," *New York Times*, 26 July 1919, 20; "Makes New Height Record," *New York Times*, 31 July 1919, 1; "Rohlfs Will Try for New Altitude," *New York Times*, 3 August 1919, 12; "Rohlfs Makes New Record," *New York Times*, 20 September 1919, 2.

23. "Rohlfs Hurt in Trial Flight for Air Race," *New York Times*, September 1920, 1.

24. Franklin Motor Company, partial advertisement, Rohlfs Family Archive.

25. Zetterholm, Rohlfs family history, 25.

26. "We Want You to Know," *Cog*, 27 September 1920, photocopy, Rohlfs Family Archive.

27. Rohlfs, advertising leaflet for "Rotarian Gavel," ca. 1920, Rohlfs Family Archive.

28. Rohlfs, advertising leaflet for "Featherweight Lamp," ca. 1923, Rohlfs Family Archive.

29. "Forsook Stage to Marry; Becomes Famous Designer."

30. Stark, "Back Stairs."

31. Rohlfs, "My Adventures in Wood-Carving," 21.

32. Rohlfs, "My Adventures in Wood-Carving," 22.

33. "Estheticism in a Business Office."

34. Jarvis, "Men You Ought to Know."

35. *New York Times*, 28 March 1928.

36. Letter, 4 April 1930, Rohlfs Family Archive.

37. Stark, "Buffalo Writer and Husband Growing Old Gracefully."

38. The obituary in the *New York Times*, sourced from the Associated Press, was laudatory, if somewhat inaccurate: "Charles Rohlfs, credited with being the originator of mission furniture, died here yesterday. . . . In 1890 he began the manufacture of furniture and conceived the idea for mission furniture. Later he abandoned his original designs and developed 'Rohlfs' furniture. He was an actor before he became a designer. . . . But he had started to make furniture for his own home and by 1896 he had become so successful that he abandoned the stage to devote all of his time to furniture. His designs were purchased abroad as well as in the United States. He was a member of the Royal Society of Arts, London, and he was the only American invited to exhibit furniture at an exhibition held in Turin, Italy." *New York Times*, 1 July 1936, 25.

39. James F. Schrader, "Charles Rohlfs, Designer of World Fame, Dies Here," obituary, n.p., n.d., Rohlfs Family Archive.

SELECTED BIBLIOGRAPHY

Unless otherwise noted, all references to sources in the Winterthur Library are to archival materials donated by Charles Rohlfs's great-granddaughter to form the Charles Rohlfs Archive in The Winterthur Library: Joseph Downs Collection of Manuscripts and Printed Ephemera, Winterthur, Delaware.

"An Adirondack Lodge for William A. Read." *American Architect and Building News*, 14 July 1906.

"An Adirondack Camp." *International Studio*, July 1909, xxv.

Appelbaum, Stanley, ed. *Traditional Chinese Designs*. New York: Dover, 1987.

Beaver Manufacturing. Advertisement for "Beaver Board," showing the interior of the Rohlfs dining room. *House Beautiful*, March 1909.

Bowman, Leslie. *American Arts and Crafts: Virtue in Design*. Los Angeles: Los Angeles County Museum of Art, 1990.

"Buffalo's Most Noted Novelist." Unknown publication, ca. late 1904.

Cathers, David. *Furniture of the American Arts and Crafts Movement*. Rev. ed. Philmont, N.Y.: Turn of the Century Editions, 1996.

——. *Gustav Stickley*. New York: Phaidon Press, 2003.

"Chamber Director Honored." *Buffalo Live Wire*, n.d., 315.

"Charles Rohlfs, Artistic Designer." *Furniture World*. 24 August 1902: 6–8.

"Charles Rohlfs Delighted." *Buffalo Morning Express*, 21 June 1902.

Clark, Robert Judson, ed. *The Arts and Crafts Movement in America, 1876–1918*. Princeton, N.J.: Princeton University Press, 1972.

Clemens, Will M. "A New Art and a New Artist." *Puritan*, August 1900, 585–592.

D'Ambrosio, Anna. *The Distinction of Being Different: Joseph P. McHugh and the American Arts and Crafts Movement*. Utica, N.Y.: Munson-Williams-Proctor Institute, 1993.

Dekorative Vorbilder (Decorative models or patterns). Stuttgart: Julius Hoffmann, 1890.

Diffin, Lola J. "Artistic Designing of House Furniture." *Buffalo Courier*, 22 April 1900.

"Dignity of Labor—Talk by Charles Rohlfs before Society of Artists." *Buffalo Express*, n.d.

"Ein Amerikanischer Möbel-Künstler: Ch. Rohlfs-Buffalo." *Dekorative Kunst*, 1901, 74–79.

"Estheticism in a Business Office." *Buffalo Arts Journal*, November 1925, 57.

Flat Ornament: A Pattern Book of Designs of Textiles, Embroideries, Wall Papers, Inlays, etc. Stuttgart: J. Englehorn, 1880, and London: B. T. Batsford, n.d.

"Forsook Stage to Marry; Becomes Famous Designer." *Buffalo Commercial*, 15 July 1922.

"Furniture: Designed and Made by Charles Rohlfs." *Art Education*, January 1901, 225–229.

Good Things from a Chafing Dish [sales and recipe book]. New York: Gorham Manufacturing, 1890. Charles Rohlfs's copy in the Winterthur Library.

Green, Anna Catherine. *Songs from the Poets: Illuminated by Anna C. Green*. Illuminated manuscript, ca. 1860s. Rohlfs Family Archive.

Greenhalgh, Paul, ed. *Art Nouveau, 1890–1914*. London: Victoria and Albert Publications, 2000.

Griesbach, C. B., ed. *Historic Ornament*. New York: Dover, 1975.

Hartford, William J. "Charles Rohlfs: A Celebrated Artist in Furniture, of International Fame." *Successful American*, March 1903, 194.

Hartmann, Sadakichi. "Charles Rohlfs: A Worker in Wood." *Wilson's Photographic Magazine*, February 1912, 69–76.

"Historic Time-Piece for New Country Home." *Buffalo Motorist*, March 1911, 15–16.

Houk, Marsha. "An Artist Who Works in Wood." *Woman's Home Companion*, June 1902, 26.

Illustrations of objects made by Charles Rohlfs. *Art and Decoration*. May 1901, 354–356.

James, Michael. *Drama in Design*. Buffalo, N.Y.: Burchfield Art Center, Buffalo State College, 1994.

Japanese Design Motifs: 4,260 Illustrations of Heraldic Crests. Comp. Matsuya Piece-Goods Store, Japan, ca. 1900.

Jarvis, H. P. "Men You Ought to Know." *Buffalo Courier-Express*, 5 September 1926.

Jones, Owen. *The Grammar of Ornament*. London: Day and Son, 1856.

Kaplan, Wendy, ed. *The Arts and Crafts Movement in Europe and America*. Los Angeles: Los Angeles County Museum of Art, 2004.

——. *The Art That Is Life*. Boston: Museum of Fine Arts, Boston, 1987.

Kardon, Janet, ed. *The Ideal Home*. New York: American Craft Museum, 1994.

"A Little-Known Husband." *Literary Digest*, 29 May 1915.

"Little Known Husbands of Well-Known Wives." *Buffalo Times*, 9 May 1915.

Livingstone, Karen, and Linda Parry, eds. *International Arts and Crafts*. London: Victoria and Albert Publications, 2005.

Marshall Field and Company. Advertisements for Rohlfs furniture and novelties. *Chicago Daily Tribune*, 10 October 1899, 16; 18 December 1899, 8; 1 October 1900, 12; 22 October 1900, 12; 5 November 1900, 12; 10 December 1900, 12; 3 June 1901, 8.

Meyer, Franz Sales. *Handbook of Ornament*. New York: Dover, 1957.

Moffitt, Charlotte. "The Rohlfs Furniture." *House Beautiful*, January 1900, 81–85.

"Mr. Rohlfs and Handicraft." *Buffalo News*, 12 March 1902.

The National Cyclopaedia of American Biography. Vol. 9. New York: James T. White, 1899.

"The New Things in Design." *Furniture Journal*, 25 August 1900, 4.

Obituary of Charles Rohlfs. *New York Times*. 1 July 1936.

"Personality Tells: Charles Rohlfs Sums up the Requirements of the Craftsman." *Buffalo Express*, 12 March 1902.

"Poems in Wood." *Buffalo Courier*, 12 March 1902.

Rohlfs, Charles. Address to Arts and Crafts Conference. Chautauqua Institution, Chautauqua, N.Y., 14 July 1902. Printed in *Chautauqua Assembly Herald*, 15 July 1902.

——. Chafing dish leaflet. ca. 1904–1907. Charles Rohlfs's annotated copy. Department of Drawings and Prints, The Metropolitan Museum of Art. Gift of Robert Judson Clark. MMA1985.1119.

——. Drawing of "A corner in the study of Anne Katherine [sic] Green." *Decorator and Furnisher*, June 1888, 78.

——. "The Grain of Wood." *House Beautiful*, February 1901, 147–148.

——. Interview with Grace Adele Pierce. *Chautauqua Assembly Herald*, 15 July 1902.

——. "My Adventures in Wood-Carving." *Buffalo Arts Journal*, October 1925, 21–22.

——. Portfolio of illustrations of objects made by Charles Rohlfs. 1 November 1907. Charles Rohlfs's annotated copy. Department of Drawings and Prints, The Metropolitan Museum of Art. Gift of Robert Judson Clark. MMA1985.1119.

——. "The Rohlfs of Buffalo." A brief history of the Rohlfs family, submitted to the Cornell University publication division. Unpublished. ca. 1920. Winterthur Library.

——. "The True and False in Furniture." Address delivered to Arts and Crafts Conference, Buffalo, N.Y., 19 April 1900. Printed in *Buffalo Morning Express*, 20 April 1900.

——, ed. "Clippings." A compilation of quotations on the decorative arts of Charles Rohlfs. Photocopy. Winterthur Library.

Rohlfs, Charles, and Anna Katharine Green. Diaries for Rosamond and Sterling Rohlfs. 31 August 1885–19 March 1894. Winterthur Library.

——. Journal of Rohlfs family trip to Europe. 21 April 1890–19 October 1890. Winterthur Library.

——. Journal for Roland Rohlfs. 10 February 1892–10 June 1894. Winterthur Library.

"Rohlfs's Dutch Kitchen." *Buffalo Morning Express*, 15 April 1901.

Ruge, Clara. "Das Kunstgewerbe Amerikas." *Kunst und Kunsthandwerk*, March 1902, 126–148.

Stark, Edith Natalie. "The Back Stairs." *Buffalo Enquirer*, 19 July 1923.

——. "Buffalo Writer and Husband Growing Old Gracefully." *Buffalo Evening News*, 29 November 1932.

Stickley, Gustav. *Chips from the Workshops of the United Crafts*. Syracuse, N.Y.: United Crafts, 1901.

——. *New Furniture from the Workshop of Gustave Stickley, Cabinetmaker, No. 1*. Syracuse, N.Y.: Gustav Stickley, 1900.

Traditional Japanese Crest Designs. Comp. Japan, ca. 1900.

Welch, Deshler. "The Chafing-Dish." *Good Housekeeping*, September 1902, 189–191.

——. "Charles Rohlfs, Laborer." *Honey Jar*, August 1910.

——. "The Home-Life of a Popular Story-Teller: Anna Katharine Green as a Wife and Mother." *Book News Monthly*, September 1906, 27–30.

Zetterholm, Rosamond Rohlfs. Handwritten notes. Unpublished. Rohlfs Family Archive.

——. Notes on Rohlfs family history. Unpublished, *typewritten notes*, ca. 1990–1994. Rohlfs Family Archive.

INDEX

Page references in boldface refer to images

ILLUSTRATION CREDITS